THE BOOK OF
35mm PHOTOGRAPHY

To Julie

Christmas, 1983

from Marie

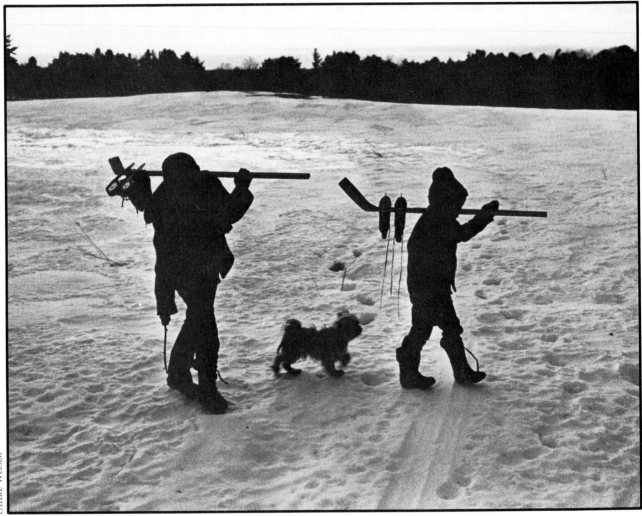

THE BOOK OF
35mm PHOTOGRAPHY

The Editors of Curtin & London

Featuring the Photographs of Ulrike Welsch

Curtin & London, Inc. Somerville, Massachusetts

Van Nostrand Reinhold Company New York Cincinnati Toronto Melbourne

Printed in the United States of America

Published in 1983 by Curtin & London, Inc.
and Van Nostrand Reinhold Company
135 West 50th Street, New York, NY 10020, U.S.A.

Van Nostrand Reinhold Limited
1410 Birchmount Road
Scarborough, Ontario M1P 2E7, Canada

Van Nostrand Reinhold Pty. Ltd.
17 Queen Street
Mitcham, Victoria 3132, Australia

10 9 8 7 6 5 4 3 2 1

Cover design and interior design: Susan Marsh
Cover photographs: Clockwise from top left: Minolta
Corp., Nikon Inc., USDA, Larry Lorusso
Line illustrations: Omnigraphics Inc.
Composition: DEKR Corp.
Printing and binding: Kingsport Press

Acknowledgments
Thank you to those organizations who granted us permission to reproduce the photographs on the following pages: *The Boston Globe,* 2, 4 (bottom), 16 (top and bottom), 17 (bottom), 26 (top), 27 (top and bottom), 30 (top), 33, 40, 43, 45 (top), 47 (top), 48, 49 (top and bottom), 51, 55 (top and bottom), 66 (top), 67, 90 (top and bottom), 91 (top and bottom), 92 (bottom), 95 (top), 110 (bottom), 115 (top), 116 (top and bottom), 122, 140; National Park Service, 6, 7 (top), 26 (bottom), 37, 52, 60, 68 (top and bottom), 77, 81, 87 (bottom), 89 (bottom), 94 (top and bottom), 98, 128 (bottom); U.S. Department of Agriculture, 7 (airplane), 10 (top), 12 (top), 17 (top), 18, 53, 58, 61, 75, 78, 82 (bottom), 86 (bottom), 97 (top), 145; Library of Congress Look Collection, 7 (wrestlers); Library of Congress American Folklife Center, 106, 112 (top); Illinois Central Gulf Railroad, 31 (top); Union Pacific Railroad, 80 (bottom); EPA Documerica, 73, 76, 86 (top), 87 (top).

Library of Congress Cataloging in Publication Data
Main entry under title:

The Book of 35mm photography.

 Includes index.
 1. 35mm cameras. 2. Photography—Handbooks, manuals, etc. I. Curtin & London, Inc. II. Title: Book of 35 millimeter photography. III. Title: Book of thirty-five millimeter photography.
TR262.B66 1983 770'.28'22 82-19879
ISBN 0-930764-41-2

Contents

National Park Service

USDA

National Park Service

For many years the 35mm single-lens-reflex (SLR) camera has been the camera of choice for anyone who wanted to take more than the simplest snapshots. Amateurs have liked its compact size and simplicity of operation. Working professionals have appreciated its reliability and flexibility—for example, the ease with which lenses can be changed or accessories added. Now, with the introduction of new features such as automatic exposure control and automatic flash, the 35mm camera has become even easier to operate and more popular than ever.

If you are considering the purchase of a quality 35mm camera or have decided to get better results with the one you already own, this comprehensive but easily understood book is the ideal place to begin. It sweeps away unnecessary complexity and explains what you really need to know about getting better photographs. It has been written by people who understand how important it is to present material clearly so the user doesn't get lost in a jungle of trivia.

The book starts with the basics of 35mm camera features and operation, shows you how to make simple camera handling choices that can turn an ordinary snapshot into an exceptional picture, and then moves on to creative and experimental techniques that can enhance your photographs even more.

Even an automatic camera doesn't automatically give perfect results every time. You may want to override the automatic exposure to make a picture lighter (a snow scene) or darker (a night scene) than the automatic circuitry would. You may want to adjust camera controls to blur a moving subject or show it sharply. You may want to have a background out of focus or sharp throughout the entire scene. Such creative choices are made by every photographer. This book shows how other photographers have made these choices and gives you some ideas on how to make them yourself.

Throughout the book are boxed sections that help make photography easier to understand and more enjoyable to learn about:

- "See for Yourself" boxes show you how to look at your own camera to see how it works. Seemingly complicated subjects like f-stops and shutter speeds come alive when you watch them in action on your own camera.

- "The Way It Was" boxes show you how the most sophisticated camera functions existed even in very early cameras. Did you know, for example, that the focal plane shutter in a modern 35mm camera performs exactly the same function that the early photographer performed by removing and then replacing a cap over the lens to make an exposure.

- "Tips" boxes give you some of the secrets of better photography used by the pros who have to perform consistently well—for instance, how to photograph at night.

- Step-by-step sections show you in easy-to-follow steps how to successfully use techniques that might otherwise seem complicated—for example, how to use a flash.

In addition, we have included a Buying Guide that describes accessories and services that are available for your camera to increase its flexibility and your creativity—for instance, lenses, lighting equipment, tripods, accessories for filing and displaying prints and slides, and custom lab services.

THE BOOK OF
35mm PHOTOGRAPHY

1 35mm photography

The 35mm single-lens-reflex (SLR) is by far the most popular camera among serious amateur and professional photographers. The reason for this overwhelming popularity is quite simple: it's the most versatile, high-quality camera available. With a basic camera and lens, you can take exceptionally fine photographs, and many photographers are content to stay with just this standard outfit. A few accessories, however, can open new worlds to anyone interested in exploring a little deeper into other facets of photography.

The 35mm SLR camera and lens have been under continual development and steadily improving for almost 50 years, especially during the past decade. The modern camera is small, light, and easy to use. Computers design lenses that now produce a brighter image, better color rendition, and sharper detail, while being smaller, lighter, and less expensive than before. The incorporation of the latest electronic technology inside the camera has made it easier to obtain consistently well-exposed photographs. As a result, pictures that are too light or too dark are now the exception, even for beginners using their first roll of film.

A wide range of relatively inexpensive available accessories can adapt the basic camera to meet almost any photographic situation. Lenses can be interchanged to allow wide-angle shots in tight spaces or to bring distant objects closer without having to move the camera or disturb the subject. Close-up accessories allow you to photograph extremely small objects so that they appear larger than life on the print or slide. Electronic flash can make pictures possible even in the darkest of settings. Lens attachments can change the way a scene appears in the photograph, either by making it look more like you actually see it or by making it appear dramatically different. Power winders, or more expensive motor drives, can automatically advance the film, making it possible to capture on film sequences of rapidly unfolding fast action.

Less exciting but equally practical accessories can be added to the basic camera to meet the special needs of almost

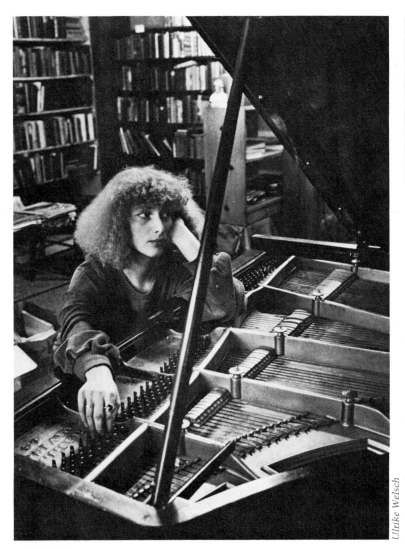

Ulrike Welsch

every photographer. Interchangeable viewfinder screens on some models can help improve focusing in critical situations. Corrected viewfinder eyepieces allow those wearing eyeglasses to put them aside when taking pictures.

To get the best results from your camera and accessories you should understand how they work and how to use them. In the rest of this book we'll explore the basic functions of your equipment and simple techniques you can use to capture life around you in exciting photographs.

You can change lenses on your 35mm SLR to increase creative control in almost any photographic situation. Here the photographer used a wide-angle lens, which lets you photograph close to a subject and gives a wide view of a scene.

Photographs by Ulrike Welsch are featured in this book. Uli came to America from her native Germany in 1964. The first female staff photographer to be hired by a Boston newspaper, she photographed daily news for five years at the *Boston Herald Traveler*, then in 1972, when that paper closed, she moved to the *Boston Globe*. Her sensitive human interest photographs were a feature of the *Globe* for more than nine years. She has traveled extensively on various photographic projects, taught photojournalism, and published several books, including *The World I Love to See* (Boston: Globe Pequot Press, 1981). She is currently freelancing and is a frequent contributor to magazines such as *Life, Time,* and *Yankee.*

Ulrike Welsch **Why I use a 35mm SLR**

A 35mm camera has many advantages—you can interchange lenses, it's fast to operate and easy to carry, but the most important reason for me is that I get to make 36 shots before I have to change film. I photograph people most of the time, and when you are working with people, you need continuity. I try to warm them up, shoot several shots just so they get used to me taking their picture, so they accept me and relax in front of the camera. I also like to move around them and shoot from different positions so I can see the light or the background from different angles. All of that uses up film and I don't want to have to stop to reload just when I've gotten them—and me—warmed up.

The other main reason that I like an SLR is that it lets me view through the lens. I often work close to a subject, and even a slight change of angle makes a big difference in the composition and framing of the picture when you are shooting up close. So I want to see exactly what I am getting—and viewing through the lens lets me do that.

Flint Born

Electronic flash is easy to use and lets you take photographs that wouldn't otherwise be possible. Not only can a flash illuminate a too dark scene, but its burst of light is so fast that it freezes fast motion, much like a disco strobe light.

Sam Laundon

Close-up accessories allow you to photograph small objects, revealing details that can't be seen well by the unaided eye.

Creative 35mm photography

If you understand the basic functions of your camera's controls, you'll find it easier to expand and improve your photography. Sometimes you may want to record a scene realistically, just the way you saw it. At other times capturing the feeling or mood may be more important than showing the details making up the scene. The versatility of the 35mm SLR lets you decide what's most important to you in a scene and makes it possible to take a photograph that best expresses what you want to convey.

Like artists in other mediums, as a photographer you have a set of "tools" that can make photographs not only exciting and interesting to others but also unique to your own, very personal view of the world. The basic tools you have to work with are the way sharpness, tone, and color interact in the scene being photographed, the vantage point from which you take the picture, and the light under which it's photographed. You can choose to keep everything in a scene sharp for maximum detail or to

Ulrike Welsch

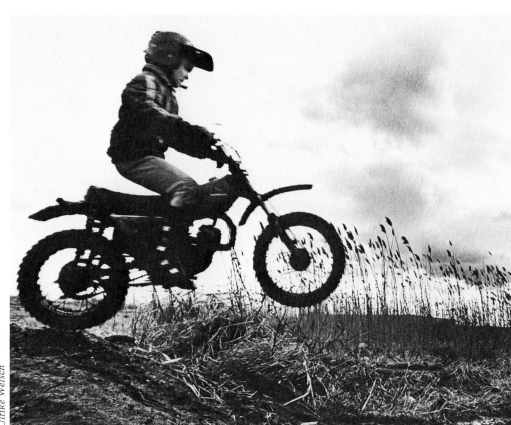

Ulrike Welsch

▲
Everything in a scene may not be equally important. When you look at the world your eye focuses sharply on only very small areas at any one time. You can select what is most important from an almost infinite number of details. Photographers can use the same technique to isolate the most important part of a scene.

◄
Sharpness in an image is one basic effect you can control in your photographs. In this photograph the photographer chose to convey a feeling of speed and motion rather than a sharp, detailed record of the event.

blur it all for an impressionistic portrayal. You can keep some parts sharp and dramatic while letting others appear soft and undistracting. You can use black-and-white film to emphasize tone, the innumerable shades of light and dark in every scene, or color film to capture bright and powerful or soft and romantic colors. You can photograph the same subject at dawn, noon, dusk, or at night, in sun, rain, snow, or fog. Each of these variables will influence the image you get.

All of this is possible by adjusting only three controls on the camera: focus, shutter speed, and aperture. These three controls, however, when combined with patience, experience, and your own personal view of the world, lend themselves to an infinite variety of possibilities, which makes photography a lifelong interest and challenge for even the most experienced photographers.

When learning and practicing photography, remember that there are no "rules," no "best" way to make a picture. Great photographs come from experimenting and trying new approaches even with old subjects.

Pictures don't always have to be sharp to be good, perfect exposures don't always give the best results, camera angles don't always have to be the same. Film is not so expensive that you should feel the need to get each shot perfect. It's likely that your photographs won't be interesting if you don't take chances and explore new approaches. When you find a situation that catches your eye, shoot it from a variety of positions. If you have extra lenses use them, change film and exposure settings, photograph the same scene at other times under different lighting conditions. Keep experimenting and trying new techniques, occasionally do things "wrong" deliberately. When you have the film developed look at the results and recall how you got them. Those results that appear interesting can be applied in other situations. Eventually you'll find a distinctive personal style that allows you to convey the world to others from your own unique viewpoint.

Ulrike Welsch

Exposure choices can be used to portray any scene as light or dark as you wish. More exposure to light makes a scene lighter, less exposure makes it darker.

For the purpose of developing vision, it doesn't matter much whether a picture is good or bad. If it is good, we search for the things that made it that way. If bad, for the negative, ineffective elements. Both experiences expand and sensitize vision. In this light, early failures aren't so bad. Instead of attempting suicide over pictures that bomb, the student should regard them as opportunities. It is true they cause griping of the gut, but that is always the price of artistic growth.

Ralph Hattersley, *Beginner's Guide to Photography* (Garden City, NY: Doubleday & Co., 1975).

The 35mm single-lens-reflex (SLR) system

A modern 35mm single-lens-reflex (SLR) camera is the heart of a complete family of components and accessories, many of them automatic in operation.

Exposing film to light determines how light or dark the final picture will be (see below). The most significant recent advance in camera design has been the incorporation of an **automatic exposure system** within the camera. This system automatically sets one or both of the camera's exposure controls (shutter speed or aperture) for perfectly exposed pictures in most situations.

Modern 35mm SLR systems have several other features that expand their versatility and convenience (see opposite). **Through-the-lens viewing** lets you see the scene the same way the film will record it when the picture is taken. An electronic **viewfinder display** tells you, without your having to take your eye from the viewfinder, what shutter speed and/or aperture the automatic exposure system has set or what settings you should use for a manually set exposure. **Interchangeable lenses** let you control how much of the scene appears in a photograph. An **automatic electronic flash** is easy to use when you need more light on a scene. A **power winder** or **motor drive** will advance the film to a fresh frame whenever a picture is taken.

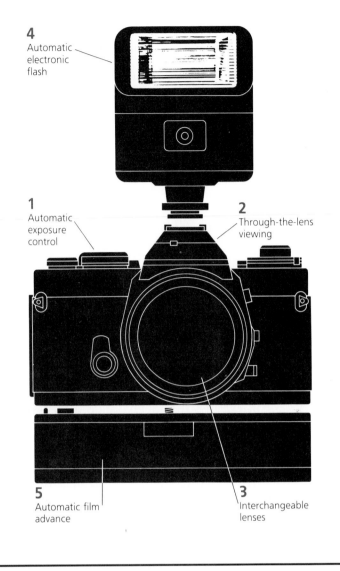

4
Automatic electronic flash

1
Automatic exposure control

2
Through-the-lens viewing

5
Automatic film advance

3
Interchangeable lenses

1 **Automatic exposure control**
The amount of light that reaches the film (the exposure) determines how light or dark the final picture will be. The more light that reaches the film, the lighter the picture will be; the less light, the darker the picture. Not enough exposure produces a murky, dark picture with shadows that do not show adequate detail (top). In most cases you will want a normal exposure with important parts of the picture showing texture and detail (center). Too much light produces a pale, washed-out picture with bright areas devoid of detail (bottom).

Two adjustable controls on the camera—the shutter and the aperture—affect the amount of light that reaches the film. A camera with an automatic exposure system can automatically set the shutter speed or the aperture (some models can set both) for a correct normal exposure. More about shutter speed and aperture and how to control them on pp. 10–17.

Dark positive

Normal positive

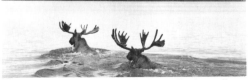

Light positive *M. Woodbridge Williams*

What is exposure?

Exposure has more than one meaning. You make an exposure when you press the shutter release button; this opens the shutter and lets light strike the film. "Making an exposure" is the same as making a photograph. Exposure also refers to the quantity of light that reaches the film. For example, you can "increase the exposure" by using a slower shutter speed.

2 **Through-the-lens viewing** When you look through your camera's viewfinder eyepiece you are actually looking through the camera's lens. You see the scene the same way the film will "see" it when you press the shutter release button. Exposure information is given by a display located in the frame around the viewing area. The amount of information displayed varies from camera to camera. The simplest type of display tells only whether there is enough light to make an exposure. More complete readouts, like the one here, show aperture and shutter speed settings and give other data, such as under- and overexposure warnings, flash unit readiness, and so on.

Richard Frear

3 **Interchangeable lenses** Do you want to see the entire scene in front of you or does just some small part of it catch your eye? You can show either from the the same position by interchanging lenses. A short-focal-length (wide-angle) lens shows a wide view (left). A normal-focal-length lens shows a scene about the way the human eye views it (center). A long-focal-length (telephoto) lens shows a narrower view, but enlarges objects more (right). More about lens focal length on pp. 104–105.

18mm focal length **50mm focal length** **500mm focal length**

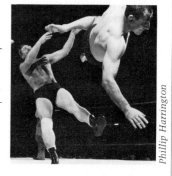

T. G. Freeman

4 **Automatic electronic flash** An electronic flash unit with automatic exposure control built into either the camera (top) or the flash unit (bottom) not only provides light for scenes that are otherwise too dark but also meters the light emitted by the flash and reflected by the subject. When the subject has been sufficiently illuminated and the correct exposure is reached, the flash is automatically cut off. More about flash lighting on pp. 128–139.

Flash metered through the lens

Flash metered by sensor built into flash unit

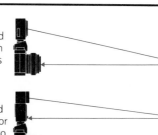
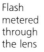
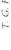

Phillip Harrington

5 **Automatic film advance** It is a rare televised press conference that lacks the whirring background noise of the power winders and motor drives that automatically advance film to the next frame when a picture is taken. Motorized film advance helps ensure that you're always ready to shoot, so that fast, fleeting actions and expressions will be captured on film. You can use it either to advance the film a single frame at a time or to capture a sequence of photographs of fast-moving action. More about these units on p. 149.

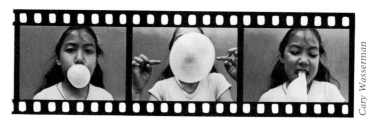

Cary Wasserman

Inside your 35mm SLR

A modern automatic 35mm SLR incorporates advanced electronic and computer technology in its design and operation. Cameras of only a few years ago were almost entirely mechanical in operation, and the mechanical linkages that controlled camera functions made cameras heavy and large compared with today's electronic models. The replacement of mechanical components with electronic circuits makes today's cameras smaller, lighter, less expensive, and easier to use.

Below is a look inside a typical single-lens-reflex camera. The SLR takes its name from its single lens (some cameras have two) used for both photographing and viewing, and from the way it reflects light upward, using a mirror, into the viewfinder. See opposite for how the camera works when a picture is taken.

The anatomy of your camera and lens

1 Camera body The light-tight outer case of the camera.
2 Lens Gathers and focuses the light from the subject onto the camera's film plane. SLR lenses are interchangeable.
 Lens elements Coated optical glass lens elements that form the image.
3 Focusing ring Turning the ring moves the lens elements farther from or closer to the film to bring objects at different distances into focus.
4 Aperture diaphragm A ring of overlapping metal leaves that can be opened to let more light into the camera or closed (stopped down) to let in less.
5 Aperture control Selects the size of the opening in the aperture diaphragm in aperture-priority or manual exposure mode. Aperture is set automatically in shutter-priority and programmed automatic exposure.
6 Reflex mirror When you are composing and focusing, light enters the lens, bounces up off the reflex mirror into the pentaprism and out the eyepiece. When you push the shutter button, the mirror moves up out of the way to let light reach the film.
7 Viewing screen A ground glass (or similar) surface onto which the reflex mirror projects the focused image upside down and reversed left to right. Some cameras have interchangeable screens for special applications.
8 Pentaprism A five-sided optical device that takes the image on the ground glass and reverses it left to right and inverts it top to bottom so the scene appears correct in the eyepiece.

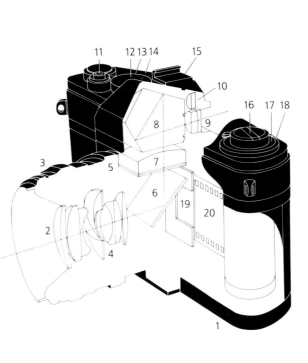

9 Viewfinder eyepiece A window into which you look to view the scene as it appears through the lens. Some cameras have provisions for corrected eyepieces for eyeglass wearers.
 Eyepiece blind Covers the viewfinder eyepiece when the camera is on a tripod to keep stray light from affecting the automatic exposure sytem.
 Depth-of-field preview button Available on some camera models for previewing which parts of the scene will be sharp in the photograph.

10 Metering cell Measures the brightness of the light entering the camera.
11 Shutter release button Initiates the exposure sequence (described opposite) when depressed. Usually is designed to prevent accidental multiple exposures.
12 Shutter speed control Selects the shutter speed in shutter-priority automatic or manual exposure mode. Shutter speed is set automatically when using aperture-priority or programmed automatic.

Automatic exposure system The camera's electronic circuitry used to control exposure.
13 Exposure mode selector switch Used on multimode cameras to switch from one exposure mode to another.
14 Film advance lever Advances the film to the next unexposed frame after a picture is taken. It's usually connected to a frame counter so you can tell how many pictures are left on the roll.
15 Hot shoe A bracket on top of the camera where an electronic flash can be mounted. Connects the flash electrically to the camera so the flash and camera shutter are synchronized.
16 Film rewind crank Rewinds the film into its light-tight cassette after the final exposure is made.
 Rewind button (underneath the camera) Must be depressed to allow the rewind crank to rewind the film into its cassette.
17 Film speed dial Used to enter the film speed (ISO/ASA or DIN) so that the autoexposure system can determine the correct amount of light needed for exposure.
18 Exposure compensation dial or backlight button Overrides automatic exposure system when you want to do so.
19 Focal-plane shutter Opens to uncover the **film (20)** when the shutter release is pressed and the reflex mirror swings up out of the way.

How your camera works

1 Viewing and composing
When you look into the camera's viewfinder eyepiece (1), you are seeing the image of the scene through the camera's lens, the view that the film will record when the picture is taken. Light reflecting from the scene is gathered by the camera lens (2). It then passes through the lens aperture (3), which, to make focusing and composing easier, is wide open to give the brightest possible viewfinder image. The light then bounces off the reflex mirror (4) up to the viewing screen (5). If you were able to look directly at this image on the screen you would see that it is upside down and reversed left to right. The image is corrected, so it appears the way you normally see it, by the five-sided pentaprism (6) through which you view the image on the viewing screen.

As the light follows its path through the camera, it is measured by metering cells (7) located near the pentaprism or, in some cameras, near the shutter.

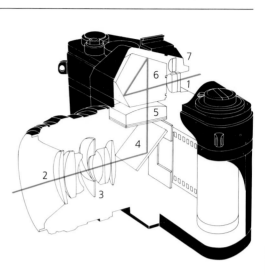

2 Focusing and setting the exposure controls As you turn the focusing ring on the lens (1) the lens elements move closer to or farther from the film. As they move, objects at different distances from the camera move into or out of sharp focus. To choose an aperture lens opening (2) you rotate the aperture ring on the lens (3). At this time the aperture remains wide open to give a bright viewfinder image. It will stop down to the aperture you have chosen when the shutter release is depressed (below). You select a shutter speed by rotating the speed dial (4). When using a camera with either an aperture-priority or shutter-priority automatic exposure mode, you select only one exposure setting, either the aperture or the shutter speed. The camera will then automatically select the other to give a good exposure. Cameras with a fully automatic (programmed) exposure mode select both the aperture and shutter speed for you, so all you have to do is focus and take the picture.

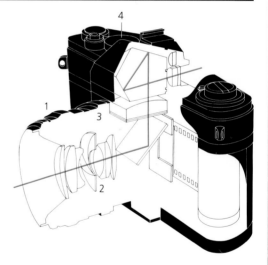

3 Taking the picture
Pushing the shutter release button (1) begins the actual exposure sequence. The metering cells (2) measure the light entering the lens, and the automatic exposure system calculates the best possible exposure settings. In aperture-priority exposure mode, it automatically sets the shutter speed (3), in shutter-priority mode the aperture (4), and in fully automatic mode it sets both. The aperture closes from its widest opening to the one you (or the automatic exposure system) have selected. The reflex mirror (5) swings up out of the way so light can reach the film (your view through the eyepiece temporarily goes dark). The shutter (6) opens, exposing the film to light, then closes again after the predetermined amount of time. At this point the picture-taking process is complete. The reflex mirror swings back down, allowing you to see through the lens again, and the aperture diaphragm opens back up to its widest opening for a bright viewfinder image.

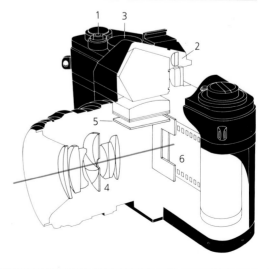

The shutter controls light and motion

The shutter keeps light away from the film in your camera except during an exposure, when it opens to let light strike the film. The shutter speed—the length of time that the shutter remains open—is adjustable. You can set the shutter speed to stay open for as little as 1/1000 sec. (1/2000 sec. on some cameras) or up to 1 sec. or longer.

Your ability to choose a shutter speed affects your photograph in two ways (right). First, it affects the exposure (the amount of light that reaches the film), and so the lightness or darkness of the final picture. (The aperture, pp. 12–13, is the other control over the exposure.) Second, the shutter speed is the most important control you have over how motion is represented in a photograph.

Both the shutter speed and the aperture can be used to lighten or darken a picture, and most of the time you can let your camera's automatic exposure circuitry set one or the other to get a good exposure. But knowing how to choose the right shutter speed is vital if you want to show a moving subject sharply or if you want to show it blurred. You also need to choose the correct speed if you want to prevent the blur caused by camera motion during the time the shutter is open. More about shutter speed and subject motion on pp. 30–31, shutter speed and camera motion on pp. 28–29.

Tips Getting the shutter speed you want

If your camera has a manual exposure mode just set the shutter to the speed you want. The faster the shutter speed, the less chance that a moving subject (or camera) will blur the picture. For a correct exposure in manual operation use the viewfinder exposure display to determine the correct corresponding aperture. In shutter-priority mode select the shutter speed and the camera will automatically select the aperture for a correct exposure. In aperture-priority mode rotate the aperture ring, while watching the shutter speeds displayed in the viewfinder, until you turn to an aperture that gives you the shutter speed you want.

How shutter speed affects your picture

The longer the shutter remains open, the more light will reach the film, and the lighter the final picture will be. A faster shutter speed exposes the film to less light and makes the picture darker. The length of time the shutter is open also lets you control the way a moving subject will appear in a photograph. The longer the shutter is open, the more a moving subject will be blurred in the picture.

Fast shutter speed, less light

Slow shutter speed, more light

Charles O'Rear

In these pictures, the exposure was set manually so that the shutter speed could be changed while the aperture remained the same. The picture on the right is lighter because the shutter speed was slower, increasing the amount of light that reached the film.

Fast shutter speed, motion stopped

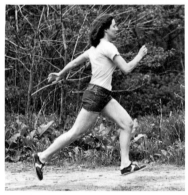

Slow shutter speed, motion blurred

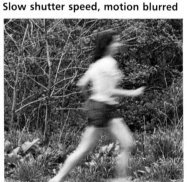

Elizabeth Hamlin

Unlike a fast shutter speed (left) where the shutter opens and closes so quickly a moving subject (or a moving camera) doesn't move very far during the exposure, a slow speed can be open so long that moving objects will move sufficiently far to blur their image on the film (right).

Notice that the picture on the right did not get lighter. The camera was set for shutter-priority automatic exposure so that when the shutter speed was changed, the camera automatically changed the aperture to maintain the same amount of light.

How the shutter works

A focal-plane shutter uses two fabric or metal curtains, one to begin and the other to end an exposure. Between exposures the film is completely covered by one of the curtains. When you depress the shutter button this curtain begins to move (1), uncovering the film and exposing it to light. At slow speeds (left column), the first curtain completely uncovers the film (3) before the second curtain begins its journey to recover it (4) and end the exposure.

At fast shutter speeds (right column) the second curtain begins to re-cover the film (2) before the first has completely uncovered it. The result is a slit moving across the film (2, 3, 4) exposing it to light. At the end of the exposure the film is again completely covered.

How to read shutter speed settings

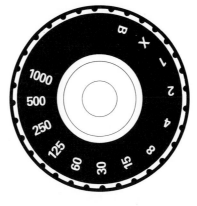

Shutter speed settings are arranged in a sequence in which each setting lets in half as much light as the next slowest setting and twice as much as the next fastest. All speeds faster than 1 second are actually fractions of a second, but only the bottom number of the fraction appears on the shutter speed dial and in the viewfinder display. The numbers on the dial (listed from the fastest to the slowest speeds) and their actual speeds are usually 1000 (1/1000), 500 (1/500), 250 (1/250), 125 (1/125), 60 (1/60), 30 (1/30), 15 (1/15), 8 (1/8), 4 (1/4), 2 (1/2), 1 (1 second). Other settings may include X (used to synchronize the shutter with a flash), B (used for time exposures: the shutter will stay open from the time you depress the shutter button until you release it), and A for automatic exposure operation.

Slow **Fast**

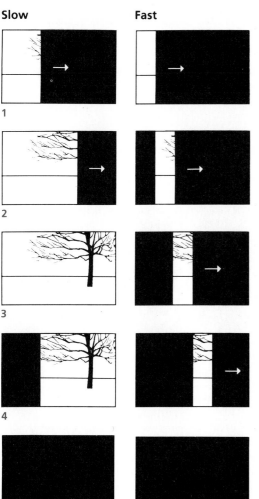

See for yourself **The shutter in action**

In some cameras the shutter moves horizontally as illustrated at left; in others it moves vertically. You can see your camera's shutter in operation if you open the back of your unloaded camera, set the shutter to a slow speed, and press the shutter release. Try doing this at various shutter speeds; at the fastest speed you will hardly see the shutter move because it happens so fast. You may be able to see the effect better if you open the lens to its widest aperture and point the camera toward a light while watching through the shutter from the back. At very fast shutter speeds you will see a very brief flash of light. Avoid touching the shutter; it is a delicate mechanism.

The way it was **Early shutter designs**

The shutter, used to control the amount of time that light exposes the film, has changed considerably over the years. The earliest cameras, using materials that might take minutes to be properly exposed, used a lens cap that the photographer removed, then replaced. Removing the cap began the exposure, and replacing it ended it. As film became more sensitive and exposures shorter, faster shutters were needed. One kind used a swinging plate while another design used a guillotine-like blade. As it moved past the lens opening, a hole in the blade allowed light to reach the film.

The aperture controls light and depth of field

The aperture diaphragm, a ring of overlapping leaves within the camera lens, adjusts the size of the opening in the lens through which light passes to the camera interior. It can be opened wide to let in more light or closed down ("stopped down") to let in less.

The size of the aperture affects your picture in two ways (shown at right). It is one of the two controls over exposure (along with shutter speed, pp. 10–11) that determine how light or dark the final picture will be. Like shutter speed, it also affects the sharpness of your picture, but in a different way. Changing the aperture changes the depth of field, the depth in a scene from foreground to background that will be sharp in a photograph.

For some pictures—for example, a landscape—you may want maximum depth of field so that everything from near foreground to distant background is sharp. But perhaps in a portrait you will want to decrease the depth of field so that your subject's face is sharp but the background is soft and out of focus. Find out how to do so here and on pp. 40–41.

Tips How to get the aperture you want

If your camera has a manual exposure mode, you simply set the aperture to the desired size. Use a large f-stop number (small aperture opening) for maximum depth of field, a small number (large opening) for shallow depth of field. For a correct exposure in manual operation use the viewfinder exposure display to find the correct corresponding shutter speed. In aperture-priority mode, select the aperture and the camera will automatically select the shutter speed for a correct exposure. In shutter-priority mode, turn the shutter speed selector, while watching the apertures displayed in the viewfinder, until you turn to a shutter speed that gives you the aperture you want.

How the aperture affects your picture

The lens aperture functions somewhat like a window shade over a bright window. You can pull down the shade to darken a room or roll it up to the top to let in the maximum amount of light. A small aperture (such as f/16) lets less light reach the film and makes the final picture darker. A larger aperture (such as f/2.8) exposes the film to more light and makes the picture lighter. The size of the lens aperture also affects depth of field, the distance between the nearest and farthest objects that will be acceptably sharp in a photograph. The smaller the aperture you use, the greater the area of a scene that will be sharp.

Large aperture, more light

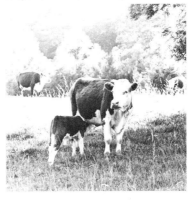

Small aperture, less light

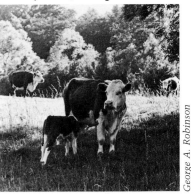

George A. Robinson

The exposure was set manually for these pictures. The aperture was changed while the shutter speed remained the same. The picture on the right is darker because the smaller aperture reduced the amount of light.

Large aperture, less depth of field

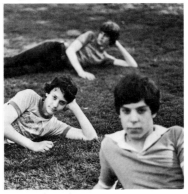

Small aperture, more depth of field

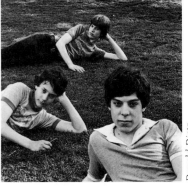

Donald Dietz

Smaller apertures give greater depth of field: more of the scene in front of the camera is acceptably sharp in the photograph. Why isn't the picture on the right darker, even though the aperture was smaller? The camera was set for aperture-priority automatic exposure so that when the aperture changed, the camera automatically changed the shutter speed to keep the amount of light the same.

How the aperture diaphragm works

The lens aperture diaphragm, located inside the lens between the glass lens elements, consists of a ring of overlapping metal blades. When you are focusing and composing (1) the aperture is at its maximum opening to produce a bright viewfinder image. When you depress the shutter button (2) the lens diaphragm automatically stops down (reduces in size) to the aperture you (or the automatic exposure system) have selected. When the exposure is completed (3), the lens reopens to its maximum aperture so you can compose and focus the next picture.

The way it was **Early apertures**

A variety of diaphragm designs in the past century and a half enabled the photographer to change the size of the lens opening. A form of the iris diaphragm, used in today's cameras, was used as early as the 1820s by Joseph Nicéphore Niepce, one of the inventors of photography. Waterhouse stops, used in the 1850s, were a series of blackened metal plates with holes of different sizes cut in them. To change apertures the photographer chose the one desired and slid it into a slot in the lens barrel. With wheel stops, different size apertures were cut into a revolving plate. The photographer changed the size of the aperture by rotating the plate to align the desired opening with the lens.

How to read aperture settings

The aperture ring on a lens is marked with a series of numbers called f-stops, which indicate the size of the aperture opening inside the lens. Each f-stop lets in half as much light as the next larger opening, twice as much light as the next smaller opening. From the largest possible opening to increasingly smaller ones, the f-stops are f/1, f/1.4, f/2, f/2.8, f/4, f/5.6, f/8, f/11, f/16, f/22, f/32, f/45. No lens has the full range of settings; for example, the standard lens that is supplied when you purchase a 35mm camera will range from about f/2 to about f/16. The maximum (widest) aperture on a lens may be in between two of the main numbers in the series, for example, f/1.7 or f/3.5. Notice that as the f-stop number gets larger (f/8 to f/11, for example), the aperture size gets smaller. This may be easier to remember if you think of the f-number as a fraction: 1/11 is less than 1/8, just as the size of the f/11 lens opening is smaller than the size of the f/8 opening.

See for yourself **The aperture in action**

You can see the effect of changing the aperture very clearly if you try the following:
1 Open the back of your unloaded camera.
2 Cut a piece of wax paper or thin stationery to fit over the opening in the back of the camera where the focal plane shutter is. The paper should be larger than the opening so that you can hold it in place against the body of the camera without touching the shutter area.
3 Open the aperture to its widest opening. Set the shutter to B and depress the shutter release.

Hold the button down so the shutter stays open.
4 Point the camera toward a well-illuminated scene. It helps to see the image on the paper better if you are in a slightly darkened room.
5 You will notice an upside down and backwards image on the paper positioned where the film would normally be. Now with your free hand rotate the aperture ring to the next smaller aperture (the next larger f-number). Notice how with each change the image on the paper becomes increasingly darker.

Using shutter speed and aperture together

Both shutter speed and aperture affect the exposure, the total amount of light reaching the film, and so the picture's lightness or darkness. The shutter speed controls the length of time the film is exposed to light and the aperture controls the brightness of the light. You can pair a fast shutter speed (to let in light for a short time) with a wide aperture (to let in bright light) or a slow shutter speed (long time) with a small aperture (dim light) and still come up with the same exposure (see combination below). Speaking of exposure only, it doesn't make any difference which of the combinations you choose. But in other ways, it does make a difference which you choose, and it is just this difference that gives you some interesting creative opportunities.

How shutter speed and aperture affect your image

Shutter speed and aperture settings are reciprocal. Each setting is 1 "stop" from the next and lets in half (or twice) the light of the next setting. A shutter speed of 1/60 sec. lets in half the light that 1/30 sec. does, twice the light of 1/125 sec. An aperture of f/8 lets in half the light that f/5.6 does, twice the light of f/11.

If you make the shutter speed 1 stop slower (letting in 1 stop more light), and the aperture 1 stop smaller (letting in 1 stop less light), the result is a change in shutter speed and a change in aperture, but a constant quantity of light.

The scene at right was photographed with different combinations of shutter speed and aperture. The combinations all let in the same total amount of light, so the overall exposure for the pictures stayed the same. But the sharpness of the pictures changed in two ways: moving objects appear sharper at faster shutter speeds, but the scene appears sharper from near to far (has greater depth of field) at smaller apertures.

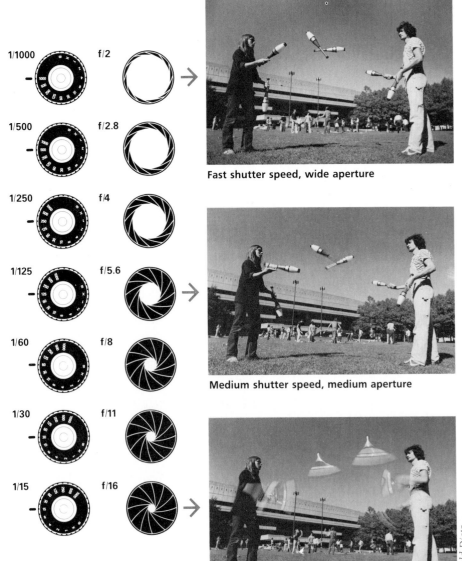

1/1000 f/2

1/500 f/2.8

1/250 f/4

1/125 f/5.6

1/60 f/8

1/30 f/11

1/15 f/16

Fast shutter speed, wide aperture

Medium shutter speed, medium aperture

Slow shutter speed, small aperture

Donald Dietz

See for yourself **The viewfinder display in action**

The time to think about the effects of the relationship between aperture and shutter speed is before you take a picture. With your camera set to automatic exposure your viewfinder display will give you a feeling for the relationship between the two exposure controls. While watching the viewfinder display, change either the shutter speed (in shutter-priority operation) or the aperture setting (in aperture-priority operation). In many camera viewfinder displays you will see the other setting change automatically to keep the exposure constant. Reminder: On some cameras you have to depress the shutter release button slightly to activate the display.

Stop-go indicators are much like traffic lights. A colored diode (usually green) will light up to indicate when there is enough light for a good exposure. When you change the aperture or shutter speed settings, this light indicates when you can use the chosen combination. If the exposure system cannot find a matching aperture or shutter speed, a light of a different color (usually red) indicates that the chosen setting will either underexpose or overexpose the picture.

Stop-go indicator

Needle indicators use a moving needle to indicate correct exposure as you change the aperture or the shutter speed settings. As you change one setting the needle moves to indicate the matching setting.

Needle indicator

Light-emitting diodes (LEDs) light up next to the shutter speed and/or aperture to which the camera is set. When you change an exposure setting, a different diode lights up to indicate which matching setting the camera has selected. Some displays have a special diode that lights up when you choose an aperture or shutter speed for which the camera can't find a correct matching setting. Pictures taken when this diode is lit will be under- or overexposed.

Light-emitting diode

Digital displays are easy to read even in dim light because the liquid crystal display actually lights up the shutter speed and aperture numerals.

Digital display

Tips **How to choose a shutter speed and aperture combination**

For general shooting, use at least a medium shutter speed (1/60 sec. or faster) and a medium aperture (f/5.6 or smaller). You can use slower shutter speeds if you have the camera on a tripod, but if you are hand-holding the camera, use wider apertures before you switch to slower shutter speeds. (Pages 10 and 12 tell how to adjust shutter speed and aperture in various exposure modes.)

Is sharpness of a fast-moving subject important? Use a fast shutter speed, at least 1/250 sec. The focal length of the lens you are using, the closeness of the subject, and the direction it is moving also affect motion (see pp. 30–31).

Do you want maximum depth of field, with the entire scene sharp from near to far? Use as small an aperture as you can. The focal length of the lens and the distance to the subject also affect depth of field (see pp. 38–39).

EV (exposure value) numbers

The range of light conditions, from very bright to very dim, that an exposure system is capable of measuring and correctly exposing is sometimes described in terms of EV or exposure values. The EV number describes the combinations of shutter speed and aperture that will correctly expose a given film speed at a given light intensity. For example, EV 17 means a shutter speed and aperture combination of 1/1000 sec. at f/11 or any other equivalent combination of shutter speed and aperture, such as 1/500 sec. at f/16, 1/2000 sec. at f/8, and so on. A typical exposure system might be usable in automatic operation (with an ISO/ASA 100 film speed) from EV 17 to EV 2 (1/2 sec. at f/1.4 or any other equivalent combination).

Using shutter speed and aperture creatively

One of the things that makes photography so enjoyable is the chance you get to interpret a scene in your own way. Shutter speed and aperture controls are two of the most important ways you have of making a picture uniquely your own. As you become more familiar with their effects on a picture, you will find yourself making choices about them more instinctively: knowing, for example, that you want only the main subject sharp and so turning to a larger aperture. On these pages, Using Shutter Speed and Aperture Creatively, and in other sections such as Using Sharpness Creatively, pp. 46–47, and Using Exposure Creatively, pp. 66–67, you'll see some of the choices other photographers have made and find some ideas for your own work.

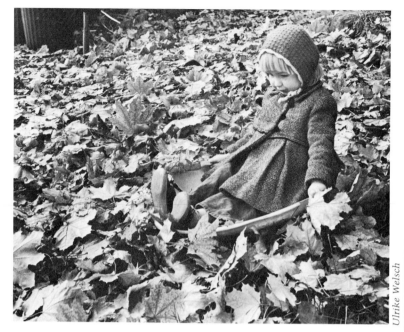

Ulrike Welsch

To get every leaf sharp from foreground to background (top) the photographer chose a small aperture, f/16. The woman blowing bubbles (bottom) was the most important element in the scene and the photographer chose a larger aperture, f/2, so that the background would be out of focus and indistinct.*

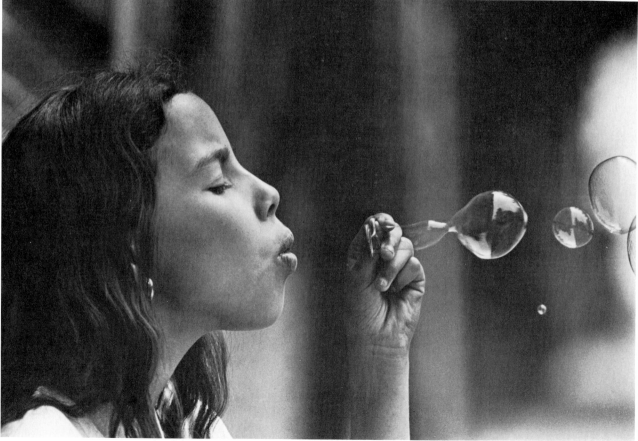

Ulrike Welsch

16

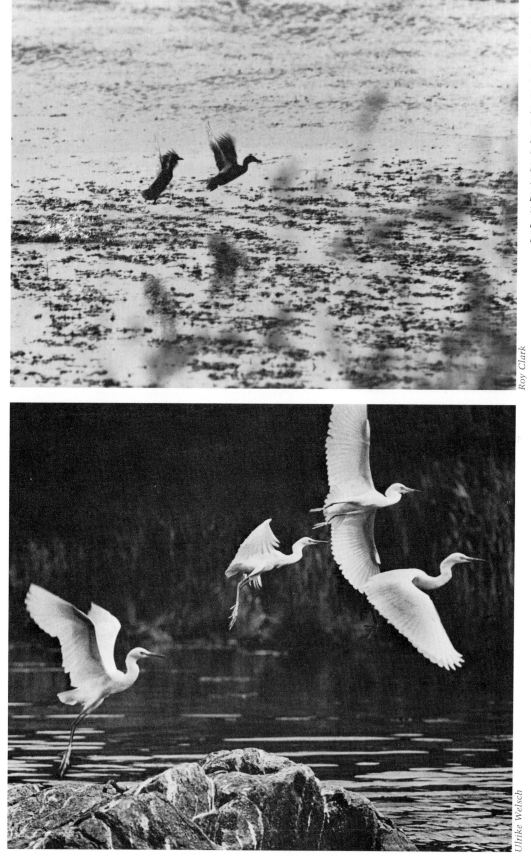

Some of the birds in motion (top) are blurred by a relatively long shutter speed of 1/30 sec.; all are shown sharply (below) at a faster shutter speed of 1/250 sec. Both pictures strikingly convey the feeling of flight and both could have been interpreted differently— the top picture sharp and the bottom one blurred.

Roy Clark

Ulrike Welsch

Making a picture: Step by step

The first time you try something new is always a time for the jitters, whether it is riding your first bike, using a new camera, or doing anything else you haven't done before. So if you are new to photography, don't close your eyes as you hop on, just keep them open and follow the directions below. (It won't hurt to have read your camera manufacturer's instruction book first.)

1 Buy a roll of film for color slides, for color prints, or for black-and-white prints. Ask for a film with a speed of 400. A 36-exposure roll will cost a bit less per picture; a 20-exposure roll will give you faster feedback because it won't take you as long to use up the roll.

2 Load the camera by attaching the film leader to the take-up spool. Use the film advance lever to advance the film until both edges are engaged by the sprockets. When the film advance lever stops, push the shutter release and continue. Close the back of the camera.

3 Advance the film. Move the film advance lever a full stroke, then release the shutter; repeat two times. The film rewind knob rotates if the film is loading properly; if it does not, open the back to check the loading.

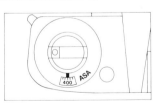

4 Enter the film speed by adjusting the dial marked ASA until it reads 400.

5 Look through the viewfinder and compose the subject. Focus by turning the focus ring on the lens until the image is not split (with a split-image rangefinder) or is sharp (with a ground glass or micro-prism).

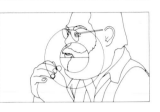

6 Take a look at the lighting of the scene. On your first time out, find a more or less evenly lit scene, not one where the subject is against a very bright background.

Charles O'Rear

7 Use automatic exposure your first time out. Set the automatic exposure mode, if you have a choice: aperture-priority, shutter-priority, or programmed (see manufacturer's instructions).

8 **A** In aperture-priority operation, set the aperture control ring to f/5.6 or smaller (f/8 or larger number).

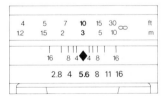

Tips **How to point and shoot**

If this is the first time you have ever used a 35mm camera, you might try simplifying the whole procedure to its absolute minimum. Follow steps 1, 2, 3, and 4. Turn the lens until 10 feet on the lens distance scale lines up with the focusing index (a diamond-shaped or straight-line pointer). Set the camera to automatic exposure. In aperture-priority automatic operation set the aperture to f/11; or in shutter-priority automatic operation set the shutter speed to 1/500. Find a scene in the sun. Get the scene you want in the viewfinder and shoot.

8 **B** Check the viewfinder readout for the shutter speed. If it is slower than 1/60 sec., find a scene in brighter light. If the viewfinder is signalling overexposure, set the aperture to a smaller opening (a larger number on the control ring) or find a scene where the light is not so bright.

9 **A** In shutter-priority operation, set the shutter speed control to 1/60 sec. or faster.

9 **B** Check the viewfinder readout for the aperture size. It should be f/5.6 or a larger number. If the number is f/4 or smaller, find a scene in brighter light. If the viewfinder signals overexposure, set the shutter speed to a faster one or find a scene where the light is not so bright.

10 In programmed operation, the camera will set both shutter speed and aperture for you according to the brightness of the scene. Check the viewfinder. If it signals underexposure, find a scene in brighter light. If it signals overexposure, find a scene where the light is not so bright.

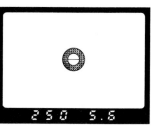

11 **A** For horizontal photographs, hold the camera in your right hand with the forefinger near the shutter release button. Use your left hand to focus. Use your right forefinger to depress the shutter release.

11 **B** For vertical photographs, support the camera with either your right or your left hand. Use your left hand to focus. Use your right hand to depress the shutter release button and to advance the film.

12 Make an exposure. Brace your camera and yourself, hold your breath, and slowly depress the shutter release (don't jab it). Just before exposing, recheck the focus and composition of the picture.

13 Make several more exposures, perhaps from different angles or positions and at different apertures and shutter speeds. Expose the whole roll of film. Have it processed and enjoy the results.

Exposure modes

In automatic exposure operation, your camera automatically sets the shutter speed or aperture or both to the combination that will produce a correct normal exposure. In manual exposure operation, you set both shutter speed and aperture yourself.

The types of exposure modes (three automatic and one manual) that are found on 35mm automatic cameras are described below. Most cameras have one automatic mode plus manual operation; some have more than one automatic mode; some operate only in automatic. See your camera's instruction book for details on which modes your camera has.

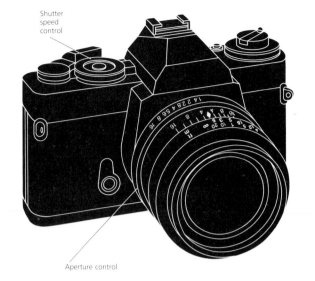

Shutter speed control

Aperture control

How they work	Typical examples

Aperture-priority mode You select the aperture (lens opening) needed to obtain the depth of field you want and the exposure system automatically sets the shutter speed to give you a good exposure.

Pentax Corp.

Shutter-priority mode You choose the shutter speed you need to freeze or deliberately blur camera or subject motion and the camera automatically sets the corresponding aperture for a good exposure.

Canon Inc.

Fully automatic (often called programmed) The camera automatically sets both the shutter speed and aperture without your intervention. Different models have different programs. In one, the camera starts at the highest shutter speed and searches for an aperture; if it can't find one it lowers the shutter speed and looks again.

Minolta Corp.

Multimode These cameras have more than one exposure mode. The less expensive cameras offer a choice between automatic (either aperture- or shutter-priority) and manual. More expensive models give you a choice of aperture-priority, shutter-priority, manual, and sometimes fully automatic.

Canon Inc.

Manual mode You manually set both the aperture and shutter speed controls on the camera. Neither control operates automatically when the camera is in this mode.

Nikon Inc.

Tips Which exposure mode is best?

All automatic exposure modes give equally good results in the vast majority of photographic situations. If you photograph mainly in specific kinds of situations, some exposure modes may have marginal advantages.

If you normally photograph action scenes, such as those encountered by sports photographers and photojournalists, a camera with a shutter-priority mode might be best. With fast action scenes you will often want to be sure your shutter speed is fast enough. With a shutter-priority camera you can select the shutter speed you need and then forget it. With an aperture-priority camera you have to check the shutter speed every time the light or your position relative to the subject changes to see if the shutter speed has changed.

If you normally photograph landscapes or travel scenes, a camera with an aperture-priority exposure mode might be slightly better. It allows you to select directly the aperture for the depth of field you want.

If you want to be free of any concern about choosing an aperture or shutter speed, a camera with a fully automatic exposure mode is ideal. This exposure mode sets both the aperture and shutter speed for you.

If you specialize in close-up, wildlife, or astronomical photography, a camera with an aperture-priority mode is probably best. It will work in automatic exposure mode when used with the close-up bellows and extension tubes used to photograph very small subjects, and with the telephoto mirror lenses and teleconverters used to magnify distant objects. Shutter-priority cameras will not work on automatic when used with these accessories.

Main advantages

The aperture is usually easier to change since it is located next to the focus control on the lens (on most cameras). Changing the shutter speed usually requires you to move your hand from the focus control to the top of the camera where most shutter speed dials are located. You have direct control over depth of field, which is determined by the aperture used.

You are in direct control over the shutter speed and therefore over how motion is conveyed in your pictures. You can choose a slow shutter speed deliberately to blur fast-moving objects or a fast shutter speed to freeze them. You can set (and maintain without further attention) a shutter speed fast enough to prevent blur from camera motion.

Fully automatic cameras allow you to shoot without paying attention to settings. The camera will set both the shutter speed and aperture for you, and all you have to do is compose and focus the image.

Since each exposure priority mode has its advantages, it helps at certain times to have access to all of them. When capturing action is important you can use the shutter-priority mode. When depth of field is paramount you can use the aperture-priority mode.

Since you select both the aperture and shutter speed you will be more conscious of the decisions you have to make. This is likely to improve your technique faster.

Main disadvantages

Unless you look at the shutter speed the camera is using, you are likely to encounter what is referred to as "the perfectly exposed blur." The aperture you select may require a shutter speed that's so slow camera or subject movement will appear in your photographs as blur.

Shutter-priority cameras lose some of their automatic functions when used with mirror lenses and some close-up accessories. Mirror lenses (see p. 115) have only one aperture which predetermines the exposure. Close-up bellows and extension tubes inserted between the camera body and the lens may interrupt the automatic linkage.

With pictures so easy to take one can stop thinking about them altogether. In some cases this leads to good, informal results but sometimes the resulting images may be less well thought out.

It's hard to find fault with multimode cameras since they offer the best of all possible worlds. The only drawbacks are that you really don't need all of the exposure modes they offer to get good results and the price is somewhat higher.

Setting the shutter speed and aperture manually requires you to know a little more about your camera before snapping off the first pictures. However, with match needle cameras, operation is no more complicated than aligning a needle against a marker or another needle to get a good exposure.

Caring for your camera at home and on the road

A 35mm camera can last a lifetime if properly cared for. Leland Howe of Lee's Camera Repair in Boston gives some tips to keep in mind when storing, traveling with, cleaning, or troubleshooting your photographic equipment.

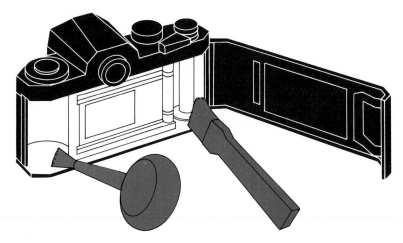

Under normal circumstances your camera and lens need less cleaning than you might imagine. Since there is always the possibility that the camera or lens might be damaged during cleaning, do so only when necessary. Do check your camera periodically, however. See box opposite.

Cleaning the camera The outside of the camera can be cleaned with a soft, lint-free cloth. Open the back occasionally and use a soft brush or blower to remove dust and any bits of film that might have broken off. Use the cloth to clean the pressure plate on the camera back. Denatured alcohol on a Q-tip can be used to clean metal parts of the camera, if necessary. Never touch the shutter or mirror mechanisms and never lubricate any part of the camera yourself; leave such service to a professional.

Cleaning the lens The first rule is to clean the lens only when absolutely necessary. A little dust on the lens won't affect the image, so don't be compulsive. When needed, use a soft brush, such as a sable artist's brush, and a blower (an ear syringe makes a good one) to remove dust. Fingerprints can be very harmful to the lens coating and should be removed as soon as possible. Many photographers permanently keep a UV or 1A filter on the front of their lens when shooting to reduce the amount of lens cleaning required. Keep a lens cap in place when the camera is not in use. If you have more than one lens, always cap the lens' front and back when it is off the camera.

Clean a lens by first using a brush or blower to remove abrasive dust particles. Then roll up a piece of photographic lens cleaning tissue (never use silicon-coated eyeglass tissue) and tear the end off to leave a brush-like surface. Put a small drop of lens cleaning fluid on the end of the tissue. (Your breath on the lens also works well.) Never put cleaning fluid directly on the lens; it might run down between the lens elements. Using a circular motion, clean the lens surface with the tissue, then use a dry piece of tissue, rolled and torn the same way to dry. Never reuse tissues and don't press hard when cleaning because the front element of the lens is covered with a relatively delicate lens coating.

Protection from heat Neither camera nor film should be exposed to excessively high temperatures. If at all possible, don't leave camera or film in a car on a hot day if the sun is shining on the car (or if it will later when the sun changes position). Avoid storage near radiators or in other places likely to get hot or humid. Special insulated bags are available from camera dealers to store film on hot trips and insulated coolers can be adapted for the same purpose. According to Lee Howe, this is the most common avoidable problem that can create a need for repairs. Heat softens oil in pores of the metal in the camera. The

oil can then run out and get where it shouldn't, such as on the diaphragm blades of the lens, jamming them.

Protection from cold Keep the camera as warm as possible by keeping it under your coat. Always carry extra batteries. Those in your camera may weaken at low temperatures just like the one in your car weakens in winter. Prevent condensation when taking the camera from a cold area to a warm one by wrapping the camera in a plastic bag or newspaper until its temperature climbs to that in the room. If some condensation does occur, do not take the camera back out in the cold with condensation still on it or it can freeze up camera operation.

Protection from water, spray, and sand Always protect equipment from water, especially salt water, and from dust, dirt, and sand. A camera case helps but at the beach a plastic bag is even better.

Protection when traveling Use lens cases and caps to protect lenses. Keep the camera in a case. Store all small items and other accessories in cases and pack everything carefully so bangs and bumps won't cause them to hit each other. Be careful packing photographic equipment in soft luggage where it can be easily damaged. When flying, try to pack equipment in carry-on luggage, and store film in lead-lined bags so security X-rays won't harm it. In many cases you can ask to have film and camera hand-inspected to reduce the possibility of X-ray induced damage.

Storing a camera and equipment Wrap film in a tightly sealed plastic bag and store in a cool place; a freezer or refrigerator is ideal. Leave film in the plastic bag after removing from cold storage until it adjusts to room temperature; if opened immediately condensation can affect the film. Protect stored cameras and other equipment from dust, heat, and humidity. A large camera bag or case (see p. 158) makes an excellent storage container. Remove batteries and leave shutter uncocked before storing.

Tips **Troubleshooting**

Battery failure If the viewfinder display begins to fail or act erratically, the batteries may be getting weak. Try cleaning the ends of the batteries and the battery contacts in the camera with a pencil eraser in case it is just poor contact. Warming the batteries might also bring them temporarily back to life.

Water immersion If your camera falls into the water, especially salt water, the chances are it is ruined, but it might possibly be saved. A quick rescue from partial immersion will cause less damage than if you have to fish around to find the camera. If it falls into salt water, first rinse it with fresh water to remove all corrosive salts. Shake all water out of the camera and dry in a slightly warm oven (less than 100°F) overnight. As soon as possible, take or send the camera to a repair shop to see if it can be salvaged.

Film advance or rewind is jammed Use a dark closet or changing bag (a light-tight bag sold in camera stores) to remove the exposed film. You can improvise a darkroom by using a coat wrapped around the camera and your hands while removing the film. Rewind the film back into its cassette by hand by turning the movable end of the cassette. If you can't get it rewound, you can either try wrapping it around the cassette or removing it entirely from the cassette and winding it up. Then store it in the plastic container the film came in and attach a note stating, "Unprotected film inside; open only in dark." Once the film is removed and safely stored, try advancing or rewinding the camera. Don't use force; if it doesn't move easily take it to a camera repair shop for help.

Leland Howe **How to check your own camera**

You can check your own camera to get a fairly good idea of how it is operating. If your camera is a mechanical camera, set the shutter speed at 1 sec. and trip the shutter. You should hear a steady buzzing sound that has no hesitation during its cycle. You can time it approximately with the sweep second hand of your watch. If your camera is an electronic camera, then you won't hear the buzzing sound but can still time it the same way. Now set the shutter at its fastest speed and with the lens removed and the back open, point the camera at a bright light and look through it as you trip the shutter. You should be able to see the entire film opening. If any part of it is cut off then you need a repair person.

While your camera is open you can check the synchronization for electronic flash by connecting the flash unit and looking through the back with the camera pointed at a light-colored wall. When you trip the shutter you should again see the full film opening with no part of it cut off. Be sure your shutter is set correctly for flash use.

Now install the lens and set the diaphragm at its smallest opening (highest f-number). Set the shutter at a slow speed such as 1 sec. and look through the back as you trip the shutter. The diaphragm should be closed to its set aperture when you first see it. If you can see it closing down, your lens needs repair.

An accurate check of your meter would require equipment that only a repair shop would have, but if your pictures look good and are not too dark or too light then your meter is probably OK.

Inside a pro's camera bag

A basic camera outfit

The popularity of the automatic 35mm SLR results not only from its small size and high quality, but also from its great versatility. By adding a few accessories, you can adapt your basic camera to a wide variety of situations.

The camera Automatic exposure cameras are available with various operating modes: aperture-priority, shutter-priority, programmed (totally automatic), and manual. Some have more than one mode, allowing you to select the most appropriate mode for a particular situation (see pp. 20–21).

Tripod and cable release Tripods and cable releases are used in low light or with long-focal-length lenses to eliminate blurring caused by camera movement.

Film Film in the 35mm format is widely available in many varieties. A negative film produces negatives that are then used to make prints. A reversal film is processed directly into slides (see pp. 70–75).

Batteries Battery failure will result in the loss of some or all of your camera's functions. Always carry spares for the camera, flash, and power winder.

Lens hood Besides protecting the lens from rain or accidental bumps, the lens hood (or lens shade) improves your photographs by eliminating the flare caused by stray light (see p. 119).

Lens cleaning material Always use special tissue and cleaning fluids to prevent damage to the sensitive lens surface (see p. 22)

Interchangeable lenses The SLR's versatility is greatly enhanced by its ability to use a variety of lenses (see pp. 106–115).

Filters and lens attachments Screwed onto the front of the lens, filters can change contrast, balance colors, and achieve certain special effects (see pp. 118–127).

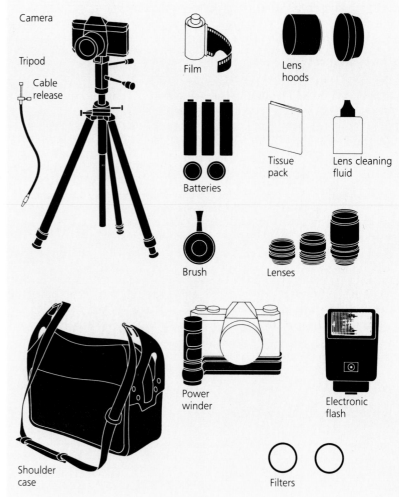

Camera
Tripod
Cable release
Film
Lens hoods
Batteries
Tissue pack
Lens cleaning fluid
Brush
Lenses
Power winder
Electronic flash
Shoulder case
Filters

Electronic flash Electronic flash is a convenient way to add light to a scene. Many flash units are automatic in operation (see pp. 128–139).

Power winder A power winder automatically advances the film every time you press the shutter release. The power winder is useful for photographing sports and other rapidly changing scenes.

Camera case A camera case is invaluable for conveniently and safely transporting your camera and accessories.

For more information on these items, see also Buying Guide, pp. 148–165.

Ulrike Welsch **What a pro carries**

When I photograph people, I want to have as much of my attention as possible available for them. I want to interact with them and not get bogged down with equipment or techniques. So I have pared down my working methods and the equipment I carry to just those things that I really need.

I always carry two camera bodies, sometimes three. Depending on the project, I might have one body loaded with black-and-white film and another loaded with color or both loaded with black-and-white. When I'm shooting black-and-white, I'll have two bodies with ASA 400 film hung around my neck or over my shoulder. In case I want to move indoors quickly and continue shooting, I keep in my camera bag the third body loaded with film rated at ASA 1600; I use ASA 400 film for this and push process it to ASA 1600. [See push processing, p. 164.] For me it is usually easier to use extra-fast film than it is to hook up a flash unit. I know that many other photographers use flash instead, but this is my personal preference. I always try to carry more film than I can shoot on a particular day, at least ten rolls, sometimes more. To save space in the camera bag, I take the film out of the boxes and just carry the cassettes in their individual plastic containers.

I always carry a small flash unit for those emergency times when extra lighting is es-sential, extra batteries for both camera and flash, an extra synch cord for the flash, a screwdriver set, a notebook and pen, and model release forms. My favorite lens cleaner is a soft chamois cloth, which I can also use to wrap a camera, and I prefer rubber lens shades rather than metal ones because they are flexible, don't take up extra space in the bag, and help cushion the impact of an accidental bump.

I take a motor drive unit if I know that I will be photographing action, such as a sports event. I take a tripod and cable release if I plan to shoot at twilight or in some other location where I may want a shutter speed too long to hand-hold the camera.

The camera bag itself is an important choice. The 10–15 pounds of equipment that I pack gets very heavy by the end of the day and I want a wide strap that doesn't hurt my neck or slip off my shoulder. I always carry my bag on my shoulder while I am shooting because I want my equipment handy and, even more important, I don't want to worry about the equipment being safe. If I put a camera bag down while I am shooting, it is too easy to lose track of it; I don't want my attention diverted from picture-taking by sudden concern for my camera gear. All of my choices aim at the same goal: having my attention free for my subject.

Barbara London

Ulrike Welsch at work.

The way it was **Early photography**

In the early days of photography life was considerably more complicated than it is now. Negatives were exposed on glass plates, which had to be coated, sensitized, and developed on the spot. Enlargements weren't possible, so if you wanted an 8 × 10 print, you needed a negative of the same size. A portable darkroom and large camera were basic equipment that had to be transported to wherever you wanted to photograph. An assistant—if you could arrange for one—completed the ensemble.

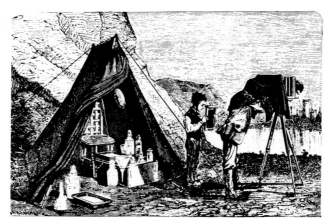

2 Fine tuning sharpness

One of the first things you notice about a photograph is whether or not it is sharp. Extremely sharp photographs reveal a richness of detail, more than you would normally notice in the scene itself. If the entire image isn't sharp, your eye is immediately drawn to the part that is. Deciding which parts of a scene to show sharply, and which parts not to, is important because it influences how viewers will react to the image.

Your pictures can be sharp in different ways. The first way concerns motion. If you are photographing a moving subject, you can choose to show the subject sharp, even if it is in mid-motion. *Frozen* is sometimes the word used to describe the effect. Using a fast shutter speed is the easiest way to show motion sharply. If you use too slow a shutter speed, the shutter will be open long enough for the subject's image to move across the film, resulting in less sharpness in the picture. See pp. 30–31 for more about other factors that affect motion, such as lens focal length and subject speed, direction, and distance.

Another kind of sharpness concerns depth of field, how much of the scene will be sharp in the picture. Even if you are photographing a static scene, your picture may not be sharp if you do not have enough depth of field. Several factors affect depth of field, including lens aperture, lens focal length, focus, and subject distance. See pp. 34–35.

The first goal is to get pictures sharp when you want them that way. It's disappointing to photograph at a wedding and have the cake look fuzzy when you wanted to show its detail clearly or to photograph at a circus and have your favorite clown come out as an indistinguishable blur.

As you learn how to control sharpness, you're also learning how to get things *unsharp* when you want them that way. You can make a busy background less distracting by having it out of focus in the picture. Or you may want to evoke the feeling of motion by letting a moving subject blur. The following pages tell you how to get the results you want.

26

Ulrike Welsch

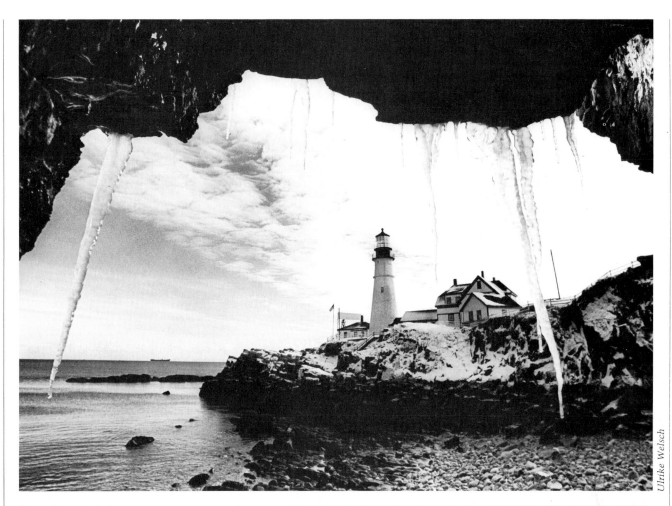

Ulrike Welsch

Sometimes it is important to see an entire scene sharply, from foreground icicles to background lighthouse (top). Sometimes you will want to focus attention on a foreground subject by making the background less sharp (bottom) or vice versa. Depth of field, the amount of a scene sharp from foreground to background, helps direct your viewer to the part of the photograph that you consider important.

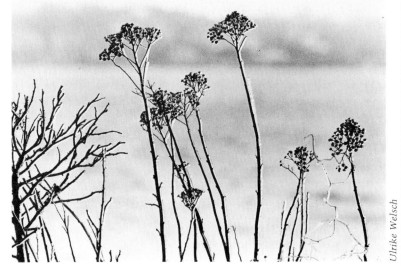

Ulrike Welsch

◄

What conveys the feeling of motion? It can be freezing action sharply in mid-motion (opposite top) or letting a moving subject blur (opposite bottom). Shutter speed is the main control of the sharpness of the moving subjects that you photograph.

Causes of (and cures for) unsharp pictures

Unsharp pictures are seldom caused by a faulty lens or a defective camera. If your pictures are not as sharp as you want them to be, try to identify the cause of the unsharpness. You'll find the cure is relatively simple. It probably involves using a faster shutter speed to prevent subject or camera motion, using a smaller aperture to increase your depth of field, or improving your focusing.

Common causes

Example

Camera movement during an exposure is the most frequent cause of unsharp pictures. When the shutter is open, the light from the scene is projected onto the film by the lens. If the camera moves while the shutter is open, the image on the film will also move. The movement of the image "paints" the picture across the film surface, causing everything in the image to appear blurred.

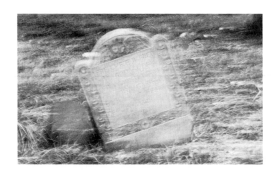

Subject movement during an exposure has the same effect as camera movement. The moving subject projects a moving, and so blurred, image on the film. Unlike blur caused by camera movement, blur caused by a moving subject may be confined to that subject while stationary objects in the scene may appear sharp.

Focusing on the wrong part of the scene can also cause the image to be soft and out of focus. Unlike the more or less streaked blur caused by camera or subject movement, an out-of-focus image appears soft, as if you are looking at it through a very dirty window. Often some part of the scene, although not the part you intended, will appear sharp.

Depth of field describes the area in the scene from near to far that will be acceptably sharp in the image. A lens can only focus at one distance in front of the camera at a time. Objects near to the sharply focused distance may be within the depth of field and appear acceptably sharp, but those that are too far from it will appear unsharp. The extent of the depth of field is influenced by several factors.

Easy solutions	Example

Camera movement and the blur it causes can be reduced by practice. Smoothly depress the shutter button rather than jab it. Use a tripod at slow shutter speeds or brace yourself when taking the picture. Blur is more likely to occur at slower shutter speeds, so use fast speeds to help reduce it in your pictures. The longer the focal length of the lens you use, the faster the shutter speed needed to eliminate blur caused by camera movement. The basic rule of thumb is always to use a shutter speed faster than your lens focal length. Use a 35mm or 50mm lens at 1/60 sec. or faster, a 100mm lens at 1/125 sec., a 200mm lens at 1/250 sec., and so on.

 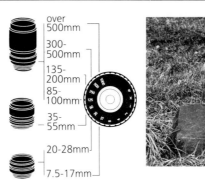

The way a moving subject appears in a photograph is controlled primarily by the shutter speed you choose. The faster an object is moving, the faster the shutter speed needed to show it sharply. Blur caused by subject movement can also be reduced by changing your position relative to the direction of movement (objects moving toward the camera won't blur as much as objects moving parallel to the camera, even at the same speed), by increasing your distance from the subject, or by using a shorter focal-length lens. More about motion on pp. 30–31.

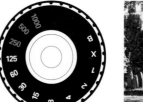

Focus can be improved by carefully watching the viewfinder as you rotate the focusing ring on the lens. With a split-image rangefinder it is easiest to focus on a clearly visible vertical line. When this line is exactly aligned in the split image of the viewfinder, everything in the scene at that distance from the camera will be sharply focused. You can also focus by turning the lens until the microprism collar (around the split image) or the ground glass (that occupies the rest of the viewfinder) is sharp.

Depth of field is influenced by the aperture, lens focal length, and distance from the subject. If your main subject is in focus but objects in the background or foreground are not, the cause is insufficient depth of field. Increase it by using a smaller aperture or a shorter focal-length lens, or by moving the camera farther from the subject. For more on depth of field see pp. 32–35.

Alan Oransky

29

How to photograph motion sharply

Blurred motion always occurs when the image formed by the lens moves across the film during the time the shutter is open. To show a moving subject sharply, the shutter needs to open and close before the image on the film moves a significant amount. If you want to photograph a moving subject sharply, you need a shutter speed that is fast enough. But just how fast is fast enough? The answer depends on four factors:

1 The speed of the subject.
2 The direction the subject is moving relative to the camera.
3 The camera's distance from the subject.
4 The focal length of the lens (affects the *apparent* distance to the subject).

Because several variables are involved, you can't always predict how the motion will look in the final photograph. So bracket your exposures to make several shots: make one at the shutter speed you think is fast enough, then another at the next fastest shutter setting. Try shooting from a different angle or perhaps at a pause in the action. You are much more likely to get a good shot if you have several to choose from than if you make just one and hope for the best. See also pp. 44–45; showing motion sharply is not your only choice.

1 Speed of subject The faster a subject is moving, the faster the shutter speed you need if you want to have a sharp image. A pretzel vendor reading a book while he waits for customers can be photographed sharply at a slower shutter speed than the same vendor hustling his cart through traffic. If you were using a 50mm lens, a speed of 1/60 sec. would be a safe shutter speed to show this scene sharply, but even at 1/30 sec. there would probably not be enough motion during the time the shutter was open to cause blur in the picture.

Ulrike Welsch

2 Direction the subject is moving relative to the camera A subject moving parallel to the camera back (and so parallel to the film) will cross more of the film and be more blurred than a subject moving directly toward or away from the camera. You can sharply photograph a child who is running toward (or away from) you at a slower shutter speed than the same child running from one side of the scene to the other.

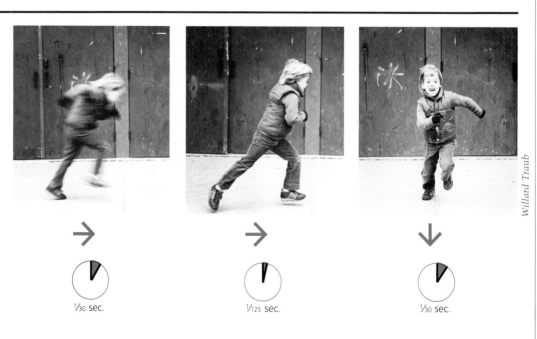

1/30 sec. 1/125 sec. 1/30 sec.

Willard Traub

3 **Distance to subject** If a subject is close to the camera, even very slight movement is enough to cause blur. A subject—or part of one—far from the camera can move a considerable actual distance before its image on the film appears to move. All the cars of this freight train are obviously moving at the same speed and in the same direction, but the part of the train closest to the camera is blurred into a streak while the cars that are farther away are sharp. You may have noticed a similar phenomenon when you are riding in an automobile. Fence posts or power poles close to the road zip past quickly, while a house or mountain in the distance takes a long time to move across your field of view.

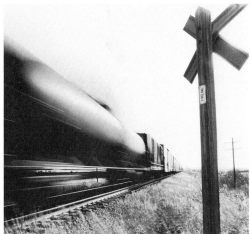

Jack Rudman

Tips **How to photograph motion sharply**

Use a fast shutter speed. See chart below for some suggested speeds. Notice that the closer you are to the subject, the faster the speed should be. Using a long-focal-length lens has the same effect as moving closer to the subject, so increase your shutter speed accordingly.

Shutter speeds for action parallel to film plane

Type of motion	Camera-to-subject distance		
	25 ft (7.6 m)	50 ft (15.2 m)	100 ft (30.4 m)
Very fast walker (5 mph)	1/125	1/60	1/30
Children running (10 mph)	1/250	1/125	1/60
Good sprinter (20 mph)	1/500	1/250	1/125
Speeding cars (50 mph)	1/1000	1/500	1/250
Airplanes	—	—	1/500

Use a film that has a fast speed (ISO/ASA 400). The greater the film speed, the less light you need to expose the film and so the faster the shutter speed you can use. (See pp. 72–73.)

Preset camera controls if you can so that you don't have to make hasty last-minute adjustments. Make a preliminary metering of the light so you can see what shutter speed and aperture combinations are possible; the wider the aperture, the faster the shutter speed will be. If you are photographing against a bright sky or in unusual lighting conditions, you may want to override the camera's automatic exposure system (see pp. 58–61). See also "How to zone focus your lens," p. 42, for a way to preset your focusing.

4 **Focal length of lens** Increasing the focal length of your lens—for example, changing from a 50mm normal-focal-length lens to a 135mm long-focal-length lens— has the same effect as moving closer to your subject. The longer the focal length of the lens, the less a subject has to move in order to have its image move on the film and be blurred as a result. Here, the speed of the woman running, her direction of movement, her distance, and the shutter speed were identical. The only difference was in the focal length of the lens used.

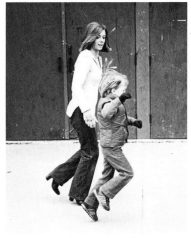

Short-focal-length lens

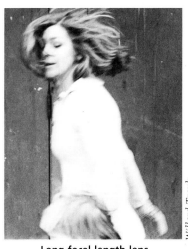

Long-focal-length lens

Willard Traub

Focus and depth of field

Focus is only one of the factors affecting the apparent sharpness of your photographs, but it is a crucial one because it determines which parts of the picture will be the sharpest. You will have much more control over the final image if you learn how focus relates to the overall sharpness of a scene.

How to focus a lens

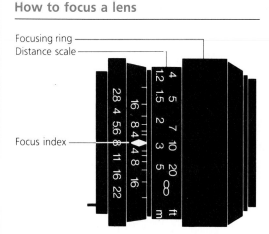

Focusing ring
Distance scale
Focus index

Rotating the **focusing ring** on the barrel of the lens moves glass elements inside the lens closer to or farther from the film and as a result moves objects at different distances into or out of sharp focus. The **distance scale** engraved on the lens barrel shows the distance on which the lens is focused. The **focus index** (diamond-shaped here) points to the distance in both feet and meters (here about 8 feet or 2.5 meters). Pages 36–37 tell how to use the aperture ring and depth of field scale, which also appear on the lens barrel.

Focusing through the viewfinder

You can see where the lens is focused by looking through the camera's viewfinder. The **split image** in the center of the viewfinder makes objects in the scene that are out of focus appear separated. Objects in focus appear aligned in the split image. To focus using the split image, look through the viewfinder and superimpose the split image over the part of the scene you want the sharpest. Rotate the focus ring on the lens until the image appears aligned. The alignment of the split image is easier to see if you focus on a vertical line, especially if you are shooting in dim light.

Bringing an object into sharp focus can also be seen by the **microprism collar** around the split image becoming clearer and by the image on the **ground glass**, which makes up the rest of the viewfinder, becoming sharper.

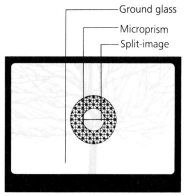

Ground glass
Microprism
Split-image

Out of focus In focus

When is an object in focus?

Imagine the part of the scene on which you focus as a flat plane (much like a pane of glass) superimposed from one side to the other of a scene (A), so that the plane is parallel to the back of the camera (the film plane). Objects falling exactly on this imaginary plane will be in focus, the sharpest part of your picture. This plane of critical focus is a very shallow band and includes only those parts of the scene located at identical distances from the camera. As you turn the focus control on the lens, the plane moves closer to (B) or farther from the camera. As the plane moves, various objects at different distances from the camera come into or go out of focus.

How focus affects depth of field

A lens can only bring objects at any single distance from the camera into sharp focus. But if you look at the photograph below right, you can see that a considerable area of the scene from near to far appears sharp. Even though theoretically only one narrow plane is critically sharp, other parts of the scene in front of and behind the most sharply focused plane appear acceptably sharp. This area in which everything looks sharp is called the *depth of field*. Objects within the depth of field become less and less sharp the farther they are from the plane of critical focus. Eventually they become so much out of focus that they no longer appear sharp at all.

The near and far limits of the depth of field are drawn above right as two planes (B and C), parallel to the plane of critical focus (A). Actually, they are usually not visible as exactly defined boundaries. Nor can you usually find the plane of critical focus by looking at a picture. Instead, sharp areas imperceptibly merge into unsharp ones. Notice that in the diagram the depth of field is not equally divided. At normal shooting distances, shown here, about one-third of the depth of field is in front of the plane of critical focus (toward the camera), and two-thirds is behind (away from the camera). When the camera is focused very close to an object, the depth of field becomes more evenly divided.

Here's how depth of field can be of use to you when you photograph. Often it doesn't matter so much exactly what object you are focused on. What does matter is whether or not all the objects that you want to be sharp are within the depth of field. If they are, they will be sharp. If you want a large part of the scene to be sharp, you can increase the depth of field. You can decrease it if you want less of the scene sharp. (Pages 34–35 tell how to do this.) If you want to make sure that a certain object—for example, the entire car in the photograph below right—will be sharp in the picture, you can preview the depth of field. (Pages 36–37 tell how.) As you move the focus distance back and forth, the depth of field moves back and forth also. In some scenes, such as landscapes, you can significantly increase the depth of field simply by shifting the point on which you are focused. (Pages 38–39 tell how.)

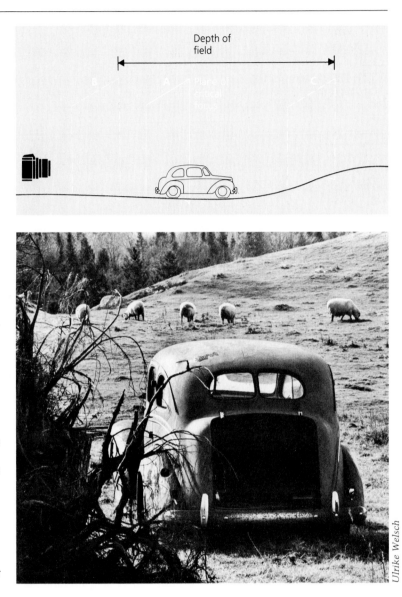

Ulrike Welsch

Controlling depth of field

Sharpness—or the lack of it—is immediately noticeable when you look at a photograph. If you are making a portrait, you may want only the person to be sharply focused, but not a distracting background. In a landscape, on the other hand, often you will want everything sharp from close-up rock to faraway mountain. Once you understand how to control depth of field, you will feel much more confident when you want to be sure something is—or isn't—sharp.

Three factors control the extent of the depth of field:

1 Aperture size The smaller the size of the lens aperture (the larger the f-number), the greater the depth of field.
2 Camera-to-subject distance As the distance increases between your camera and the object you are focused on, the depth of field increases also.
3 Lens focal length The longer the focal length of your lens, the greater the depth of field. (Lens focal length will be covered in detail in Chapter 5. Briefly, short-focal-length, wide-angle lenses show a wide view of a scene; long-focal-length, telephoto lenses show an enlarged view of a narrow part of a scene; a normal-focal-length lens is somewhere in between.)

Each of these three factors affects depth of field by itself, but even more so in combination. You get the shallowest depth of field with a long-focal-length lens used at a large aperture close to the subject. You get the deepest depth of field with a short-focal-length lens used at a small aperture far from a subject.

Aperture size

Far limit of depth of field

Plane of critical focus

Near limit of depth of field

Large aperture: shallow depth of field If you photograph with your lens set to a large aperture such as f/2, depth of field will be relatively shallow. Only objects close to the one you are focused on will be acceptably sharp. Adjusting the aperture is usually the easiest way to get more depth of field when you want more of a scene to be sharp.

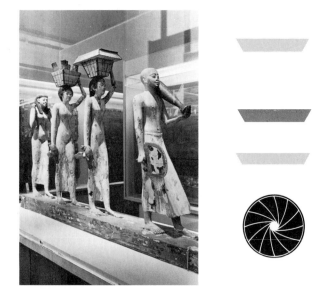

Small aperture: increased depth of field If you keep all other factors the same, but simply set your lens to a small aperture such as f/16, the area of sharpness will be expanded. The near limit of the depth of field moves closer to the camera, and the far limit moves farther away.

Camera-to-subject distance

Camera close to subject: shallow depth of field Depth of field decreases the closer you come to a subject. In close-up photography such as of flowers, insects, or other small objects, the camera may be only a few inches from the subject and depth of field is at a minimum, 1/4 inch or even less from the nearest to the farthest point in focus.

Camera farther from subject: increased depth of field As you step back from a subject (and refocus the lens accordingly) the sharpness of the image increases from near to far. Notice that stepping back creates another change: the subject appears smaller and you see more of the overall scene.

Lens focal length

Long-focal-length lens: shallow depth of field The longer the focal length of your lens, the less depth of field you will have. Only objects close to the most sharply focused one will look sharp. Sports photographers shooting from the sidelines of a playing field use lenses of very long focal length; such pictures typically show central figures sharp and the background out of focus.

Alan Oransky

Short-focal-length lens: increased depth of field Using a lens of shorter focal length has the same effect as stepping back from the subject (bottom, left). The depth of field increases and more of the overall scene is shown. Photojournalists like the great depth of field of a short lens because often they don't have time to get a subject in exact focus.

Previewing depth of field

If you look around you—the book in your hand, the chair across the room, the far wall—everything seems to be sharp. That is because your eyes refocus every time you look at an object at a different distance. But the sharpness you see when you glance at a scene is not always what you get in a photograph of that scene. You need some way to preview the depth of field, some way of knowing before you take a picture how much of the scene will be sharp in the photograph. You can do this in several ways:

• A depth-of-field preview button, if your camera has one, will give you a visual preview (see below).

• The depth-of-field scale on your lens tells the extent of the depth of field in feet and meters.

• Depth-of-field charts are supplied by lens manufacturers and give the extent of the depth of field for various lens focal lengths, apertures, and subject distances. If you have a separate instruction booklet for your lens, you'll probably find a depth-of-field chart in the back. Charts are a bit tedious to use because you must measure the distance from camera to subject, but they may be useful in certain special applications.

You don't need to preview the depth of field every time you take a picture. Many shots do not require that kind of exactitude, but certain shots do. It is convenient to be able to predict the depth of field when the sharpness of objects at different distances is important to you.

Using a depth-of-field preview button

When you look at a scene in the camera's viewfinder, you are viewing directly through the lens, and in order to give you the brightest possible viewfinder image, the lens aperture ordinarily is open to its largest setting (right, top). The size of the aperture affects depth of field (the larger the aperture, the less the depth of field), so you view the scene with depth of field at its shallowest. When you press the shutter release, the lens diaphragm automatically stops down to the aperture at which you're taking the picture, and, as a result, depth of field increases (unless you are shooting with the lens at its widest opening).

Some cameras have a depth-of-field preview button located on the camera body near the lens mount. Depressing this button stops down (closes) the lens diaphragm to the taking aperture so you can visually preview depth of field as it will appear in the picture (right, bottom). Unfortunately, stopping down the lens also decreases the amount of light, and that makes the viewfinder image darker. A depth-of-field preview button works well when light on the scene is bright and the lens aperture is not too small, but in dim light or at a very small aperture, the viewfinder image may be too dark to see clearly.

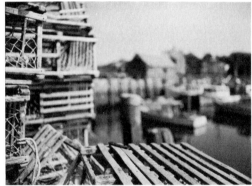

Normal viewfinder image

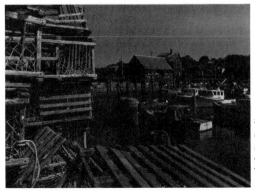

With preview button depressed

Using the lens depth-of-field scale

The depth-of-field scale engraved on your lens barrel (right) gives you another way to gauge the extent of the depth of field. (Zoom lenses may not have this feature.) It tells, in feet and meters, the distances for the near and far limits of the depth of field. Here's how to use the scale, step by step:

Aperture ring
Depth-of-field scale
Distance scale

M. Woodbridge Williams

1 Find the aperture you will be using. In aperture-priority automatic or manual exposure mode, you can usually read the aperture directly off the aperture ring. (With most cameras in these modes, you select the aperture by actually turning the ring.)

In shutter-priority or programmed mode, look at the viewfinder readout to find the aperture and set the lens aperture ring accordingly. (With these modes, the aperture ring is preset to a standard position and the camera selects the aperture internally.)

Previewing the depth of field is useful when you want to make sure that all the objects in a scene that you want to be sharp will actually be that way in the photograph. Here, the day was bright enough so that the photographer could use the depth-of-field preview button and still see the image clearly even though it darkened when the lens stopped down (see opposite bottom).

2 The focus index (here, shown as a diamond shape on the depth-of-field scale) will point to the distance (on the distance scale) at which you are focused. The infinity marking (∞) on the distance scale is a relatively far distance (about 40 ft.) and also includes all distances beyond that point.

3 On either side of the focus index are pairs of aperture markings. Find the pair for the aperture you are using (in this case f/8). Opposite them on the distance scale will be the near and far limits of the depth of field (here, 7 ft., 2 m. to 20 ft., 5 m.). Everything between these two distances will be within the depth of field and acceptably sharp.

How to get maximum depth of field

Many times when you are photographing you will want to get as much depth of field as you can because important parts of a scene are both near to and far from the camera, and you want them all to be sharp. The box at right gives some tips for getting maximum depth of field.

Maximum depth of field seems particularly important for photographs of landscapes or other scenes where a distant horizon is a part of the picture—for example, the scene at bottom. See opposite page for a way to focus (on the hyperfocal distance) so that you utilize all of the available depth of field in a large-scale scene outdoors.

Tips How to get maximum depth of field

Use the smallest aperture possible If a small aperture requires a corresponding shutter speed that is too slow to hand-hold the camera safely, use a tripod or other camera support to prevent blur caused by camera movement.

Use a film with a fast speed (such as ISO/ASA 400) Faster films allow the use of smaller apertures because they need less light for a correct exposure. The trade offs with using high film speed include increased image grain; see pp. 72–73.

Check your focus When the scene includes a far distance, focus on the hyperfocal distance (explained opposite) so that you don't waste any of the available depth of field. This will keep as much as possible of the foreground sharp.

Other possibilities When it is practical to do so, use a short-focal-length lens or try to position your camera as far as possible from the nearest part of the scene that you want to be sharp. These two procedures do increase the depth of field and get more of the scene sharp, but are not always feasible because in the course of using a shorter lens or moving back, you may change the picture too much from what you originally envisioned.

Preview the depth of field (pp. 36–37 tell how) to be sure you will get the effect you want.

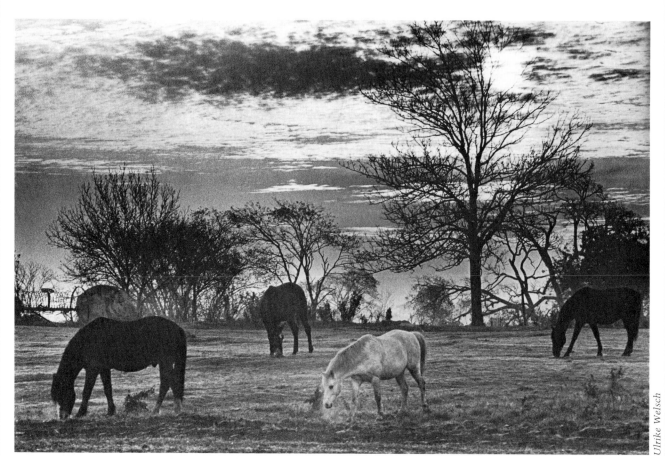

Ulrike Welsch

Step by step **Getting extra depth of field**

When a subject extends to the far distance, many photographers unthinkingly focus on that part of the scene (infinity, ∞ on the lens distance scale). Infinity, in photographic terms, is an inclusive term that designates everything from about 40 ft. to as far as you—or the lens—can see. So when you are focused on infinity everything from that point and beyond will be sharp. But since one-third of the available depth of field falls in front of the point on which you are focused and two-thirds falls behind it (diagrammed on p. 33), focusing on infinity wastes two-thirds of the possible depth of field because everything from the infinity point and beyond is going to be sharp anyway. That may mean that some other part of the scene in the foreground will not be included in the one-third remaining depth of field and consequently will not be sharp.

Instead of focusing on infinity, if you adjust the lens so that infinity just falls within the depth of field (in other words, so it falls just before the far limit of the depth of field), you will have brought forward the point on which you are focused, and so increased the depth of field in the foreground of your picture. This new point of focus is called the *hyperfocal distance*.

To focus for maximum depth of field in a scene that includes infinity, follow these steps.

1 Select an aperture and shutter speed combination. Use the smallest aperture that will give you a shutter speed fast enough to prevent blur from camera motion during the exposure. If you use a tripod you can use slower shutter speeds and so smaller apertures.

2 Locate that aperture (f/16 in this example) on the depth-of-field scale on the lens barrel. The aperture appears twice, once on each side of the focus index marking the distance on which you are focused.

3 Turn the focusing ring until the infinity symbol (∞) on the distance scale is opposite your aperture (f/16) on the depth-of-field scale.

The pair of apertures on the depth-of-field scale now line up opposite the distance scale to show the near and far limits of your depth of field, the area in the picture that will be acceptably sharp. Here, from 8 ft. (2.5 m.) to infinity.

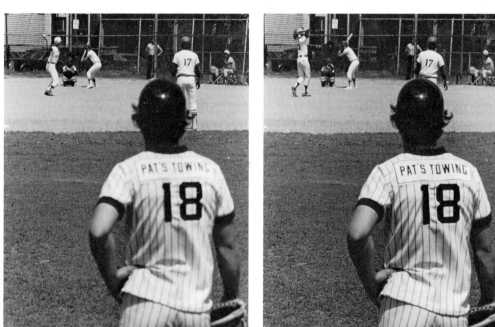

Donald Dietz

Left: the photographer focused on the batter in the far distance (infinity, ∞). At f/22 everything from infinity to 50 ft., 16 m. was sharp, but not the ballplayer in the foreground. Right: by moving ∞ on the distance scale so that it was opposite f/22 on the depth-of-field scale, the photographer increased the depth of field so that everything was sharp from ∞ to 26 ft., 8 m., including the foreground.

Selective focus: When you don't want everything sharp

Imagine you are photographing a scene something like the one at right. Which part of the scene are you most interested in? Chances are that it is the boy and the squirrel and not the objects in the background. One way to make something stand out is to photograph it so that it will be sharper than its surroundings. When everything in a picture is equally sharp, the viewer tends to give equal attention to all parts of the scene. But if some parts are sharp and others are not, the eye tends to look first at the sharpest part of the image.

You can selectively focus the camera and your viewer's attention on the most important part of the scene if you restrict the depth of field so that the significant elements are sharp while the foreground and background are less so.

Ulrike Welsch **Photographing people**

There is one crucial secret to photographing people, and it isn't any technical hint or special piece of equipment. You simply have to feel good about yourself and about the whole process of taking someone's picture. Your state of mind communicates itself to other people and if you feel awkward, nervous, or uneasy, especially about photographing strangers, they will immediately pick up on your feeling and become uneasy, suspicious, or even antagonistic. On the other hand, if you are feeling friendly and cheerful and smile at people as you take their picture, you are likely to get a friendly reaction from them.

Of course, there are times when you must respect people's privacy, but on other occasions you have to outwit them to get the picture you want. For example, if someone is nervous or if kids are clowning for the benefit of the camera, I pretend to make lots of exposures. This gets people used to the camera and relaxes them, and it eventually bores kids who are making funny faces. People go back to what they are doing and I am free to photograph. I don't hide my camera, but I do try to stay reasonably inconspicuous.

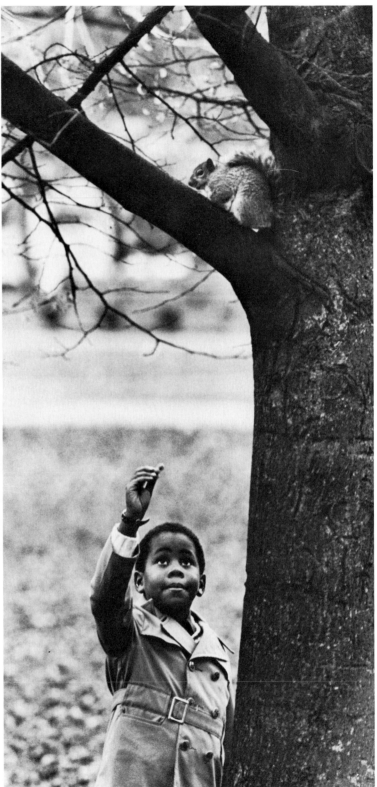

Ulrike Welsch

40

Step by step **Getting shallow depth of field**

When you want to get the shallowest depth of field possible, you can use the exposure readouts in the viewfinder and the depth-of-field scale on the lens to set the camera exposure controls and preview your results.

1 Begin by focusing on the scene and selecting the aperture. Change either the aperture (in aperture-priority mode) or the shutter speed (in shutter-priority mode) until you set the largest aperture possible that won't overexpose the film. The corresponding shutter speed will often be the fastest one on your camera. Identify the aperture you are using. Some cameras display the aperture in the viewfinder. If your camera does not, you may be able to read the aperture off the aperture ring.

2 Set the lens to this aperture (if it isn't already). In this example the lens aperture is set to f/4. In shutter-priority automatic operation, the lens is usually set to a standard position. If this is the case with your camera, reset the lens to the correct position for automatic operation after previewing the depth of field (step 3).

3 If your camera has a depth-of-field preview button, depress it. Depth of field can then be seen in the viewfinder image.

4 You can also preview your depth of field by reading the depth-of-field scale on the lens barrel. Find the numbers on the scale on either side of the focus index mark indicating the aperture you are using. Read the distances falling between these two numbers on the distance scale. In this example the pair of 4's on either side of the focus index mark indicate the depth of field for an aperture of f/4. On the distance scale the distances between these two 4's ranges from about 9 feet (less than 3 meters) to 11 feet (just over 3 meters). This area will be sharp in your image. With larger apertures there may not be room on the depth-of-field scale for all the aperture numbers. However, lines on the depth-of-field scale will indicate the position of these "missing" apertures.

Tips **Reducing depth of field**

Use a large aperture The larger the aperture, the less the depth of field. You don't necessarily want the lens' maximum aperture because that may make the depth of field so shallow that too much of the scene will be unsharp. If you put certain filters over the lens you will decrease the amount of light reaching the film. More light will be required for a correct exposure, and this in turn will let you set a larger aperture.

Use a film with a slow speed (ISO/ASA 100 or less) Slower films let you use larger apertures because they need more light for a correct exposure. On bright days outdoors, a slow film is almost a necessity when you want less than maximum depth of field. ISO/ASA 400 film requires exposure settings in the sun of about f/16 at 1/500 sec. shutter speed. If your camera's fastest shutter speed is 1/1000 sec., the smallest aperture you would be able to set would be f/11, a setting that produces considerable depth of field. (See pp. 14–15 if you want to review the relationship between shutter speed and aperture.)

Other possibilities When it is feasible to do so, use a long-focal-length lens or move in closer to the subject. The longer the focal length of the lens and the closer you are to the subject, the less depth of field you will have.

Preview the depth of field You may want less depth of field but not an absolute minimum. The depth-of-field scale on your lens will tell you the limits of the depth of field. A depth-of-field preview button, if your camera has one, will give you a visual preview of the areas that will be sharp and how much out of focus other parts of the scene will be.

Capturing unexpected fast action

How many times have you seen something interesting happen and either didn't have your camera with you, or even more regrettably, you had it but weren't ready? You wouldn't have to miss fleeting opportunities if you did just a little advance planning. If you want to get a picture without first fumbling with the camera, use the following techniques to preset your camera controls. If you do so, and a passing opportunity presents itself, all you then have to do is quickly compose the image and take the picture.

Anticipate the range of distances within which a picture might occur, then select the aperture you need for sufficient depth of field to cover this area. Set the focus on your lens accordingly (see right). If action happens within the anticipated zone, you will be able to take the picture quickly, without having to take time to focus the camera.

Anticipate the speed of the action and select a fast enough shutter speed to freeze it (or deliberately to blur it if that's your aim).

Anticipate the direction in which a picture might present itself relative to the source of light, then set your exposure compensation controls if necessary. If you expect a picture to happen in a direction facing away from the sun, or if it's an overcast day, exposure compensation won't be necessary and you can trust your automatic exposure system. If you expect it to happen with you facing into the sun, use exposure compensation to open up 1 or 2 stops (+1 to +2).

Step by step How to zone focus your lens

You can make sure an entire area in a scene will be sharp if you zone focus—set your focus and lens aperture beforehand, as explained below.

1 Focus on the nearest point where action that you want to photograph might take place. Read that distance off the lens distance scale: here, 15 ft. (4.5 m.).

2 Then focus on the farthest point where action might take place. Read that distance off the distance scale: 30 ft. (9 m.).

3 Line up those two distances so that they are opposite a pair of aperture indicators on the depth-of-field scale, here f/16.

4 A If you set your lens to this aperture, everything from 15–30 ft. (4.5–9 m.) will be within the depth of field and acceptably sharp in the final picture.

4 B With a shutter-priority camera, try a series of shutter speeds until the desired aperture appears in the viewfinder exposure information readout.

5 After setting the aperture, check your shutter speed to make sure it is fast enough to hand-hold the camera without risk of camera motion, as well as being fast enough to keep a moving subject sharp. You may have to settle for a wider aperture (with less depth of field) to get a suitable shutter speed.

Ulrike Welsch **How I stay ready for action shooting**

The first thing that I always do is to have my camera ready. In the car, my camera sits next to me, loaded and ready to shoot. I don't hesitate to shoot out of the car window when I see something that might not be there if I stopped to get out of the car. When I am walking around, I always have at least one camera out of my case and in hand. I keep the shutter cocked because I would rather lose a frame by accidentally touching the shutter release button than miss a picture that disappeared in the split second it takes to advance the shutter. I also estimate the exposure and may prefocus if I have some feeling for the location or area where I expect something to happen.

In this particular photo, I saw the girls running through the spray. I quickly set the exposure, prefocused, and checked the depth of field before I began to shoot. A motor drive unit can be useful in an action scene like this one because it advances the film more rapidly than you can and it lets you concentrate on what's happening.

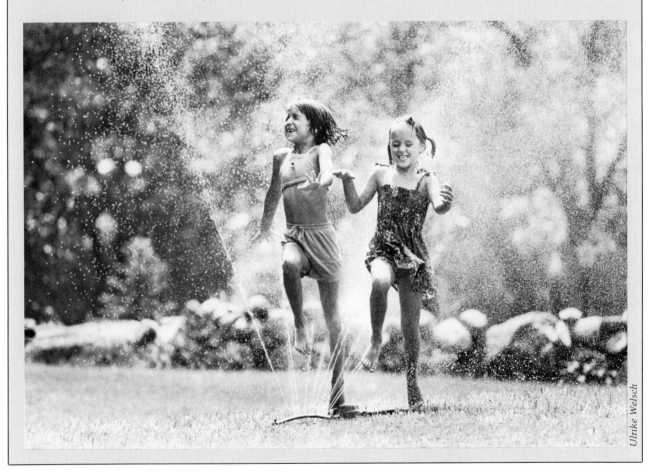

Ulrike Welsch

Conveying the feeling of motion

Photographs don't have to be sharp to be effective. Blur can contribute a feeling of motion in the image that may be missing from a more static shot. Using a slow shutter speed when photographing a moving subject or using one of the other techniques shown here causes the image to move across the film during the exposure. The resulting blur can clearly say: Motion.

Always try several different shots at various shutter speeds when experimenting with blur. You might try starting at a shutter speed of about 1/15 sec., then proceeding to slower speeds.

During a long exposure at night, traffic moving through a scene will leave light trails. Place your camera on a steady support (a tripod is best) and try exposures of 1 to 30 sec. at about f/8 to f/11.

Tips How to get a slow shutter speed

To show motion blurred you will be using a relatively slow shutter speed in most cases. This is usually easy to do; you either set the shutter speed directly or set the lens to a small aperture. (If you want to review the shutter speed/aperture relationship, see pp. 14–15. Pages 20–21 tell how to set the shutter speed in various exposure modes.) But in some very bright scenes you may run out of apertures before you get to a slow enough shutter speed, so that even at the smallest aperture your picture will be overexposed and too light if you use the slow shutter speed you want. If this happens, try one of the following.

Use a film that has a slower speed. The slower the film speed, the more light it needs for a correct exposure. If you are shooting outdoors on a bright day and have a film with a speed of ISO/ASA 400 in your camera, even a small aperture like f/22 will require a shutter speed of about 1/250 sec.—not a very slow setting. But if you have a film with a speed of ISO/ASA 50 in the camera, you can use a shutter speed of 1/30 sec.—3 stops (three shutter settings) slower than 1/250 sec.

Use a filter on the lens to absorb some of the light. This is more complicated than switching to a slower film speed, but can be useful in special situations. The name "filter" tells what one does: it filters out a certain portion of the light that passes through it. Depending on the filter, this has various effects such as changing the color of the picture, but it also decreases the brightness of the light that reaches the film and so requires an increase in the exposure. Result: you get to use a slower shutter speed.

Some filters (such as a 1A or UV filter) decrease the brightness so little that no exposure increase is needed. Others (such as a light yellow filter) require only a small increase. But some (such as a polarizing filter or dark red filter) require a significant increase of 1, 2 or even 3 stops. If you are using color film, a polarizing filter or neutral density filter decreases the brightness of the light without causing color shifts in the picture. You can also use these filters with black-and-white film, or you can use one of the deeply colored filters (see Filters and exposure, p. 118).

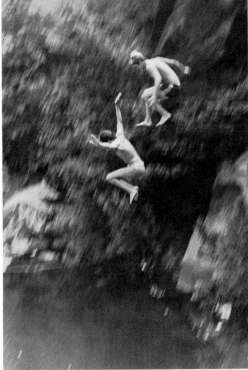

Ulrike Welsch

Moving the camera during the exposure in the same direction as a moving subject produces an image where the subject is relatively sharp against a blurred background. Start with a shutter speed between 1/30 sec. and 1/8 sec. Your movement should be smooth and controlled to get a good pan, so begin to move the camera before the subject enters your viewfinder. Smoothly depress the shutter release as you follow the motion of the subject, keeping it in the same position in the viewfinder. Follow through as you would in golf or tennis. Panning takes practice; try a few dry runs, if you can, before making the exposure. Results are quite unpredictable here because your body motion adds yet another variable to the final picture, so make several shots at each of various shutter speeds.

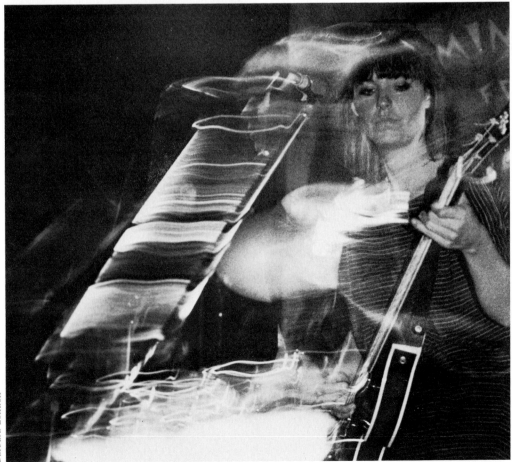

Barbara London

If you move the camera during a relatively long exposure, the resulting streaking (particularly noticeable when bright highlights are seen against a dark background) can emphasize motion or add it to a relatively static scene. This rock musician in performance was in a relatively dark part of the stage, but the mike stands and other equipment were reflecting bright highlights. The photographer moved the camera during a 1-second exposure (which recorded the highlights), then while the shutter was still open, triggered a flash unit to light the performer.

Using sharpness creatively

The sharpness of different parts of an image helps direct the viewer's eye, which tends to look first at the most sharply focused part of the image. In addition, sharpness itself can be part of the message of a photograph. The immobility of the woman in the wheelchair (right) is emphasized because other people are blurred in motion. The skateboarder (opposite top), completely sharp and motionless, hangs forever poised on the crest of his concrete wave. Sometimes you have to decide which is the most important part of a photograph because it may be impossible to get the entire scene in focus. Making that decision, as in the reflection scene (opposite bottom), is part of the challenge of photographing creatively.

You can blur moving objects so much that they lose their shape or disappear altogether. If the exposure is long enough, fast-moving objects such as traffic on a busy street can pass through a scene before it records on the film.

In this photograph made to illustrate the difficulties for handicapped students, the photographer mounted the camera on a tripod and then used a 1-second exposure to take the picture. The woman in the wheelchair did not move, so she appears sharp, but the other students walking down the stairs during the exposure appear blurred—and obviously mobile.

If you want to try to make moving objects disappear altogether, you'll need as long an exposure as possible—at least several seconds or even longer depending on how fast the people, cars, or other objects that you want gone are moving. To get a long exposure time, use a slow film, your smallest aperture, and, if necessary, neutral density filters to decrease the brightness of light.

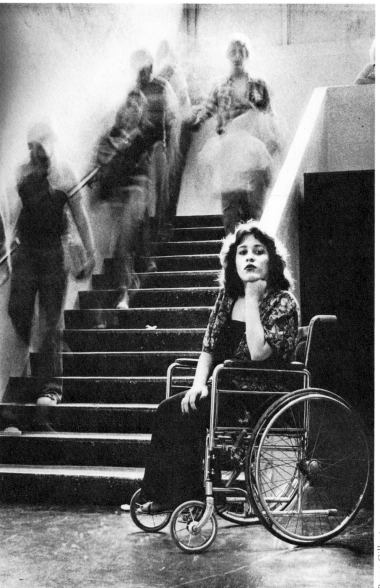

Bruce Gilbert

What do you do if, for example, light is dim and you think that your fastest usable shutter speed may not be fast enough? Even a fast-moving subject will slow down if its motion changes direction. A bolting rabbit making a zig-zag change in course or a race car on a curve have reduced their speed and can be photographed sharply at a slower shutter speed than they otherwise could.

When photographing sports or other action, you can use a slower shutter speed if you time your shot to coincide with a peak in the action. For example, a skateboarder moves rapidly up a slope, reaches a peak of upward motion, then heads down again. It is at this peak of movement, just before changing direction, when you can show action sharply at a comparatively slow shutter speed. You also have a safety factor at these times. Using a fast shutter speed and shooting when action peaks almost guarantees that motion will be sharp.

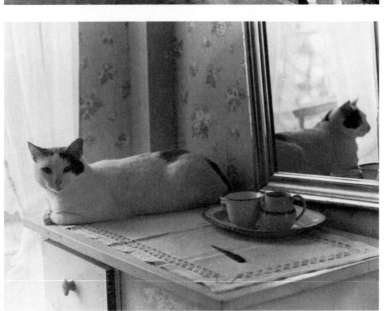

Ulrike Welsch

Jerry Howard

You may encounter a puzzling situation when making a photograph with a reflection in it—for example, a scene that includes a mirror with a reflected image. Either the area near the mirror will be sharp or the reflection will be sharp, but not both at the same time. The problem is that the reflection in the mirror is really farther away than the surface of the mirror. The distance is measured from the camera to the mirror, back to the reflecting object. You usually have to decide which is the most important part of the picture and focus on that. Focus on the actual scene if that is most significant. Focus on the reflected image if that dominates. Here, the photographer focused on the bureau top and let the reflection go slightly out of focus. Using a small lens aperture will help to get both sharp, as will stepping back from the reflecting surface or using a shorter focal length lens; any of these will increase your depth of field and make more of the picture sharp.

3 Fine tuning exposure

Automatic exposure control is one of the most useful features of your camera. The convenience of having the camera automatically measure the brightness of light, then set the correct shutter speed or aperture (or both) will be particularly evident to you if you have ever used a camera that did not function automatically in this way. It means you can often let the camera deal with the exposure while you concentrate on the image. This is especially helpful when photographing action scenes where there isn't time to evaluate the situation and then set the exposure controls manually.

You shouldn't, however, always leave the exposure to the automatic system. Automatic exposure works well in most, but not *all*, lighting conditions. At times the lighting can fool any automatic system into producing an underexposed (too dark) or overexposed (too light) picture. At these times, you will want to override the automatic system.

At certain times you may also choose to override automatic exposure in order to exploit an interesting and unusual lighting situation. For example, if you want to photograph into the sun, record a colorful sunset, or show the brilliance of a snow-covered landscape or the dark moodiness of a forest, you will probably need to adjust the exposure manually, rather than let the camera make exposure settings automatically.

Controlling your exposures depends on your understanding a few very basic concepts. This chapter will tell you what you need to know to approach any exposure with confidence. It will show those times when automatic exposure works well, plus those times when it doesn't and what to do when that is the case.

Ulrike Welsch

Automatic exposure works well when a scene contains an average range of tones from very light, through mid-grays, to very dark. In this photograph of a pond in which neither very light nor very dark tones dominate, automatic exposure would give good results. More about automatic operation on pp. 54–55.

> The next time you pick up a camera think of it not as an inflexible and automatic robot, but as a flexible instrument which you must understand to properly use.
>
> Ansel Adams, *The Camera* (Boston: New York Graphic Society, 1982)

Ulrike Welsch

▲
Suppose that a scene you want to photograph does not contain an average range of tones. For example, in this snow scene, light tones predominate. If you want a photograph to show this type of scene as you originally saw it, you will have to override the automatic system to give more exposure to the scene. If you don't increase the exposure, the photograph will be too dark. If dark tones dominate a scene and you want the photograph to show them that way, you will need to override the automatic system to decrease the exposure. *See pp. 60–61.*

▼
Automatic exposure will tend to underexpose a back-lit scene, which can make the main subject darker than you want it to be. Unless you want a subject darkly silhouetted against a bright background, you will have to increase the exposure. *See pp. 62–63.*

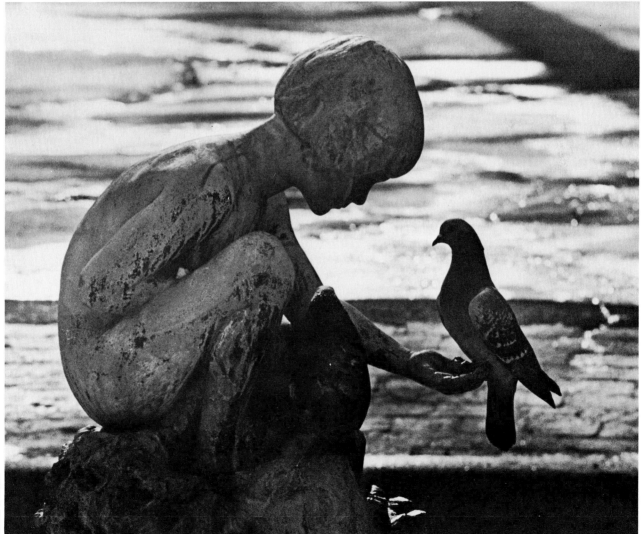

Ulrike Welsch

How your meter works

All light meters, including the one built into your 35mm SLR camera, operate by the same general principles. A light-sensitive photocell regulates the amount of electricity flowing in the metering system. As the intensity of the light changes, the amount of electricity flowing through the photocell's circuits changes.

In some light meters this electricity is used to deflect a needle indicating the absolute brightness of the light. In photography, however, it's not as important to know how bright the light is as it is to know how to set the camera's aperture and shutter speed controls to expose the film in the camera correctly. Therefore, in a camera, the light meter is made into an **exposure meter** by connecting the photocell to a movable needle or a series of diodes in the viewfinder to indicate the proper aperture and shutter speed settings to use for a good exposure.

As the brightness of the light falling on the photocell changes, the needle in the viewfinder moves or a different diode lights up to indicate the new exposure needed. In automatic cameras the photocell is also connected to the automatic exposure system, which not only shows the exposure needed but also automatically sets either the aperture or shutter speed or both accordingly.

The meter built into your SLR measures light entering the lens from the area of the scene that you see in the viewfinder. The coverage of the meter (the amount of the scene that it includes in its reading) changes, just as your viewfinder image changes, when you change your distance relative to the scene or when you change your lens' focal length. Suppose you move close or use a longer focal-length lens and see in your viewfinder only a detail in the scene, one that is darker or lighter than other objects nearby: the suggested aperture and shutter speed settings will be different than if you meter the scene overall from farther away.

The exposure meter and exposure control system in an automatic camera can't think. They do exactly what they are designed to do and they are designed to do only one thing. Regardless of the scene, its subject matter, color, brightness, or composition, the meter measures the overall amount of light reflecting into the camera lens. The automatic exposure system then calculates and sets the aperture and the shutter speed to render this level of light as "middle gray" in the photograph (see opposite). Most of the time this works very well because most scenes have an overall reflectance that does, in fact, average out to middle gray. But some scenes and situations don't, and that's when a better understanding of your exposure meter and how it determines the exposure of your photograph is essential for good results.

Meter averaging

Your exposure meter doesn't "see" a scene the same way you see it. Its view is much like yours would be if you were looking through a piece of frosted glass.

If you were looking at a chessboard, you could easily make out the light squares and the dark squares. You would say the scene was half light and half dark. However, this gray patch shows how your meter would register the same chessboard. It wouldn't see a pattern of light and dark squares; all it would record is an averaged gray tone.

Every scene you photograph is something like the chessboard, but even more complex. Portions of it are pure black, pure white, and every possible tone in between. Regardless of the elements making up the scene, a meter can average and measure brightness only. The meter built into your camera is of this averaging type.

Meter weighting

All parts of a scene are usually not equally important when determining the best exposure to use. In a landscape, for instance, the exposure of the foreground is usually more important than the exposure of the sky. For this reason the meter in your camera is "weighted" to give more importance to the light reflecting from the center and lower parts of the scene where the most important objects usually are located.

Meter weighting can cause a few problems that are easily overcome once you are aware of them. For instance, a dark object located off center against a very light background may not be exposed properly because it is not located in the area the meter is emphasizing. Or, in some cases, holding the camera vertically may give undue emphasis to one side of the scene. These occasions are uncommon, but when they occur you can insure accurate readings and exposure settings by metering the subject from close up. The camera settings can then be overridden or set manually if necessary to produce a well-exposed photograph.

Middle gray

After a light meter averages all of the individual tones in a scene to determine its overall level of brightness, the automatic exposure system computes the aperture and shutter speed settings needed to expose the film correctly. The settings it selects are those that will render this average brightness (regardless of the color or brightness of individual objects in the scene) as middle gray in a black-and-white print or as a medium tone in a color photograph. If you photograph first a white card, then a gray card, and third a black card, and each completely fills the viewfinder frame when the exposure is calculated, each of the cards will be middle gray in its print.

A continuous spectrum of tones, ranging from pure black at one end to pure white at the other (a), is contained in most scenes, for example, the pigeons, right. In simple terms, this continuous scale can be thought of as dividing into a series of individual tones (b) called a gray scale. Each of the tones in this scale has received 1 stop more exposure than the next darkest tone in the series, and 1 stop less exposure than the next lightest tone. The tone in the middle is called *middle gray*. A subject uniformly of this tone reflects exactly 18% of the light falling on it.

When you photograph a subject with an overall tone of middle gray, your camera's automatic circuitry will set an exposure so that the subject will appear in the print as middle gray. When you photograph subjects that have an overall tone lighter or darker than middle gray, they will also be middle gray in the print and therefore look too light or dark. Regardless of the actual tone of the subject the autoexposure system is designed to select the exposure settings needed to render the scene middle gray. To make scenes that don't average out to middle gray appear in a photograph the way they appear in real life, you have to use exposure compensation when taking the picture. Details on pp. 58–65.

Ulrike Welsch

A

B

Tips The first principle of metering

When you are metering, make sure that the most important area of the scene fills the viewfinder at the time a reading is made. With landscapes, city scenes, and many other common situations, the entire scene is important, so no special metering method is required. When the main center of interest is small and much lighter or darker than the background, move close enough so the main subject fills the viewfinder frame. Since the meter reads light reflecting only from the area of the scene appearing in the viewfinder, metering up close eliminates any under- or overexposure caused by the meter being overly influenced by the brightness or darkness of the background. You then use this exposure when you step back to take the photo from the original position.

How exposure affects film

When you take a photograph, the first step is the exposure of the film in the camera. The shutter opens when you press the shutter release and light, entering the camera through the lens aperture, strikes the film. The film, coated with a light-sensitive emulsion, undergoes a molecular change when the light hits it. Silver halide crystals embedded in the emulsion of the film are chemically changed by the impact of the light.

When film is exposed, the exposure isn't uniformly distributed over its surface—unless you are photographing a subject that is absolutely uniform in tone. Highlights (brighter areas) in the scene reflect the most light, and the areas of the film onto which they are focused are exposed a great deal. Darker areas, like shadows, reflect much less light, so the areas of the film onto which they are focused receive much less exposure.

After exposure the film has a record in its chemical structure of the amount of light focused onto it from various areas of the scene. At this point the image on the film still cannot be seen.

When the film is removed from the camera and developed, the exposed silver halide crystals in its emulsion become visible. How dark, or dense, they appear depends on how much light exposed them. The bright light reflected from bright areas of the scene causes dark, dense areas on the negative. The dimmer light reflecting from dark areas of the scene results in less dark or "thin" areas on the negative. The image on the negative, therefore, is reversed in tone from the original scene.

To make the image appear as it did in the original scene, the tones must be reversed one more time to obtain a positive image. This can be done by making a print, using an enlarger to project light through the negative onto a sheet of light-sensitive paper. The dark areas of the negative block the most light, so the part of the print paper onto which they are projected receives the least amount of exposure while the enlarger light is on. Thin areas of the negative block the least amount of light, so the area of the print onto which they are projected receives more exposure. After development the areas that received the least exposure appear light in the print, those that received the most appear dark. The tones of the finished print are reversed back to a positive image identical to those in the original scene.

Controlling exposures

Your exposure meter (either built into the camera or a separate hand-held one) may or may not choose the best aperture and shutter speed combination. To get consistently good results you should learn to interpret what the meter tells you.

The meter tries to make every scene appear middle gray in the photograph, but that may or may not be the tone you want. In this series of photographs you can see the effects of using exposure compensation when taking a photograph. The camera's automatic exposure system was used to take the center picture and exposure compensation was used to take the rest. Exposure compensation can make a scene darker or lighter. The greater the exposure (left) the lighter the final image gets. When the exposure is decreased (right) the final image becomes darker.

Increased exposure **Exposure set by meter** **Decreased exposure**

Ellis Herwig

The negative and positive

All color and black-and-white negative films go through two steps to achieve a final print. The first step after the development of the exposed film results in a negative. The second step involves making a positive (usually enlarged) print from the developed negative. Slide films (also called *reversal films*) are changed from negative to positive during the chemical processing of the film that was exposed in the camera.

A typical scene includes a variety of tones and colors, all of which reflect different amounts of the light falling on them. The negative reverses the tones in the scene: light objects in the scene appear as dark areas on the negative and vice versa. Color negative film also reverses the colors in the scene. A positive can be made by projecting light through the negative onto a sheet of light-sensitive paper. The tones are reversed back to those in the original scene.

Negative

Positive

Underexposure and overexposure

Whenever film is not exposed to the correct amount of light the final image will suffer. Color slides are made from actual film exposed in the camera, which is developed and then chemically reversed to a positive image. Their exposure must be almost perfect to get a good image. As little as 1/2 stop underexposure and the slides may look too dark. Even less overexposure and they may look too light. When using color or black-and-white negative film, underexposure or overexposure results in negatives that are either too light or too dark. About 1 stop under- or overexposure is tolerable but ideally the best print is made from a well-exposed negative. Gross exposure errors are impossible to correct completely. When evaluating the quality of your prints, compare them to the negatives from which they were made for possible clues to why some of your prints look much better than others.

An underexposed image happens when the camera's exposure controls are set so that too little light reaches the film. An under-exposed negative looks "thin" and weak. No details show in the shadow areas and even the brightest areas of the scene look weak on the negative. A print made from such a negative may appear too dark. No details will show in the shadow areas and the brightest areas of the scene will appear gray. If the exposure was changed when the print was made, to compensate for the thinness of the negative, the print may still have contrast that is too low; the image will look flat without a rich range of tones from pure white to pure black.

An overexposed image results when the camera's exposure controls are set so that too much light reaches the film. An over-exposed negative looks dark and dense. Bright areas of the scene (highlights) appear opaque and dense on the negative, and details are lost. A print made from an overexposed negative will have a very high contrast, too many pure blacks and pure whites without good distribution of tones in between. Details in the highlights are lost and they look "chalky" and overly light.

Underexposed negative

Print from underexposed negative

Overexposed negative

Print from overexposed negative

When automatic exposure works well

The aperture and shutter speed settings selected, either by you or by your automatic camera, affect how light or dark the final photograph will be. All light meters and all automatic exposure systems work on the same basic principle. They select the combination of aperture and shutter speed that will make the scene, regardless of its actual brightness, appear middle gray in the photograph. Because the scenes you photograph usually have an overall brightness of middle gray, automatic exposure most often works well. Some areas of the scene may reflect 90% of the light and other parts may reflect 5%, but overall the average amount of light reflecting from the scene is 18%, the amount reflected by a middle gray subject.

Whenever you photograph a normal scene with an average brightness of middle gray, your automatic exposure system exposes it correctly, for example:

• Scenes in bright sunlight where the subject is front-lit, that is, the sun is behind you when you face the scene.

• Scenes taken on overcast days or under diffused light, such as in the shade or in evenly lit scenes indoors.

Of course, although many scenes are of these types, not all scenes are. The following pages will tell you exactly what to do when you encounter different types of scenes, for example:

• Subjects that are lighter or darker overall than middle gray, for example, bright sandy beaches and snow-covered landscapes. See pp. 58–59.

• Scenes where the subject is relatively small and is against a much lighter or darker background, such as a portrait against a bright sky or a sunlit subject against a background of deep shadow. See pp. 60–61.

• Scenes with high contrast between the brightest and darkest areas of the scene and where good exposure is possible for one, but not both, of the extremes. This often occurs when the subject is lit from the back or side. See pp. 62–63.

Ulrike Welsch

Let your automatic camera take care of exposure calculations in scenes such as these where the subject is evenly illuminated and contains an "average" range of tones from light to dark. Above: a front-lit scene. Light is coming from behind the photographer and so illuminates the side of the subject visible to the camera.

Ulrike Welsch

Automatic exposure usually works well in diffused light (left and below) because the subject is evenly illuminated by light coming from several directions or sources.

Ulrike Welsch

How to override automatic exposure

Every camera has at least one way to override automatic exposure and many models allow it to be overridden in a variety of ways. See chart, below.

Remember that changes in exposure are measured in "stops." Each aperture or shutter speed setting is 1 stop from the next setting. Increasing the exposure 1 or more stops makes a picture lighter, decreasing the exposure makes it darker.

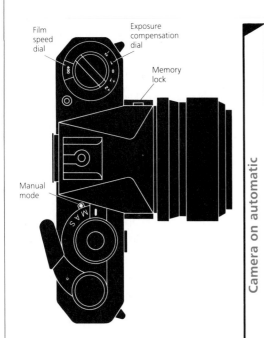

Film speed dial

Exposure compensation dial

Memory lock

Manual mode

Memory lock A memory lock temporarily locks in an exposure so you can move up close to take a reading of a particular area, lock in the desired setting, step back, and then photograph the entire scene. Only a few of the more expensive cameras have this device.

Camera on automatic

1 **Back-light button** Depressing a back-light button adds a fixed amount of exposure (usually 1 to 1 1/2 stops) and lightens the picture. It cannot be used to decrease exposure. A camera may have this device if it does not have an exposure compensation dial.

2 **Exposure compensation dial** Moving the dial to +1 or +2 increases the exposure and lightens the picture (some dials say X2 or X4 for equivalent settings). Moving the dial to –1 or –2 (X1/2 or X1/4 on some dials) decreases the exposure and darkens the picture.

Lighten
Darken

3 **Film speed dial** Even if a camera has no other means of exposure compensation, you can always change the film speed dial. The camera then responds as if the film is slower or faster than it really is. With ISO/ASA-rated film, doubling the film speed (e.g. from ASA 100 to ASA 200) darkens the picture by decreasing the exposure 1 stop. Halving the film speed (e.g. from ASA 400 to ASA 200) lightens the picture by increasing the exposure 1 stop.

Lighten
Darken

Camera on manual

4 **Manual mode: Aperture setting** In manual mode, you select a shutter speed and aperture combination yourself. Exposure can be increased to lighten the picture or decreased to darken it as you wish. Many cameras have a manual mode though some less expensive models do not.

Lighten Darken

5.6 8 11 16 22

5 **Manual mode: Shutter speed setting** See number 4, above.

Darken
Lighten

+2	+1	0	−1	−2
Increase the exposure 1 stop for • Side-lit or back-lit scenes • Beach or snow scenes • Scenes (such as a sunset) that include bright light source • Natural rendition of very light objects (such as a white cat on a white pillow) **Increase the exposure 2 stops** when the light is extremely contrasty and important shadowed areas are much darker than brightly lit ones.		Use the exposure set automatically for scenes that are evenly lit as viewed from camera position and when important shadowed areas are not too much darker than brightly lit ones.	**Decrease the exposure 1 stop** for • Scenes where the background is much darker than the subject (such as a portrait in front of a very dark wall) • Natural rendition of very dark objects (such as a black cat on a black pillow) **Decrease the exposure 2 stops** for scenes of unusual contrast, as when an extremely dark background occupies a very large part of the image.	
Depress back-light button	Depress back-light button	Do not press back-light button	Cannot be done with back-light button	Cannot be done with back-light button
Move exposure compensation dial to +2 (or X4)	Move exposure compensation dial to +1 (or X2)	Leave exposure compensation dial unchanged	Move exposure compensation dial to −1 (or X1/2)	Move exposure compensation dial to −2 (or X1/4)
Reduce ISO/ASA setting by 3/4 (Example—from ASA 400 to ASA 100). Or reduce DIN setting by 6 (Example—from 18 to 12)	Reduce ISO/ASA setting by 1/2 (Example—from ASA 400 to ASA 200). Or reduce DIN setting by 3 (Example—from 18 to 15)	Leave film speed setting unchanged	Multiply ISO/ASA setting by 2 (Example—from ASA 400 to ASA 800). Or increase DIN setting by 3 (Example—from 12 to 15)	Multiply ISO/ASA setting by 4 (Example—from ASA 400 to ASA 1600). Or increase DIN setting by 6 (Example—from 12 to 18)
Open up 2 stops (Example—from f/11 to f/5.6)	Open up 1 stop (Example—from f/11 to f/8)	Leave aperture unchanged from automatic setting	Close down 1 stop (Example—from f/11 to f/16)	Close down 2 stops (Example—from f/11 to f/22)
Reduce shutter speed by 2 stops (Example—from 1/60 to 1/15)	Reduce shutter speed by 1 stop (Example—from 1/60 to 1/30)	Leave shutter speed unchanged from automatic setting	Increase shutter speed by 1 stop (Example—from 1/60 to 1/125)	Increase shutter speed by 2 stops (Example—from 1/60 to 1/250)

When to override automatic exposure

Scenes lighter than middle gray

An automatic exposure system works extremely well for most scenes, but for some it cannot be trusted to give correct exposure settings. It does work well when the scene averages out to middle gray, that is, when the scene reflects about 18% of the light falling on it (see pp. 50–51). It does not work well when the scene overall is much lighter or much darker than middle gray.

Scenes lighter than middle gray, such as beach scenes on bright sand or snow-covered landscapes, reflect *more* than 18% of the light falling on them. The automatic exposure system doesn't know that the scene should look bright. It calculates an exposure to produce an overall middle gray in the print or slide, resulting in a photograph that will be too dark. To produce a picture with an average overall tone lighter than middle gray, so the tones in the print match those in the original scene, you must override the camera's automatic exposure system to add exposure and make the image lighter than the automatic exposure system would make it.

The snow scene, right, is typical of scenes that are lighter than middle gray. Most of the tones in the scene are at the lighter end of the gray scale. The overall "average" tone would be about 1 stop brighter than middle gray on the gray scale.

For a good exposure you have to override the camera's automatic exposure system to expose the scene for its actual tone. In this case, you would have to give the scene 1 stop of exposure more than the automatic system would. This increase in the exposure will increase the amount of light reaching the film, making the photograph lighter than middle gray, as it should be. See pp. 56–57 for how to override the automatic exposure system.

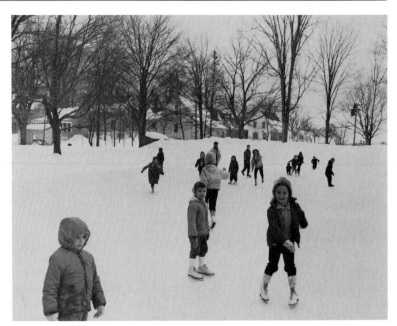

Exposure set by meter: too dark

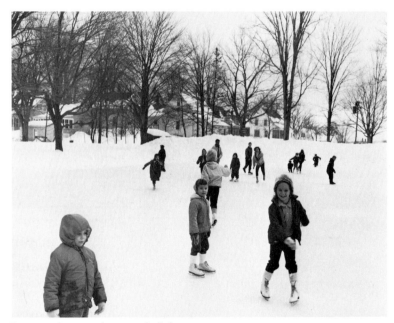

Exposure increased: correctly light

Scenes darker than middle gray

Scenes that are darker than middle gray, such as deep shadows, dark foliage, and black cloth, reflect *less* than 18% of the light falling on them. Although such scenes are not as common as scenes lighter than middle gray, you will come across them occasionally. Such scenes, if they are photographed using automatic exposure, will appear too light. The meter cannot tell if the scene is dark or just an ordinary scene with less light falling on it. In either case it opens up the camera's aperture or slows the shutter speed to make the image lighter. When it does this with a dark scene, it overexposes the negative and makes the scene too light. To produce a picture with an overall tone darker than middle gray, you need to override the automatic system to decrease the exposure.

The black cat, right, is darker than middle gray. Although there are a few light areas in the scene, the majority of the scene falls at the darker end of the gray scale. The average, overall tone is about 2 stops darker than middle gray. Because the automatic exposure system is designed to expose every scene for middle gray, this scene is overexposed. To show it darker, more like the way it appears to the eye, the automatic exposure would have to be decreased by 2 stops.

Exposure set by meter: too light

Fredrik D. Bodin

Exposure increased: correctly dark

When to override automatic exposure *continued*

Subject against very light background

Subjects against a very light background (for example, a portrait against a bright sky or bright sand or snow) can confuse an automatic exposure system, particularly if the subject occupies a relatively small part of the image. The brightness of the background is so predominant that the automatic exposure system reduces the aperture or increases the shutter speed to render this brightness as a medium gray in a black-and-white photograph (or a medium tone in a color one). The result is an underexposed and too-dark main subject.

In the example above the main subject is approximately middle gray while the background is much brighter.

When the picture is taken on the recommended automatic setting, the resulting image is underexposed. In this example, the background looks more or less normally exposed but the main subject has become a silhouette.

In situations like this, you can get a better exposure of the main subject by moving closer during metering, so it completely fills the viewfinder frame. Here the best exposure to show detail in the windmill is actually 2 stops more than indicated when metering from farther away.

Mishi Kamiya

After metering close up, return to shooting position and either set the exposure manually based on the reading up close or use one of the exposure compensation techniques to open up 2 stops. You might, instead, choose to underexpose and silhouette the windmill. What you don't want is for the camera automatically to make that choice for you.

Subject against very dark background

When a small light subject appears against a large dark background, your automatic exposure system assumes the overall average tone to be darker than it actually is, because so much of the scene is dark compared to the smaller brighter main subject. The automatic exposure system opens the aperture or slows the shutter speed to produce a middle gray tone in a black-and-white print (or a medium tone in a color one). The result is an overexposed and too-light main subject.

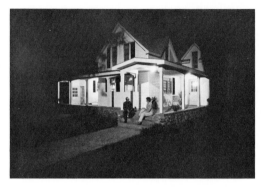

In this example, the main subject is approximately middle gray but the large background is much darker.

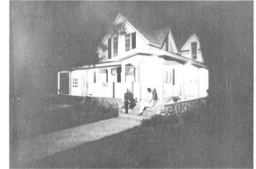

When the picture is taken using the aperture/shutter speed settings indicated by the automatic exposure system, the image is overexposed. Everything in the scene appears lighter than it should be. The background is gray instead of black, and the main subject shows a loss of detail in the highlights.

You can get a better exposure by moving close enough to the main subject to completely fill the viewfinder when metering. Here, the best exposure is 1 stop less than the meter indicates when the scene is viewed from the shooting position.

To get a better exposure, either set the exposure manually or override the automatic exposure to decrease the exposure by 1 stop.

When to override automatic exposure *continued*

Scenes with high contrast

Many scenes, especially those with brightly lit highlights and deep shadows, have a brightness range that cannot be completely recorded on film without using customized exposure and development techniques. When confronted with such scenes, in which there are both large, important bright areas and large, important shadowed areas, you have to decide whether the highlight or shadow area is most important, then expose the film so that area is shown accurately in the final picture. In high contrast situations, move close enough so the most important area fills the viewfinder frame. Use the aperture/shutter speed combination recommended from that position to make the exposure.

Some photographers expose differently depending on whether they are using negative film (from which prints will be made) or reversal film (for slides). They would suggest that with negative film, you should expose for the shadows, that is, move in close to meter shadow areas. When a print is made from negative film, the highlights, which would be somewhat overexposed and too light when the shadows are exposed correctly, can be "burned in" and darkened. When shooting color slides, expose for the highlights, because underexposed, dark shadows are usually less distracting in a slide than too-light highlights.

In contrasty scenes, particularly when you are shooting slides, it is important for you to look at the scene the way it will appear in your picture, choose the areas that you feel are most important, and then override your automatic exposure system to expose for those areas.

One way to deal with high contrast is to lighten the shadows by adding fill light from a reflector or flash. A portrait, for example, lit from the back or side is often more effective and interesting than one lit from the front. But when the light on the scene is contrasty, too much of the person's face may be in overly dark shadow. How to use a reflector to add fill light is shown at right.

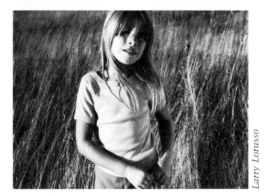

Larry Lorusso

Top: This side-lit portrait is potentially interesting but too much of the face is in dark shadow. This would be least desirable with color slide film which has little tolerance for high contrast.

Middle: To lighten shadows you can use a light-colored card or cloth to reflect back some light into the shadows to lighten them.

Bottom: Shadows are still visible but much lighter and less prominent. If you are shooting color film, use a neutral colored reflector so you do not get unexpected color tints on the subject. You can also add fill light with a flash unit; see p. 137.

In these photographs, the one exposed on autoexposure (top) has lost detail in both the highlight and shadow areas. This is because the average tone of the scene was about middle gray and the camera exposed the scene for that tone. As a result, all of the tones in the subject that are near middle gray are well-exposed. But the range of brightness was too great for the film to record, so areas with very dark tones and those with very light tones lack realistic substance and detail.

To expose for the shadows (middle), a close-up reading was made of a shadowed part of the scene. The reading indicated that the exposure should be increased 2 stops. Notice that exposing for the shadows caused the highlights to be overexposed and much too light.

To expose for the highlights (bottom), a close-up reading was made of a bright area. The reading indicated that the exposure should be decreased 2 stops. Notice how the shadows have become quite dark and lost detail.

Fredrik D. Bodin

When to override automatic exposure *continued*

Hard-to-meter scenes

Exposures for hard-to-meter situations

Occasionally it's not convenient or even possible to meter a scene. Neon street signs, spot-lit circus acts, fireworks, moon-lit scenes, and many similar situations are all difficult and sometimes impossible to meter. In these cases, it's easiest simply to refer to a table of suggested exposure settings. The table at right gives exposure settings for many common situations and film speeds. When using this table keep the following points in mind:

Bracket your exposures because no table can be perfectly accurate for every situation. There are always variables such as light intensity, subject reflectance, and so on. Make one picture at the recommended setting, then take another giving 1 stop more exposure, and a third giving 1 stop less. You can select the best exposure after processing.

You can adjust the shutter speed or aperture settings recommended in the table. If, for instance, the table lists a setting of f/8 at 1/60, you can increase the shutter speed (to freeze motion) to 1/125 if you open the aperture an equal amount, in this case from f/8 to f/5.6. See pp. 14–15 if you want to review the relationship between shutter speed and aperture.

Film speeds

Subjects	ASA 50–80 DIN 18–20		ASA 100–160 DIN 21–23		ASA 200–400 DIN 24–27		ASA 1000 DIN 31	
	Suggested exposure times							
Outdoors/Night Streets	1/30	f/2	1/60	f/2	1/125	f/2	1/125	f/2.8
Night club and theatre districts, brightly lit	1/60	f/2	1/60	f/2.8	1/125	f/2.8	1/125	f/4
Neon and other lighted signs	1/60	f/2.8	1/60	f/4	1/60	f/5.6	1/60	f/8
Christmas lighting	1	f/4	1/2	f/4	1/4	f/4	1/8	f/4
Floodlighted buildings, fountains/monuments	1/4	f/2	1/8	f/2	1/15	f/2	1/30	f/2
Skyline—distant lighted buildings	2	f/2	1	f/2	1/2	f/2	1/4	f/2
Skyline—10 min. after sunset	1/30	f/4	1/60	f/4	1/60	f/5.6	1/125	f/5.6
Fairs/amusement parks	1/15	f/2	1/30	f/2	1/60	f/2	1/60	f/2.8
Fireworks, on ground	1/30	f/2.8	1/60	f/2.8	1/60	f/4	1/60	f/5.6
Fireworks, in air	Keep shutter open for several bursts.							
		f/8		f/11		f/16		f/22
Fires/bonfires/campfires	1/30	f/2.8	1/60	f/2.8	1/60	f/4	1/60	f/5.6
Lightning	Keep shutter open for several flashes.							
		f/5.6		f/8		f/11		f/16
Landscapes by moonlight	30 sec.	f/2	15	f/2	8	f/2	4	f/2
Snow scenes by moonlight	15	f/2	8	f/2	4	f/2	2	f/2
Full moon	1/125	f/11	1/125	f/16	1/250	f/16	1/250	f/22
Half moon	1/60	f/8	1/125	f/8	1/125	f/11	1/125	f/16
Indoors/Artificial light Close-up by candlelight	1/4	f/2	1/8	f/2	1/15	f/2	1/30	f/2
Christmas trees	1	f/4	1/2	f/4	1/4	f/4	1/8	f/4
School stage or auditorium	1/15	f/2	1/30	f/2	1/60	f/2	1/60	f/2.8
Boxing, wrestling	1/60	f/2	1/125	f/2	1/125	f/2.8	1/125	f/4
Stage shows, average light	1/30	f/2	1/60	f/2	1/125	f/2	1/125	f/2.8
Stage shows, bright	1/60	f/2.8	1/60	f/4	1/125	f/4	1/125	f/5.6
Circus, floodlighted act	1/30	f/2	1/60	f/2	1/125	f/2	1/125	f/2.8
Circus, spotlighted act	1/125	f/2	1/125	f/2.8	1/125	f/4	1/125	f/5.6
Ice shows, floodlighted act	1/60	f/2	1/125	f/2	1/125	f/2.8	1/125	f/4
Ice shows, spotlighted act	1/125	f/2	1/125	f/2.8	1/125	f/4	1/125	f/5.6

Table adapted from chart © Eastman Kodak Company, 1978.

Ulrike Welsch

Using substitute readings

Not every scene lends itself to automatic exposure control, and when you do have to override the automatic exposure system, it is usually best to do so by getting close to the subject to meter just the most important area. But what do you do when it is impractical to meter from up close? For example, what if you are photographing wildlife or if the subject is so small that even if you do get close you are still metering more background than subject? In such cases, a substitute reading will give you the correct exposure.

To make a substitute reading you meter some convenient object such as a gray card or the palm of your hand, holding it in light similar to that falling on the object you want to photograph. You then use the aperture/shutter speed settings recommended for the substitute object to determine the overall exposure.

The most accurate substitute object is a gray card, available at most stores that sell photographic supplies. The darker side of a gray card is exactly of that middle gray tone. Metering a gray card will give you the best settings to use regardless of the individual tones that make up the scene.

Instead of a gray card, many photographers use the palm of their hand. It is convenient, always with you, and takes up no space in your camera bag. If you have average Caucasian skin, increase the exposure 1 stop more than the meter recommends. If you have darker skin, you can use the settings indicated.

Tips Setting the exposure when your batteries fail

Many cameras with automatic exposure systems are totally dependent on battery power. In every camera, battery power determines the exposure and, in some cases, actually works the camera controls. If your batteries fail when you are out taking pictures, and you have a manual exposure mode that works without batteries, there are two ways you can determine the best exposure without a meter.

The instructions packed with film may give suggested exposure settings for various lighting conditions, for instance, bright sun, cloudy day, or heavy overcast. If, however, your camera works at only one shutter speed when batteries fail, you may have to convert the aperture and shutter speed combination given with the film to the correct aperture for your camera's functioning shutter speed. For example, if your shutter works only at 1/60 sec. when batteries are dead, and the film instructions suggest f/5.6 at 1/125 sec., shoot at f/8 at 1/60 sec.

If there are no instructions packed with the film, you can figure out the exposure using what is sometimes called the "f/16" rule. In bright sun, the correct exposure would be f/16 and the correct shutter speed would be that closest to 1/ASA, as shown in the table below.

Film ASA	Shutter speed
25	1/30
32	1/30
64	1/60
125	1/125
160	1/250
200	1/250
400	1/500

If you are photographing in light other than bright sunlight make these exposure adjustments:

Light	Exposure
Bright or hazy sun (distinct shadows)	As given above
Bright or hazy sun on light sand or snow	−1 stop
Weak sun (soft shadows)	+1 stop
Cloudy bright (no shadows)	+2 stops
Heavy overcast or open shade	+3 stops

Remember that you need to adjust the aperture to make these changes if your camera is functioning at only one shutter speed.

◄
When using a gray card (or other substitute object for metering), make sure the card is in the same position relative to the light as the subject you are going to photograph. For example, if your subject is back-lit, make sure the card is back-lit also. Make sure the card entirely fills the viewfinder, so the meter sees only its tone. When you meter, don't move in so close that your own body casts a shadow on the card, since this will influence the metering.

Using exposure creatively

Just as you can direct your viewer's eye to the important part of a scene by controlling sharpness, you can also direct attention by controlling the lightness or darkness of different parts of a picture. The eye notices contrast between light and dark areas, so you may be able to emphasize a subject by placing it against a lighter or darker background (opposite). If the shape of a subject is more important than showing details in it, you can silhouette it (right, top). Sometimes the pattern made by light and dark areas *is* the subject of the picture (right, below).

Two birds are completely silhouetted against a bright sky (right, top). To guarantee that the birds would be silhouettes, the photographer gave the overall scene about 2 stops less exposure than that recommended by the automatic exposure system.

The pattern of bright sunlight reflecting off water (right, bottom) was made by giving the scene 2 stops less exposure than recommended by the automatic system.

A dog framed by a dark doorway (opposite) was made by the photographer first metering the outside scene, then setting the exposure manually. If automatic exposure had been used, the camera would have increased the exposure because of the dark foreground and so made the outside street much too light.

Ulrike Welsch

Ulrike Welsch

Common exposure problems

Many pictures too dark

Dark photographs occur when film is underexposed (not exposed to enough light). If this occurs on only some pictures on a roll, the cause was most likely a metering problem. If an entire roll (or rolls) has this problem you may have set the controls (film speed, exposure compensation) incorrectly or you may have a camera malfunction.

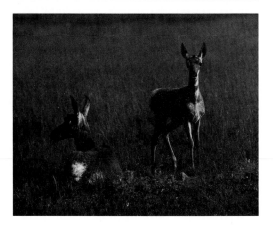

Light too dim for the aperture or shutter speed selected. In automatic operation, your selected aperture required a slower shutter speed (or your selected shutter speed required a wider aperture) than your camera could provide. In manual operation, you set in too fast a shutter speed, too small an aperture, or both.

Wrong film speed entered into film speed dial. If the camera is set to a number higher than the film actually in the camera, the exposure system will let in less light because faster film requires less. The result will be a darker-than-normal image.

Exposure compensation dial not returned to zero. If you used exposure compensation at a −1 or −2 setting and forgot to return the dial to zero, you will underexpose subsequent pictures.

Light entered the eyepiece, influencing the built-in meter, as when the camera is on a tripod and you are not looking through the eyepiece. When you use the camera in bright light without blocking the viewfinder with your eye, shade the eyepiece with your hand during the exposure or use the eyepiece blind designed for this purpose.

Shutter is operating too fast or (rarely) aperture is stopping down too much.

Many pictures too light

Pictures that are too light are the result of the film being overexposed (too much light reaching the film). With slides, colors appear weak and washed out in direct relation to the amount of overexposure. Prints do not show this as clearly because some corrections can be made when the negatives are printed.

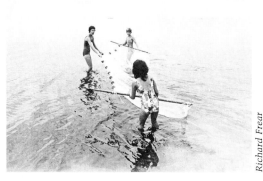

Richard Frear

Light too bright for the aperture or shutter speed selected. In automatic operation, your selected aperture required a faster shutter speed (or your selected shutter speed required a smaller aperture) than your camera could provide. In manual operation, you set in too slow a shutter speed, too wide an aperture, or both.

Wrong film speed entered into film speed dial. If the speed is set to a number lower than the actual film speed being used, the camera exposure system will overexpose.

Exposure compensation dial not returned to zero. If you used exposure compensation at a +1 or +2 setting on a previous picture (or used a back-light button) and forgot to return the dial to zero, you will overexpose subsequent pictures.

Shutter is operating too slow or aperture is failing to stop down.

Subject very dark against light background

If your main subject is in front of a large, much brighter background, the camera tends to expose the background properly, because that is the predominant part of the scene. As a result, the main subject will be underexposed and too dark.

Nancy Benjamin

Autoexposure system was influenced by a very bright background. The camera exposed so that the background appears normal, resulting in the main subject being underexposed and too dark. If a relatively small, dark, or medium-toned area is most important, you can move close enough to meter just it or use exposure compensation to increase the exposure 1 or 2 stops.

Not enough light on the main subject. If the most important subject is dark surrounded by a very light area and you want both properly exposed, use fill-in flash or reflectors to lighten the main subject.

Subject very light against dark background

When a relatively light or medium-toned subject is in front of a large, much darker background, the camera's automatic exposure system will be overly influenced by the darkness of the background. This will make the main subject overexposed and too light.

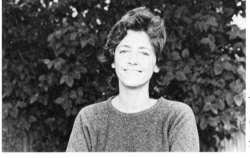

Alan Oransky

Autoexposure system influenced by a very dark background. The autoexposure system exposes for the average brightness of the scene that fills most of the viewfinder. To meter a relatively small object against a large, much darker background, move close enough to the main subject to meter just it or use exposure compensation to decrease the exposure 1 or 2 stops.

No picture at all

Both image area and edges are clear in a slide, black in a negative.

Overexposed to light but not through the lens/shutter. Camera back inadvertently opened (usually affects only part of the roll).

Image area is clear but edges are black (except for film frame numbers) in a slide. Image area is black but edges are clear (except for film frame numbers) in a negative. (Shown at right.)

Overexposed to light through the lens/shutter. Massive overexposure because of wrong (much too low) film speed entered on camera's film speed dial. Aperture failed to stop down. Shutter sluggish or failed to close (especially in cold weather). Shutter was set at "B," causing massive overexposure.

Both image area and edges (except for film frame numbers) are black in a slide, clear in a negative.

Film not exposed to light. Film not put in (or not run through) the camera. Flash failed to fire. Shutter accidentally released with lens cap left on. Shutter failed to open or mirror failed to move up.

4 Film, color, and light

Choosing film

The film display in a well-stocked camera store is an impressive sight. Seemingly endless rows of film boxes in a variety of designs and colors, each with different names and code numbers, can perplex the unprepared buyer. Choosing the best possible film for your needs requires a little understanding of how film, color, and light interact. Before you go in to buy, think about the following questions:

1 Do I want black-and-white or color film?
2 What film speed do I need?
3 If I want color film, will it be used to photograph in daylight or under tungsten (household lamp) light?
4 Do I want slides or prints?
5 How many exposures do I want per roll?
6 What brand should I get?

In this chapter we'll explore the answers to these questions.

Film layers

Scratch-resistant topcoat

Light-sensitive emulsion

Film base with antihalation dye

A cross-section of film reveals several thin layers. The bottom layer is a flexible strip of cellulose acetate or polyester that provides a base for the other layers. On top of the base layer is an adhesive and then the light-sensitive emulsion layer containing crystals of silver halide which turn dark when exposed to light. Color film contains more than one layer of emulsion. The top layer of the film, a scratch-resistant topcoat, protects the film from scratches during ordinary handling.

Film terms

Color sensitivity The parts of the visible spectrum to which a film responds.

Film speed The overall sensitivity of a film to light as compared to other films.

Latitude The amount that film can be overexposed or underexposed and still produce an acceptable print or slide.

Grain The granularity or speckled effect produced by tiny specks of silver in the emulsion clumping together.

Contrast The range of tones from dark to light that a film produces. Films of normal contrast show blacks, whites, and a wide range of tones in between. High-contrast black-and-white films record all the tones in a scene as either black or white or something close to these extremes.

Emulsion The light-sensitive coating applied to photographic films and papers. It consists of silver halide crystals plus other chemicals, suspended in gelatin.

Base The backing of film or paper on which emulsion is coated.

Negative An image, usually on film, with tones that are the opposite of those in the original scene; light areas in the original are dark in the negative, dark areas are light.

Positive An image on paper or film with tones that are the same as those in the original scene.

Transparency Usually, a positive color image on film. A slide is a transparency mounted in a small frame of cardboard or other material so it can be inserted in a projector or viewer.

Reversal processing The procedure by which a positive image is made directly from a scene or from another positive; making a color slide directly from film exposed in the camera is an example.

Tips Storing your film

Prior to development, film keeps best in a cool place. A refrigerator or freezer is excellent if you have to store the film for an extended period. Before opening a film box that has been cooled, allow it to reach room temperature to prevent condensation on the film surface. At warm temperatures, film deteriorates rapidly, so avoid storage near radiators, in the sun, in car glove compartments in hot weather, or in any other place where heat is likely to be a factor. Certain films, such as infrared film, are particularly susceptible to damage due to excessive heat and should be refrigerated if at all possible.

Reading your film box

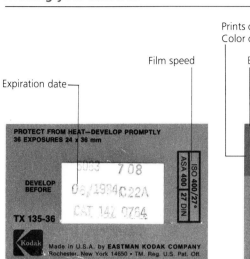

Expiration date

Film speed

Prints or slides
Color or black-and-white

Brand name and type

Format (here, 35mm)

Number of exposures

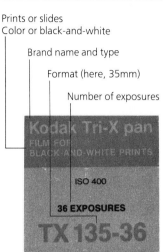

On the film box you can read basic information about the film, such as brand name, type of film, and number of exposures. Additional information may be provided inside the box.

Brand name and type Different brands or different types of film within a brand may record images somewhat differently; for example, the color balance or grain in color films varies from type to type. You may find that you prefer one kind of film over another, so it pays to try a variety of films before you settle on one for regular use.

Color or black-and-white Color photography tends to be more expensive than black-and-white but is still reasonable in cost and is extremely popular. The choice between color or black-and-white usually depends on the use to which the photograph will be put and on the personal preference of the photographer. Photojournalists, for example, often need black-and-white prints for reproduction in newspapers. Many photographers simply prefer the way black-and-white prints look.

Prints or slides Each has certain advantages and disadvantages (see p. 75). Your choice should be based on your own needs and preferences. Color reversal film (for slides) usually has the word "-chrome" in the name, for example, Kodachrome or Agfachrome. Negative film (for prints) is usually designated "-color", as in Kodacolor or Fujicolor.

Color balance A color film produces the best color balance when used with the particular light source for which it was designed. Daylight-balanced film gives natural-looking colors when used in mid-day daylight or with electronic flash. Tungsten-balanced film is best used with tungsten bulbs. For more on color balance, see pp. 78–79.

Number of exposures per roll
36-exposure rolls are less expensive per shot, but if you often move from indoors (where tungsten-balanced film is best) to outdoors (where you'll want to use daylight-balanced film), then 12-, 20-, or 24-exposure rolls are preferable. If cost is very important, you can load your own film from bulk rolls; you'll also need to buy a bulk film loader and empty film cassettes, but the overall cost will be lower.

Format Each type of film has its own manufacturer code. The number "35" usually appears in the code that identifies film for 35mm cameras.

Expiration date Film can be exposed after this date, particularly if it has been refrigerated, but it gradually loses contrast, speed, and accuracy of color balance.

Film speed Indicates how sensitive the film is to light. The higher the number (in a given rating system) the more sensitive the film and the less light it needs for a correct exposure.

Film and light

The light we see and that we use to expose film is from a small section of the electromagnetic spectrum and consists of forms of energy that travel much like waves. Long waves (those with a long distance between wave peaks) cannot be seen but are used for radio transmission. Short waves (those packed closely together) are also invisible but are used for X-rays and in astronomy.

The visible band of light can also be divided into smaller segments. Longer waves appear to the eye as reddish colors. As the wavelength gets progressively shorter, the light appears first as yellow, then green, blue, and violet. Just outside the visible range of light is the still shorter ultraviolet frequency which, although invisible to the eye, can be recorded on film as an overall blue cast.

Different films record the visible spectrum of light in different ways. Silver halide crystals, the light-sensitive part of film, respond primarily to the blue, violet, and ultraviolet portion of the light spectrum, but dyes can be incorporated in the film emulsion to expand its sensitivity to the red, yellow, and green portions of the spectrum. Panchromatic (or pan) film responds to the visible spectrum rather like the human eye.

Some films are designed to respond to only certain portions of the light spectrum. Orthochromatic film, for instance, is most sensitive to blue and green wavelengths. Infrared film responds primarily to the invisible infrared wavelengths.

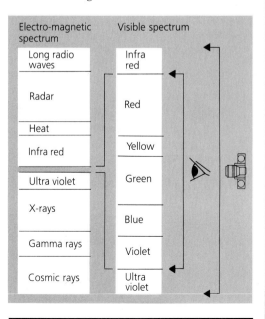

Film speed and grain

The "speed" of a film refers to its sensitivity to light. The faster the film, the more sensitive it is and the less light it requires for a good exposure. The film speed affects both the quality of the image and your ability to take photographs in different situations. Film speed is indicated by one of three kinds of systems: an ASA rating, a DIN rating, or an ISO rating. How these three systems compare is described opposite.

Fast films (those with high ASA, DIN, or ISO numbers) need less light for a good exposure, which is an advantage whenever you photograph in dim light, or need a small aperture (for depth of field) or a fast shutter speed (to show a moving subject sharply or to prevent blur caused by camera motion). Fast films, however, don't give the same image quality as slower films do. A film's speed is increased by using larger crystals of silver halide in the light-sensitive emulsion. After development, the exposed crystals tend to overlap more in the negative (or slide), causing the image to have more "grain." Fast film doesn't necessarily mean objectionable grain, but graininess is a factor you should at least be aware of.

Slow films are less sensitive to light than are faster films, so require more exposure—either a slower shutter speed or a larger aperture. Less grain may be evident in the final image compared to a similar scene shot with fast film. In some cases the advantage of fine grain is worth the trade offs that have to be made: slower shutter speeds may mean you will have to put the camera on a tripod to prevent blur caused by camera movement and they may cause blur due to subject movement; larger apertures reduce the depth of field. For detailed, grainless images, however, slower film is the preferred choice.

What film you use depends on how you want your images to look. Many professional photographers regularly use a fast film because the fast shutter speeds and small apertures it permits far outweigh the minor differences in grain.

The effect of film speed on grain

The three photographs below show the effect of increased film speed on grain. The very fast film (left) shows somewhat less contrast and detail than the medium speed film (middle) and the slow film (right). The difference in grain can be seen in a side-by-side comparison.

ASA 1250 **ASA 400** **ASA 32**

Donald Dietz

Tips **Pushing film speed**

The film manufacturer tests and establishes the speed of each type of film, but you don't necessarily have to use that speed when you take a picture. When even a fast film is not fast enough for your needs, you can "push" certain films, that is, give them special development so that their speed is increased over the standard rated speed. For example, instead of using Kodak's black-and-white negative film Tri-X at the normal rating of ASA 400, you can expose it at ASA 800, 1 full stop increase in the film speed. You must then give the whole roll of film special processing to compensate for the change in rated speed or, if you send your film to a lab for processing, you must be sure to tell the lab to do so.

In certain situations, especially in dim light, you may need just one more stop of film speed so that you can shoot, for example, at 1/60 sec. instead of 1/30 sec. One stop can sometimes make the difference between a sharp picture and a blurred one. Pushing film speed increases graininess and contrast somewhat, but can be a useful option. See manufacturer's instructions packed with the film to see if pushing film speed is recommended.

Setting your film speed dial

To calculate the correct exposure, your camera must know the speed of the film that you are using. Your exposure system will give under- or overexposed pictures if the film speed dial is not set properly. Most dials have some numbers left off for lack of room. The chart of film speeds (opposite) shows all the numbers.

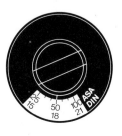

Film speed ratings

Film speeds are always given in one of three rating systems: ASA, DIN, or ISO, and sometimes in all three. Film manufacturers, however, are now standardizing on the ISO system, which may in time simplify film speed listings. Here are the three systems and how to understand them.

The ASA (American Standards Association) rating is found on films sold in English-speaking countries. Each doubling of the ASA rating number indicates an increased sensitivity to light equal to 1 stop of exposure. If you change from a 200 ASA to a 400 ASA film, you need 1 stop less of exposure (for example, by closing the aperture from f/8 to f/11 or by increasing the shutter speed from 1/60 to 1/125).

A DIN (Deutsche Industrie Norm) rating increases by 3 to indicate a film speed increase of 1 stop. An increase in DIN from 24 to 27 is the same as an ASA increase from 200 to 400.

An ISO (International Standards Organization) rating is becoming the universal standard for rating film speeds, but may still vary somewhat in the form in which it is given. A film rated ASA 400 (same as DIN 27) may be listed as ISO 400/27° (combining the ASA and DIN numbers), ISO/ASA 400, or simply ISO 400. If you understand either of the other systems, it's relatively easy to understand ISO numbers.

The ASA and DIN systems are compared in the table.

Film speed comparisons

ASA	DIN	ASA	DIN
6	9	125	22
8	10	160	23
10	11	200	24
12	12	250	25
16	13	320	26
20	14	400	27
25	15	500	28
32	16	640	29
40	17	800	30
50	18	1000	31
64	19	1250	32
80	20	1600	33
100	21		

Bill Strode

A fast film is useful for shooting in low light conditions, as in this river setting at dusk, because fast films require less light to produce a correct exposure. Along with the fast speed, however, is some increase in the graininess of the image. A slow film minimizes grain and tends to produce a crisper and more detailed image, but requires more exposure than a fast film does.

Color film characteristics

Color film can be used to make slides (reversal film) or to produce negatives that then are used to make prints (negative film). The table opposite shows some of the trade offs between reversal and negative film; each has its advantages and disadvantages. The results you get with either category depend, in part, on the accuracy with which you expose the film and on the match between the color balance of the film and the color balance of the light illuminating your subject. Even if film is perfectly exposed and correctly balanced, however, no film exactly reproduces the colors you see in a scene. How colors look also depends on how the manufacturer has chosen to formulate a particular type of film. Overall color balance, contrast, grain, and other factors vary from type to type. Try some of the major types; you may find that you like the results you get better with one type than another.

Where does color come from?

Why do we see colors? Light from the sun or from a lamp seems to have no particular color of its own. It appears simply to be "white" light. However, if you pass the light through a prism, you can see that it actually contains all colors, the same effect that occurs when particles in the atmosphere separate light into a rainbow. A colored object such as a leaf appears green because when white light strikes it, the leaf reflects only the green wavelengths of light and absorbs the others. A white object such as a white flower appears white because it reflects most of the wavelengths that strike it, absorbing relatively few. Dyes in color prints also selectively absorb and reflect certain wavelengths of light and so produce the effect of color.

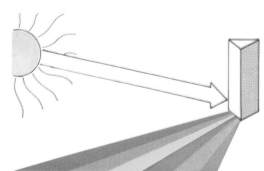

Although light from the sun appears colorless or "white," it actually contains a range of colors similar to a rainbow.

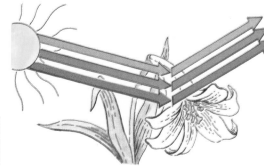

White objects reflect most of the wavelengths of light that strike them.

How film records colors

How does color film reproduce the colors in a scene? Color film consists of three layers, each of which responds to about one-third of the colors in the light spectrum. Combinations of these colors in varying amounts can create any other visible color. The layers of the film respond proportionately to the amount of light received from various parts of the scene. Dyes, which are built into the layers or added during processing, combine to reproduce in the photograph the colors visible in the scene.

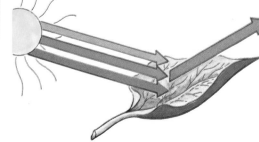

A green object such as a leaf reflects only those wavelengths that create the visual effect of green. Other colors in the light are absorbed by the leaf.

Slides or prints?

Characteristics	Reversal film (Slides)	Negative film (Prints)
Cost	Less expensive per shot, counting film and processing.	More expensive per shot, counting film, processing, and print.
Exposure	Very important because the film in the camera is developed into the actual slide. No corrections can be made during printing to make the final print lighter or darker.	Less important because film in the camera is first developed to make a negative and then the negative is used to make the print. Some corrections can be made at the printing stage to lighten or darken the print.
Convenience	For optimal viewing requires a slide projector and a screen.	Can be viewed directly, framed, or mounted in albums.
Color balance	The color balance is fixed unless the slide is reduplicated.	Like exposure, color balance can be corrected to some degree when an enlargement is made from the negative.
Prints	Can be made directly from slide, but making an internegative first is generally recommended for best quality. Cost thereby increases.	Made directly from negative.

Color negatives, slides, and prints

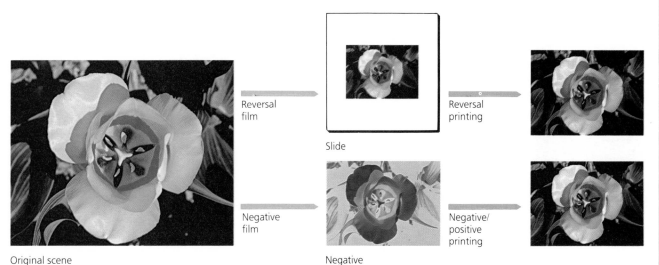

Original scene

Reversal film

Slide

Reversal printing

Negative film

Negative

Negative/ positive printing

Color negative film produces a negative after exposure and development that has a reversal of colors and density (darkness) from the original scene. When printed, the colors and density are again reversed to make a positive print similar to the scene. When color reversal film is exposed and developed, the film in the camera ends up as a strip of positive images. This strip is then cut into individual frames and mounted in slide mounts. Color slides can also be used to make prints. One method uses an internegative made by re-photographing the original slide on color negative film, which is then used to make a print. Another method uses a reversal paper which is exposed and developed to give a final print without using an intermediate negative.

Color film exposure

Any film gives the best results when it is correctly exposed. Negative films offer some exposure latitude (tolerance for under- or overexposure) because minor exposure errors can be corrected when a print is made, but you may not get the same image quality that you would with a better-exposed negative. The increased print exposure needed to compensate for an overexposed and very dense negative can make shadow areas overly dark in the print. Underexposure of a print to compensate for an underexposed and "thin" negative can make the print too low in contrast, with grayish-looking shadows. In general, negative films will tolerate about 1 stop underexposure, 1 to 2 stops overexposure before print quality is seriously affected.

Exposure is particularly important for color slide film. When the film used in the camera is developed it becomes the final slide. There is no opportunity to compensate for errors in exposure because there isn't the additional step of making a print. The series of photographs (right) demonstrates how 1 stop difference in exposure affects the way a slide looks after development. Slide films will tolerate not much more than 1/2 stop underexposure before colors begin to look too dark, and even less overexposure before colors appear too light.

The best way to get consistently good exposure is to understand how your meter reads a scene. To learn more about the basics of exposure see Chapter 3 beginning on p. 48.

Exposure with color slides

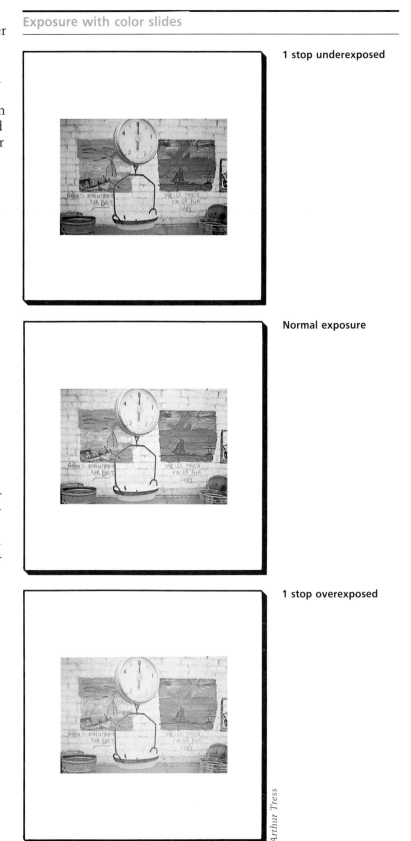

1 stop underexposed

Normal exposure

1 stop overexposed

Arthur Tress

Fred E. Mang, Jr.

Deliberate use of underexposure can be an effective technique. In this picture of Natural Bridges National Monument, the photographer metered the sky to determine the exposure. The rock formation was several stops darker than the sky, so it appears very dark, even black in some places. You can unintentionally, and not always so desirably, get the same effect if you include a bright sky in your meter reading because the brightness of the sky will cause the main subject to be underexposed and too dark.

Bracketing for certainty

When lighting is hard to interpret, but a picture looks promising, it is wise to "bracket" your exposure: underexpose and overexpose a few shots so that you are sure you will get at least one correct exposure. Bracketing also helps the first time you try a new film since every film has its own characteristics that are discovered only by experimenting. Color slide film, for instance, sometimes looks best if it is underexposed by 1/3 or 1/2 stop to give richer, more saturated colors.

To bracket, first determine the best exposure, either by trusting your automatic-exposure system or overriding the system as needed. Take the first exposure at that setting. Then take a second exposure of the same scene slightly underexposed, and a third slightly overexposed. With negative film, either color or black-and-white, use a full stop increase and decrease. With color slide film use smaller changes, either 1/3 or 1/2 stop.

Underexposure and overexposure can be made by using an exposure compensation dial if your camera has one, by switching to manual mode and setting the camera manually, or by changing the ASA setting on the film speed dial (see chart at right). See pp. 56–57 for details.

Film ASA	Change wanted	Use this ASA
	+1	32
	+2/3	40
	+1/3	50
64	no change	64
	−1/3	80
	−2/3	100
	−1	125
	+1	80
	+2/3	100
	+1/3	125
160	no change	160
	−1/3	200
	−2/3	250
	−1	320
	+1	200
	+2/3	250
	+1/3	320
400	no change	400
	−1/3	500
	−2/3	640
	−1	800

Color balance

Although light from the sun or from a light bulb looks white to us, it not only contains a mixture of all colors, it contains these colors in varying proportions. Light from the mid-day sun, for example, is much bluer than light from a tungsten lamp. To produce what appears to us to be a normal or accurate color balance, color films are balanced to match different light sources, and you have to choose the correct film to match the particular light in which you are shooting.

Color films are balanced for one of two broad categories. Daylight-balanced films yield the best results when shot in light that is rich in blue wavelengths, for example, daylight or light from electronic flash. Films for indoor use (except with flash) are mostly tungsten-balanced. They look best when shot in light that is rich in red wavelengths, such as from ordinary household bulbs. Type A indoor film is balanced slightly differently for use with 3400 K photolamps; only a few films are made with this color balance.

Color balance is particularly important when you are shooting color slides because the film in the camera is processed directly into the final image. Color negative film will tolerate some mismatch between the color balance of the film and the light source because color adjustments can be made when prints are exposed. Black-and-white film can be shot with good results in light of any color balance.

What is color temperature?

"White" light actually contains light of different colors and in different proportions. The overall color cast of the light changes as the proportions of the colors change. The color temperature of a light source is a way of describing the overall color balance of the light. The color temperature scale is calibrated in degrees Kelvin, somewhat like a thermometer that calibrates heat temperatures in degrees centigrade. The color temperature scale ranges from the lower color temperatures of reddish light to the higher color temperatures of bluish light.

Color films are balanced to match light of a particular color temperature. Daylight-balanced films are balanced for light of 5500 K, tungsten-balanced films for light of 3200 K. Your color slides are likely to have an unnatural-looking tint if they are not shot in the light for which the film was balanced (see opposite).

Film	Color Temperature	Type of Light
	12,000 K and higher	Clear skylight in open shade, snow
	10,000 K	Hazy skylight in open shade
	7000 K	Overcast sky
	6600 K	
	5900-6200 K	Electronic flash
Daylight	5500 K	Midday
	4100 K	
	3750 K	
	3600 K	
	3500 K	
Type A (indoor)	3400 K	Photolamp
Tungsten (indoor)	3200 K	
	3100 K	Sunrise, sunset
	3000 K	
	2900 K	100 watt tungsten bulb
	2800 K	
	1900 K	Candlelight, firelight

For realistic-looking colors in scenes outdoors, use daylight-balanced color film. The colors of these flowers would have looked too bluish if tungsten-balanced film had been used. See illustrations opposite, top.

How color balance affects your pictures

For the most natural looking colors, match the film you are using to the light illuminating your subject. Color films are balanced to give good results with a relatively narrow band of the color temperature scale (see opposite). Your color pictures, particularly color slides, will have an overall color cast that departs from standard balance if they are used with light different from that for which the film was designed.

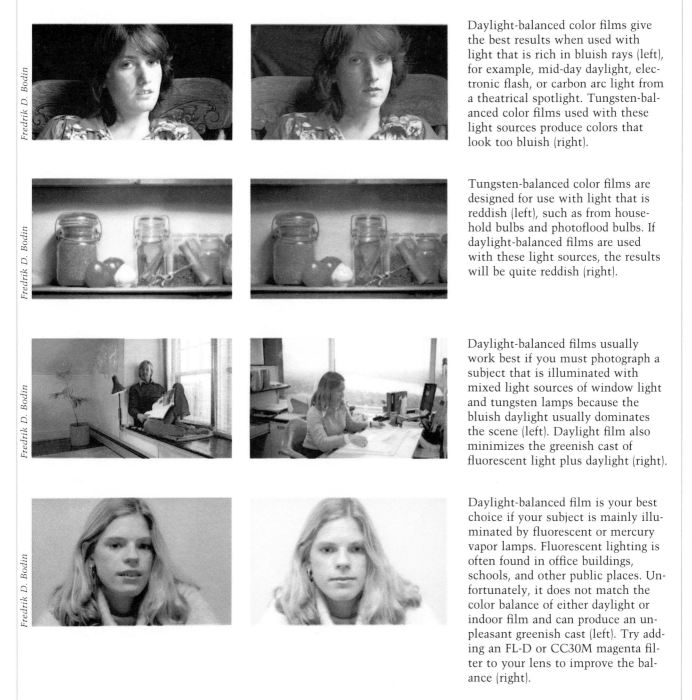

Daylight-balanced color films give the best results when used with light that is rich in bluish rays (left), for example, mid-day daylight, electronic flash, or carbon arc light from a theatrical spotlight. Tungsten-balanced color films used with these light sources produce colors that look too bluish (right).

Tungsten-balanced color films are designed for use with light that is reddish (left), such as from household bulbs and photoflood bulbs. If daylight-balanced films are used with these light sources, the results will be quite reddish (right).

Daylight-balanced films usually work best if you must photograph a subject that is illuminated with mixed light sources of window light and tungsten lamps because the bluish daylight usually dominates the scene (left). Daylight film also minimizes the greenish cast of fluorescent light plus daylight (right).

Daylight-balanced film is your best choice if your subject is mainly illuminated by fluorescent or mercury vapor lamps. Fluorescent lighting is often found in office buildings, schools, and other public places. Unfortunately, it does not match the color balance of either daylight or indoor film and can produce an unpleasant greenish cast (left). Try adding an FL-D or CC30M magenta filter to your lens to improve the balance (right).

Fredrik D. Bodin

Color balance and time of day

If you have ever carefully matched your film to the light source, shooting daylight-balanced film outdoors, and still had your picture come out with an unexpected color cast, you have experienced the effect that changing colors of daylight can have on color pictures. Daylight-balanced film is designed for optimum use in mid-day sunlight, between about 10 A.M. and 2 P.M. During these hours, colors appear clear, bright, and accurately rendered.

Before and after mid-day, light from the sun is modified by the extra distance the rays of light travel through the earth's atmosphere. Some of the blue rays are filtered out, leaving the light with a more reddish cast than at mid-day. This is easily seen very late in the day when the light is quite red-orange in tone. The color shift will affect your pictures strongly, but this reddish cast is acceptable, even effective, with some subjects. It casts an attractive warm glow on skin tones or wood. Not all subjects respond so well, however. A snow scene at sunset may simply appear oddly pink.

Just before dawn and at dusk, colors often appear muted and monochromatic. And during these hours when light is relatively dim, you often have to use an extra-long exposure time, which also affects color balance. See p. 83.

Lista Duren

Sam Laundon

Top: Mid-day light on a sunny day will produce colors that appear natural and accurately rendered when you shoot with daylight-balanced film.

Middle: Early morning and late afternoon light outdoors will produce a warmer, more reddish color balance with daylight-balanced film than you will get at mid-day.

Bottom: Sunset light is often very reddish-orange. We expect this color balance in sunset pictures so it usually looks quite natural.

Sunsets and sunrises are relatively easy to photograph because the exposure is not as critical as it is with some other scenes. If you underexpose the scene slightly, the picture will probably look the same as if you had taken it a few minutes later than you did; colors will simply be a bit richer and darker. Slight overexposure will make the same scene lighter, as if you had taken it a few minutes earlier.

However, bracketing your exposures is still a good idea when photographing sunsets and sunrises. Make one shot at the automatic exposure, then one or two shots with less exposure, one or two with more exposure. You'll be able to choose the best after the film is developed. Additional exposure is particularly important if you include the disk of the sun in your picture.

The bright disk of the sun included in a sunset or sunrise picture will elevate the meter reading so that the picture may come out somewhat underexposed and darker than you expected it to be. Add 1 or 2 stops of exposure to a sunset or sunrise that includes the disk of the sun. Pages 56–57 tell how to use exposure compensation to do this. A long-focal-length lens (or lens plus teleconverter) will enlarge the disk of the sun so that it becomes a more important part of the picture. Foreground objects, like this cactus silhouetted against the bright sky, can also add interest.

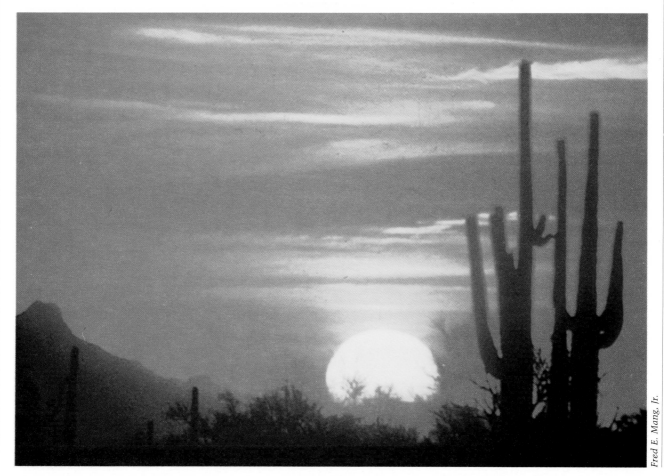

Fred E. Mang, Jr.

Weather

There's no need to leave your camera home just because the sun hasn't come out. In fact, rain, snow, fog, and mist can add interest to your pictures. Objects at a distance often appear diffused and gray in such weather, with foreground objects brighter than normal because they are seen against a muted background.

But remember to take a little extra care in bad weather to protect your camera against excessive exposure to dampness. See pp. 22–23.

Lightning can add drama to a stormy landscape. You will have to do some guessing as to when to open the shutter because you must open it in advance of the lightning streaks. At night, you can set the shutter to "B" and leave it open until one or two streaks have crossed the sky. You will need a stable support for the camera, such as a tripod, but see caution below. During the day, use as slow a shutter speed as possible to increase your chances of having the shutter open when the lightning occurs. With shutter-priority automatic exposure, select the slowest possible shutter speed. With aperture-priority automatic exposure, select the smallest aperture to produce a correspondingly slow shutter speed. When lightning is nearby don't let it strike you! Do not stand in an open field or near a solitary tree or a metal object (such as a tripod) where lightning may strike.

Falling snow muted the colors in this winter scene. Diffused light from the overcast sky also reduced the intensity of colors somewhat.

Sam Laundon

Lightning streaks across a dark, stormy sky in this prairie farm scene. The star-shaped light near the horizon is a pole-mounted light that illuminates the farmyard.

Lyle Orwig

Very long exposures

Exposures longer than about 1 second may cause unexpected shifts in color balance. Film responds less than normal when the exposure time is very long, a phenomenon called the *reciprocity effect*. Not only does the film respond less overall, but each of the three layers of color film responds at a different rate. The results include underexposure and color shifts.

Color shifts can add interest, but if you want to reduce the likelihood of this occurring, see the instructions packed with your film; you may need to add a filter during the exposure. You should definitely increase the amount of exposure if you want to prevent underexposed and too-dark pictures. In general, for exposures of 1 second or longer, increase the total exposure by 1/2 to 1 stop; for exposures of 10 seconds or longer, increase 1 to 2 stops; for exposures of 100 seconds or longer, increase 2 to 3 stops. Bracket your exposures by taking additional shots with extra exposure.

Peter Lavtin

Shifts in color occur when exposures are longer than about 1 second. A long exposure in the evening produced an unusual yellow version of a London river scene. A magenta sky often occurs when a very long exposure is made at sunset.

Color choices

The choices you make when photographing in color, such as how to position a colored object against its background or whether to concentrate on bright, brilliant colors or muted, soft ones, affect the mood and general impact of your pictures. Stop for a moment before you make an exposure and try to focus your attention only on the viewfinder image. Ask yourself how the colors relate to each other. Perhaps a change in camera position might bring one colored object to a better position in relation to another. Or perhaps you should wait until sunset turns the sky a more brilliant hue. Or you may want to use a colored filter over the lens to change colors a little or a lot. Don't limit yourself to taking the first view of a scene that comes to your attention.

Colors often create a psychological temperature. Blues and greens seem to be associated with coolness, water, or ice (top), while reds and oranges seem related to fire and warmth (bottom).

Larry Lorusso

Fuji Film

Contrasting colors can make a subject stand out, for example, the red ladybug that is bright against its blue metal background. A brightly colored subject may stand out more clearly against a muted background than it does against a very bright one that draws the eye away from the main subject.

We expect certain familiar objects like human skin or green grass to be within an accepted range of normal colors. However, if the color is not known the viewer will accept a wide range of possible colors as normal. Filters can help control colors in a photograph, either making the scene more apparently normal or less so (see pp. 122–123).

Vivitar Corp.

Rick Ashley

85

Experimenting with color

An unusual color balance can be created by using a filter over your lens or simply by taking advantage of the existing light on a scene. Try taking one picture in the usual way, then, before you move on, see if a filter or other alteration of the image might be feasible. See information on filters and lens attachments on pp. 118–127.

Erik Calonius

Red stage lighting reflecting off the artificial smoke at a rock concert gave this scene an overall red color. A red filter over the lens could have been used instead.

Underexposing a bluish scene can produce an effect that looks like a moonlit scene. You can either use daylight-balanced film with an 80B blue filter over the lens or use tungsten-balanced film without a filter. In either case, underexpose the scene by about 2 stops, then try additional exposures with even less exposure.

Chuck Herron

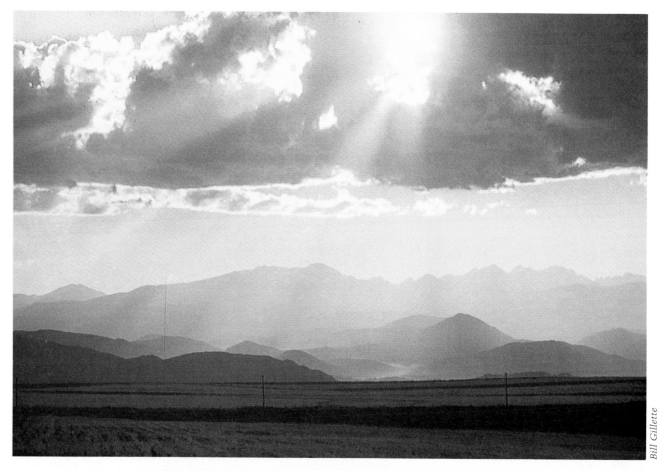

Bill Gillette

The overall color of
the landscape above
is rather yellow but
still believable. The
yellow tones in the
arctic scene below,
however, definitely
seem unrealistic.
Unusual filtration is
often more effective
with scenes that are
grayish or muted
than with brightly
colored ones.

Photographing at night

You can photograph many different things outdoors at night, so don't put your camera away just because the sun is gone for the day. Light sources (street lights, automobile lights, neon signs, or fires) or brightly lit areas (illuminated buildings or areas under street lights) will dominate pictures at night because they stand out strongly against darker backgrounds. Plan to use these bright areas as the dominant part of your picture.

Candlelight and firelight are psychologically very warm in color. The orange glow they create says "fire" to the viewer.

Set your exposure for fireworks manually using the chart on p. 64. Try different combinations of aperture and shutter speed as well as those recommended in the chart.

Sam Laundon

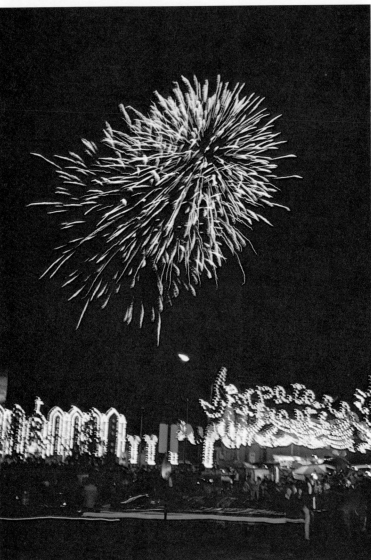

Fredrik D. Bodin

Ulrike Welsch

Use automatic exposure at night if brightly lit areas take up most of the scene visible in your viewfinder. If they do not, move in close for metering or set the exposure manually.

A large, bright light source, such as a bonfire, included in a picture can cause your camera's automatic metering system to underexpose the subject and make it too dark. Here the flames are partially shielded from the camera's view. If the people around a large fire are what you want to see clearly, move in close enough so you meter just them.

Ralph H. Anderson

Tips **Shooting at night**

For correct exposure try to move in close enough to meter the well-lit part of a night scene and base your overall exposure on that reading. Otherwise your automatic system may be misled by the dark background and so give you a picture that is too light overall. See also the chart of exposures on p. 64 for hard-to-meter situations, such as fireworks or moonlit scenes. The "B" setting on your shutter speed dial lets you keep the shutter open for very long exposures; the shutter remains open as long as the shutter release is depressed.

A fast film (ASA 400 or higher) lets you use a faster shutter speed or a smaller aperture than a slow film. You may need all the film speed you can get when light is dim; some films, like Kodak Tri-X, can be "pushed" during processing to increase the film speed.

A fast lens that opens to a very wide maximum aperture will let you use a corresponding faster shutter speed. In many cases, you will be shooting at a relatively slow shutter speed even with a lens wide open, so being able to use a shutter setting even 1 stop faster can be an advantage.

A tripod will support your camera during long exposures and prevent blur caused by camera motion during the time the shutter is open.

A flash unit is a convenient way to add light to scenes at night.

Zone focusing (prefocusing so that anything within a general area will be sharp) is helpful at night because some scenes are so dark it is difficult to see in the viewfinder whether a particular object is sharp or not. Page 42 tells how to zone focus.

Light: Its direction

The direction that light is coming from relative to camera position is important because it affects the shadows that will be visible in your picture. Photographers often talk about the quality of *light* on a subject, but they really mean the quality of the shadows that are created by that light. Four main types of lighting are illustrated here: front-lighting, side-lighting, back-lighting, and top-lighting. Notice the position of the shadows in these photographs and how they affect the subjects.

The direction of light can affect your automatic exposure. Back-lighting, for example, can leave your subject shadowed against a background so bright that your automatic exposure system will assume the subject is much brighter than it actually is, and so underexpose the scene and make the subject even darker. This is fine if you want a silhouette. If you don't, you should know how to override your automatic system to get the exposure you want (pp. 56–57 tell how to do this).

Ulrike Welsch

Ulrike Welsch

▲
Front-lighting, light that falls on the subject more or less from camera position, decreases visible shadows and so minimizes surface details such as skin texture—or here, feather texture. Front-lighting also tends to minimize the apparent roundness or volume of the subject.

◄
Back-lighting, light that comes from behind the subject, puts the side of the subject that is facing the camera more or less in shadow.

Top-lighting, light that comes from more or less overhead, can occur outdoors at noon or indoors in public buildings or other places where ceiling lights predominate. If you are photographing a person, you will notice that top-lighting tends to cast shadows in eye-sockets and illuminate the top of the nose brightly. Outdoors in strong sunlight, this sometimes can be unattractive; if so, you might try moving the person into the shade.

Side-lighting, light that falls mainly on one side of the subject, increases the sense of texture and volume because such cross-lighting casts shadows (visible from camera position) that pick out surface details. Landscape photographers often prefer to work early in the morning or late in the day because the sun low in the sky will side-light scenes and add interesting surface textures.

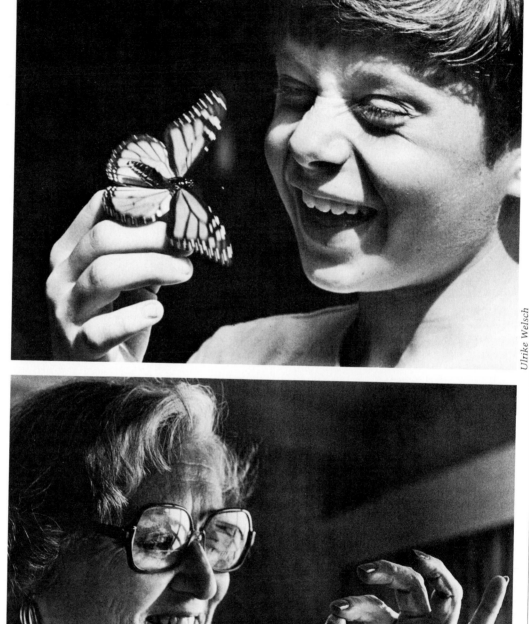

Ulrike Welsch

Ulrike Welsch

Light: From direct to diffused

Light not only has direction, it has another quality that is related to direction: light can be direct or diffused. Direct light, light coming mainly from one direction, produces relatively high contrast between bright highlights and dark shadows. Diffused light bounces onto the subject from several directions, lowering contrast. Contrast, in turn, affects the brilliance of colors, the amount of visible texture and detail, and other visual characteristics. Just as you can change the direction of light on your subject, you may want to change the contrast in certain scenes.

In direct light you may have to choose whether you want highlights or shadows

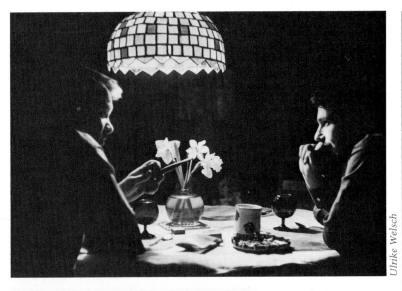

Ulrike Welsch

Ulrike Welsch

Direct light comes from a single, relatively small source such as a photoflood or flash pointed directly at the subject. Outdoors, direct light comes from the sun on a clear day (the sun is, of course, a very large body, but its disk occupies only a small part of our sky). Direct light produces dark, hard-edged shadows that crisply outline details.

to be correctly rendered because film, particularly color slides, can accurately record only a limited range of contrast between light and dark areas. If this creates a problem because both highlights and shadowed areas are important, you can sometimes add fill light (see p. 137) to lighten shadows and decrease contrast. In diffused light colors tend to be softer than in direct light and textures are also softened because shadow edges are indistinct.

Ulrike Welsch

Ulrike Welsch

Diffused light comes from a light source that is so large relative to the subject that it illuminates from several directions. For example, on an overcast day, illumination comes from the entire dome of the sky, not from the brighter, but smaller, sun. Indoors, light bounced into an umbrella reflector or onto a wall or ceiling creates a broad source of light that wraps around the subject.

Using light creatively

Light not only makes a subject visible and recordable on film, it is one of the elements of a scene that you can alter, play with, control, and make a less or more important part of your picture. Light can make a picture ominous or airy, glowing or velvety dark. To use light creatively, you may have to alter the exposure set by the camera's automatic circuitry. See Chapter 3 if you want to review your exposure choices.

A cross-screen lens attachment (star filter) makes streamers of light radiate from bright points of light (above). More about lens attachments for special effects on pp. 126–127. Rays of light are more readily visible if you can position them against a dark background, as in this scene in a redwood forest (below).

Fred R. Bell

Fred E. Mang, Jr.

Ulrike Welsch

On a foggy day, objects in the foreground tend to stand out sharply against a background that is partially obscured by light reflecting from the atmosphere. You can emphasize this effect by increasing the exposure a stop or so more than recommended by your automatic system.

Ulrike Welsch

Film can record only a limited range of brightnesses. Here the range between the dark tunnel and the brightly lit area outside was extreme. The photographer chose to silhouette the children inside the tunnel by underexposing that part of the scene. The rim of light on the ribs of the tunnel and around some of the children emphasizes the forms in the picture.

Special-purpose films

Most films are designed to respond to light in the same way that the human eye does, so that the image they produce resembles what you see when you look at a scene. Some special-purpose films, however, such as infrared and high contrast films, produce a different result, one that some photographers find preferable to more realistic images.

Tips Shooting infrared film

Storage and loading Infrared film fogs (acquires unwanted overall exposure) on exposure to heat or even slight exposure to infrared radiation. Refrigerate the film when possible and load and unload the camera in total darkness.

Focusing Infrared light focuses at a slightly different point from visible light. Most lens barrels will have a red dot or other marker to indicate how much the focusing ring should be adjusted for exact focusing of black-and-white infrared film. Such correction is usually not needed if you are using a small aperture or a short-focal-length lens, because the depth of field is generally adequate even if the critical focus point is slightly off. However, make the change if you are focusing very close to a subject or in any other situation where depth of field is likely to be shallow. No correction is needed for color infrared film.

Filtration See film manufacturer's instructions. For black-and-white infrared film, Kodak recommends for general use a No. 25 red filter, which will enhance the infrared effect by absorbing the blue light to which the film is also sensitive. With color infrared film, Kodak suggests for general use a No. 15 deep yellow filter.

Exposure Infrared radiation will not be accurately measured by a general purpose light meter or automatic exposure system. See film manufacturer's instructions for suggested settings. Kodak suggests the following manually set exposures for average, front-lit subjects in daylight.

Kodak High Speed Infrared black-and-white film with No. 25 filter: Distant scenes, 1/125 sec., f/11; Near scenes, 1/30 sec., f/11

Kodak Ektachrome Infrared color film with No. 15 filter: 1/125 sec., f/16

Use these as starting exposures, then bracket additional exposures, giving at least 1/2 stop and 1 stop more and 1/2 stop and 1 stop less exposure.

Most scenes contain a continuous range of tones from black to white with an infinite number of gray tones in between. Most films are also continuous tone, recording this infinite gradation of tones in varying degrees of darkness. High contrast film, however, converts these gradations into just two tones— black and white—resulting in a graphic abstraction of a scene. Some black-and-white materials are specifically made for high contrast work: Kodak Kodalith Ortho Film 6556, Type 3 comes in 100 ft. rolls which you must load yourself into 35mm cassettes. Some continuous-tone films (like Kodak Panatomic X) can be specially processed for high contrast.

Flint Born

Robert Branstead

Luther Smith

Infrared black-and-white film is sensitive to some visible light and also to infrared wavelengths that are invisible to the human eye. Grass and other vegetation reflect infrared wavelengths strongly, as do white clouds, so they appear very light, almost white in an infrared photograph. The blue sky does not reflect these wavelengths, so it appears very dark, even black (above). Skin tones appear softened and translucent (left). Infrared film can create unusual and sometimes dream-like images.

Infrared color film converts green colors to blue, red colors to green, and infrared radiation to red in the image. This film is mainly used for scientific and medical photography, but can produce interesting pictorial effects.

Infrared film requires somewhat different handling from ordinary films. See Tips box, opposite page.

Determining your own film speed

You may find after you have had several rolls of film processed that you have an unusual number of pictures that seem too light—not just one or two that you unintentionally overexposed, but a consistent run of slightly weak and overly light images. Or you may find the opposite, an excessive number of slightly dark and murky pictures. Exposure problems of this sort are particularly noticeable if you are shooting color slides, because the film in the camera is directly processed into the final image, but you may also notice the same effect if you have color prints made. The problem is likely to be your film speed. The manufacturer's recommendation is just that, a suggestion based on ideal laboratory conditions. Almost every camera has slight variations in meter sensitivity, aperture size, and shutter speed, which can mean that the film speed designated by the film manufacturer is not the best one for your equipment.

You can test your film speed to determine the ideal one for your camera (described opposite). The test is performed by bracketing exposures: making one at the recommended film speed, then making others giving more and less exposure. This produces a range of pictures that will vary from light to dark.

For a film speed test, you want to examine small differences in exposure, so changes are slight, 1/3 stop at a time. Use a color reversal (slide) film; it is the most sensitive to slight exposure variations. For this test try a medium-speed film, ASA 50 to 100 (DIN 18 to 21). A well-illuminated, colorful, front-lit subject is best for testing. You may want to include in each exposure a card clearly marked with the appropriate film speed setting.

The film speed dial

Space limitations on the film speed dial usually prevent the camera manufacturer from listing all of the ASA or DIN numbers. This illustration shows how to read the marks between the numbers on the dial.

Film Speed Scale													
DIN	27	26	25	24	23	22	21	20	19	18	17	16	15
ASA	400	320	250	200	160	125	100	80	64	50	40	32	25

Abbie Rowe

Determining your own film speed is most important if you frequently shoot color slides because there is no way to make corrections for underexposure or overexposure once the film has been processed. But even if you are shooting negative film to make prints, a correctly exposed negative is easiest to print and is likely to make the richest and most subtly detailed image. Even a slight amount of underexposure, which could have been caused by incorrectly rated film speed, might have lost some of the details of the water reflections here.

Step-by-step **Finding your personal film speed**

1 **The first picture** Set the film speed dial on the speed recommended by the manufacturer. (Here the recommended film speed is ASA 64/DIN 19.)

2 **The next two pictures** Take two pictures with more exposure: one with the film speed set 1/3 stop lower (in this test, ASA 50/DIN 18) and another set 2/3 stop lower (ASA 40/DIN 17).

3 **The last two pictures** Take two pictures with less exposure: one with the film speed set 1/3 stop higher (ASA 80/DIN 20) and another set 2/3 stop higher (ASA 100/DIN 21).

4 **Arrange the results** Process the slides, arrange in order of their frame numbers, and label according to film speed. The lighter slides will be those taken at the lower film speeds, the darker ones will be those taken at higher film speeds.

5 **Choose the best film speed** Project the slides as normally viewed and select the exposure you like best. Notice that the slides taken at lower film speeds may have brighter colors and more detailed shadow areas.

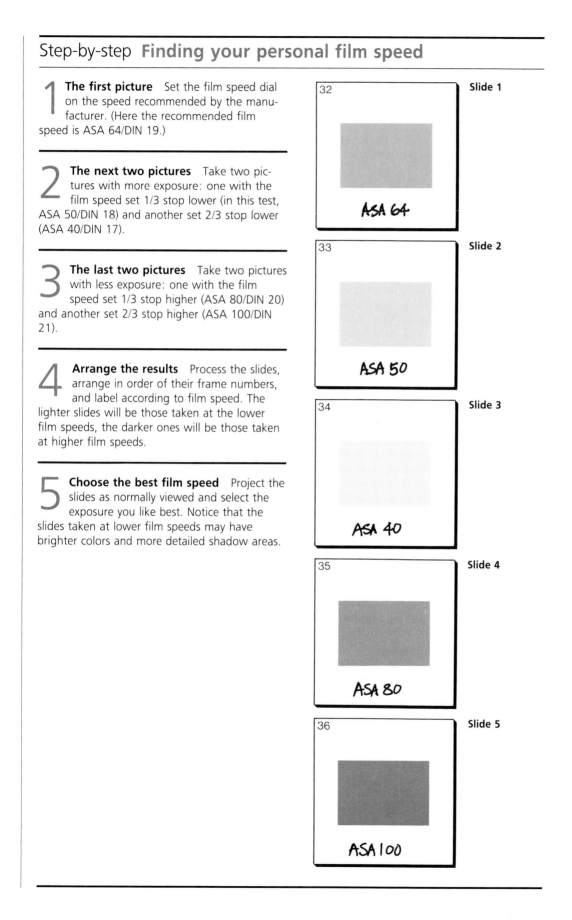

32 ASA 64 — Slide 1

33 ASA 50 — Slide 2

34 ASA 40 — Slide 3

35 ASA 80 — Slide 4

36 ASA 100 — Slide 5

5 Lenses

One important reason for the 35mm SLR camera's popularity is the freedom it gives to change lenses to meet different photographic opportunities. Small, light telephoto lenses capture distant action at sporting events or in the field; wide-angle lenses get the whole group in the picture, even in small rooms; zoom lenses lighten your load and increase your picture options. Lenses are by far the most popular SLR accessory, and most camera owners, once they get seriously involved in photography, find themselves owning more than one.

Modern camera lenses are designed on computers, ground to critical tolerances, coated with chemicals to improve light transmission, and then mounted in precision barrels and mounts. Modern lenses have excellent speed and sharpness, much more than lenses of only a few years ago. The primary function of a lens is to gather light reflecting from a scene and focus this light as sharply as possible onto the film in the camera. A high-quality lens does this very well, but to get the most out of what it has to offer you should know a few of its characteristics and how they affect your images.

Surprisingly, lenses are not actually needed to take a picture. You can make a camera out of a shoe box with a small hole in one end. Known as a pinhole camera, this primitive device can actually focus an image and record it on film. Photographs are definitely possible without a lens, but then you couldn't take advantage of what modern lenses offer.

The pinhole camera

The pinhole camera, a box with a pinhole in one end, focuses a scene without using a lens. To make a photograph, the box is loaded in the dark with light-sensitive film or paper and the pinhole is covered with tape. Peeling the tape back (much like a shutter) to uncover the pinhole (much like the lens aperture) begins the exposure, recovering the pinhole ends it. The exposed film or paper can then be removed in a darkroom and the image developed.

The modern lens

A modern compound lens combines several different glass elements, each ground and polished to different specifications to reduce the numerous aberrations found in simple lenses. The finished product gives a very bright, sharp, color-corrected, high-quality image.

Minolta Corp.

Getting to know your lens

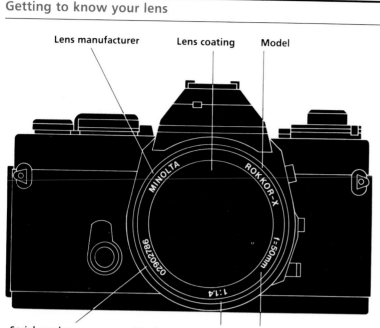

Lens manufacturer Lens coating Model

Serial number Maximum aperture Focal length

The lens manufacturer or distributor All of the large camera companies manufacture their own lenses, but many independent accessory companies distribute products carrying their brand name which are actually made by other manufacturers.

The lens coating, a chemical coating on the lens' glass surfaces, increases the amount of light transmitted through the lens and reduces internal reflections that lower the contrast of your pictures and make colors less brilliant.

The model is the trade name of the manufacturer's line of lenses. Some camera companies use different trade names for different quality lenses; the more expensive professional lenses might have one name and the amateur line another.

The serial number identifies your lens and should be recorded and saved in a safe place in case the lens is lost or stolen. It might help in

the lens' recovery and will provide evidence for any insurance claims. It is also used when declaring equipment you are carrying across an international border.

The maximum aperture (the lens' widest opening) is usually given as a ratio. 1:1.7 indicates that the maximum aperture is at the f-stop f/1.7. The term *fast lens* usually applies to lenses that can be opened up to a wide maximum aperture for their focal length. These wider openings allow more light to enter the lens in dim light. Remember that the smaller the numeral, the larger the lens opening will be. A lens with a maximum aperture of f/1.2 opens wider than a lens with a maximum aperture of f/1.8.

The focal length (given in millimeters, mm) indicates the lens' magnification, which affects how large subjects in the scene will be in the image. Long-focal-length (telephoto) lenses (those with large mm numbers such as 85mm, 150mm,

200mm) have a narrower angle of view. They magnify more and make distant subjects appear closer, a factor that is important, for example, in nature and wildlife photography. Shorter-focal-length (wide-angle) lenses such as 28mm or 35mm have a wider angle of view and include more of a scene, which is useful in crowded spaces.

ø (i.e., ø 55, ø 49 etc.) indicates the diameter of the lens accessory threads. Lens accessories such as filters and lens hoods can be screwed into these threads in the front of the lens. When buying such accessories you have to know this diameter so you can get the right size accessory for the lens on which you plan to use it. Different focal length lenses may not all take the same diameter accessories. If you have more than one lens, buy accessories that fit the lens with the largest diameter and also buy "step down" adapter rings to mount them on other lenses.

Tips **How to mount a lens**

Although every camera model is slightly different, the basic approach to mounting or removing a lens is the same.

To remove the lens, depress the lens release button on the camera body. While holding this button in, gently twist the lens (clockwise or counterclockwise, depending on the model) about 45 degrees until it hits a stopping point. At this point, when the lens can no longer be turned, move it forward off the camera. Never use force while twisting. If you are doing it correctly, the lens should turn and come off relatively easily.

To mount a lens, align the colored dot on the lens with the matching dot located on the camera body near the lens mount. Gently insert the lens mount into the lens flange on the camera body and twist the lens (the reverse direction from that for removing it) until it clicks into place. It usually takes a twist of about 45 degrees to mount it correctly and you will feel and hear a click when it locks into place. If the lens isn't twisted far enough, the auto-exposure system won't work correctly, and even worse, the lens can fall off.

Ulrike Welsch **Lenses**

Currently my favorite lenses are a 28mm wide-angle and a 105mm telephoto, so those are usually mounted on my two working camera bottles. Another favorite is a 20mm, which I use when I want to play with space relationships or unusual perspectives. I also carry a 180mm telephoto and a 300mm mirror lens. This 300mm lens has a fixed aperture of f/5.6 (which you can change to f/8 with the addition of a neutral density filter), so for those times when I want to play with depth of field and open up to a very wide aperture, I carry a 300mm telephoto lens which has fully variable f-stops. And then sometimes I carry a 500mm mirror lens if I think I might want an extremely long focal length. If I plan to photograph wildlife at a distance, I may want even longer focal lengths, so I carry a tele converter that doubles the focal length of any lens I put it on. I have a 50mm normal focal length lens, but I seldom use it, so I often leave it at home.

How a lens works

Light is bent when it passes between substances having different densities. You can see this if you look at an object that is both in and out of the water; for example, a spoon in a glass half full of water looks bent at the point where it enters the water. (See photo below.) Obviously the spoon isn't bent; the light reflecting from the spoon is, as it passes from the dense water to the less dense air. The same effect occurs when light passes from the air through a piece of glass. If the glass is curved correctly, as it is in a camera lens, it can bend the light in such a way that an image of the scene in front of the lens is focused behind it.

The focal length of any lens is the distance between the optical center of the lens and the point at which it focuses an image. When a magnifying glass is used to focus the light from the sun onto a piece of paper, the area illuminated by the beam will become larger or smaller as the distance from the magnifying glass to the paper changes. At the point where the bright circle of light is smallest (and where it might set the paper on fire), the simple lens that constitutes the magnifying glass is in focus. The distance between the magnifying glass and the paper is that lens' focal length.

No lens is absolutely perfect. Each is the result of a series of design compromises. Although modern lenses are generally of superior quality to lenses of only a few years ago, they still have and always will have small imperfections that are the result of the laws of optics, not poor design (see lens aberrations, opposite page). In most cases you will not be able to see the effects of these aberrations in your photographs except in a few rarely encountered situations.

See for yourself The image is upside down

Open the camera back, set the shutter to "B," and depress the shutter release to keep the shutter open so you can look through the lens. Hold a piece of thin paper (waxed paper is fine) up to the opening where the film normally is. Be careful not to touch the camera near the opening; the shutter mechanism is fragile and easily damaged. Point the camera at an object and you will be able to see the image projected by the lens. You might have to shade the back of the camera and point it at a bright subject to see the image clearly. The first thing you'll notice is that the image is upside down.

When light enters the lens it is bent by the glass elements. If it enters along the lens axis (A) it passes straight through to the film. If it enters at an angle (B and C), it is bent by the lens, then maintains a straight path to the film. The greater the angle, the more the light will be bent. For this reason objects in the scene that are above the center line (B) appear below the center line on the film plane. Objects below the center line in the scene (C) appear above it on the film plane. The result is an upside-down image. Similarly, light entering the lens from the sides of the scene also reverses the image laterally (left to right). When you look through the viewfinder the image looks normal because the pentaprism corrects the image.

Lens aberrations

The complexity of a modern lens is due to the effort to remove lens aberrations such as these that are present in a simple lens.

1 Spherical aberration causes rays of light that strike the edges of the lens to be bent more than those that strike the center. The result is an overall softness of focus.

2 Coma causes rays that pass obliquely through the lens to be bent at different angles. It can cause a bright point of light to appear to have a halo or something like a comet's tail.

3 Astigmatism is seen at the edges of the image. It causes horizontal lines to be focused differently from vertical lines, so that one or the other can be focused sharply, but not both at the same time.

4 Field curvature creates a sharply focused image—but along a curved plane. Film is stretched flat during an exposure, so field curvature causes one part of the image to be out of focus when another is sharp.

5 Chromatic aberration causes light rays of different colors to be bent at different angles. The result is overall softness and, occasionally, colored fringes at the edges of objects.

6 Curvilinear distortion bends lines at the edges of the image. If the lens diaphragm is in front of the lens, straight lines are bent into a barrel shape. If it is in back of the lens, straight lines are bent into a pincushion shape.

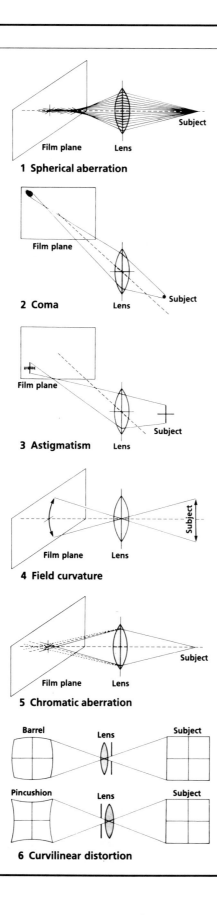

1 Spherical aberration

2 Coma

3 Astigmatism

4 Field curvature

5 Chromatic aberration

6 Curvilinear distortion

See for yourself **Automatic lenses**

Your lens and camera "communicate" through a set of movable pins located on the rear of the lens and the front of the camera body where the two join when the lens is mounted. Normally you view the scene with the lens aperture set to its widest opening to give a bright viewfinder image. When you turn the aperture ring on the lens, the size of the aperture doesn't change until you press the shutter release button. At that time the aperture closes to the one you have selected and then reopens to its widest opening when the exposure is completed.

Take the lens off your camera and find the movable pin on the back side. Set the lens aperture to f/16 and, while looking through the lens toward a light, gently press this pin sideways. You'll notice the lens aperture open to a much wider opening, the one at which the scene is normally viewed.

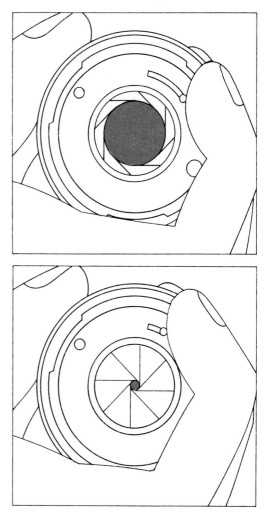

Lens focal length and angle of view

The most common way to describe a lens is by its focal length, a term that indicates the lens' magnifying power and angle of view. An SLR allows you to change lenses so that you can use different focal length lenses for different purposes. Long-focal-length (telephoto) lenses bring distant objects closer, often desirable in nature, sports, and portrait photography. Short-focal-length (wide-angle) lenses give a wide angle of view, of vast landscapes or in the cramped confines of small rooms.

When you change focal lengths, two important effects are immediately obvious in the lens' angle of view and in its magnifying power, both of which you can see in your viewfinder.

Angle of view describes how much of a scene the lens "sees." A short lens has a wide angle of view; as the focal length gets longer, the angle of view becomes narrower. A short lens will capture a wide expanse of scene on film; a long lens with its narrower angle of view will isolate small portions of the scene without your having to move the camera closer to the subject.

Magnification is related to the lens' angle of view. Since a short lens includes a wide sweep of the scene, all of the objects in the scene are reduced to fit onto the 24 × 36mm negative or slide. Long lenses have a much narrower angle of view, so objects in a scene appear larger.

The two basic kinds of lenses are fixed focal length and variable focal length (zoom). Fixed-focal-length lenses have only one focal length, for instance, 35mm, 50mm, 135mm. To change the focal length you have to physically change lenses. With variable-focal-length lenses you can select one focal length from a broad range of possibilities offered on a single lens by just pushing or rotating a ring on the lens barrel. A zoom lens with a range of focal lengths from 35mm to 80mm lets you choose any focal length between the two extremes.

Focal length and magnification

The focal length of a lens is the distance between the film plane (where the film is located) and the optical center of the lens when the lens is focused on infinity. A longer focal length lens (top) has its optical center farther from the film than a shorter focal length lens does (bottom).

The magnification of an object on the negative is directly related to the focal length of the lens. If the focal length is doubled, the size of objects in the scene will double; if the focal length is halved, it will halve the size of objects in the scene.

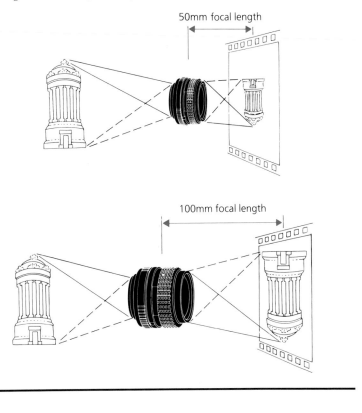

50mm focal length

100mm focal length

See for yourself **Focal length and aperture**

If you have two lenses of different focal lengths, set both of them to f/16, hold them up to the light, and look through them. You'll notice the size of the lens openings are different even though both are set at f/16. Why is this?

Lens aperture numbers (f-stops) are determined by dividing the actual diameter of the aperture opening into the focal length of the lens. An aperture of f/4 on a 50mm lens would have to measure 12.5mm across to fit into the lens' focal length 4 times. The same f/4 aperture would have to be 50mm across to fit into a lens focal length of 200mm.

The aperture f/4 on any lens lets the same amount of light reach the film. The larger diameter of a given f-stop on a long lens compensates for the longer lens spreading the same amount of light over a larger area of the film than a short lens does.

What happens when you change focal length?

When you change lenses, or zoom a variable-focal-length lens, the first thing you notice is how each lens crops the image differently. With short lenses, you see a wide expanse of the scene. Longer lenses show a much smaller area. The next thing you notice is that objects in the scene are larger when using a long-focal-length lens and smaller when using a shorter focal length lens.

In the series of photographs at right, all taken from the same camera position, only the lens focal length was changed. At the shortest focal length (top) the expanse of the scene is wide and objects in it appear small. As focal length increases, the area covered by the lens gets smaller and objects in it appear larger.

See for yourself **Using a cutout card**

You can use a cutout card to compose images and preview how different focal lengths will change the image. To make a cutout card use a gray or black card about 8″ x 10″ and cut a 4″ x 6″ hole in it (the same proportions as the 35mm negative). Use the card to frame and compose the scene you're planning to photograph. Holding it closer to your eye simulates the shorter focal length lenses and holding it farther away simulates the longer focal lengths.

8mm fisheye

(180° angle of view)

35mm lens

(62°)

50mm lens

(46°)

105mm lens

(23°)

200mm lens

(12°)

400mm lens

(6°)

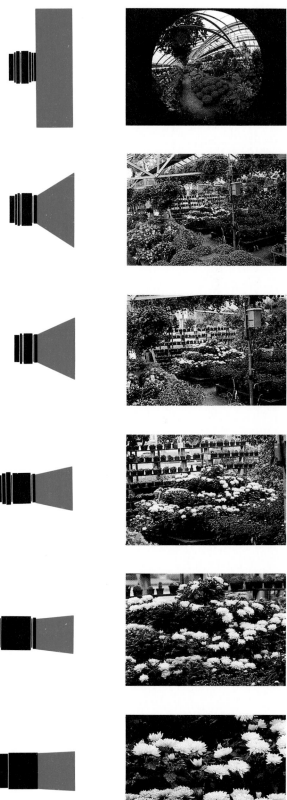

Alan Oransky

Normal-focal-length lenses

A "normal lens" for a 35mm camera usually refers to a lens with a 50mm focal length. When you put a 50mm lens on your camera and look through the viewfinder, the scene looks about the same as it does to the unaided eye. Looking through the viewfinder with a longer lens on the camera makes everything appear closer than it actually is. A shorter lens makes everything look farther away.

Normal lenses have many advantages. They are relatively easy to design and manufacture, and they are produced in such great quantities that their price is relatively low. Normal lenses tend to be faster (have larger maximum apertures) than do lenses with longer or shorter focal lengths. Maximum apertures of f/1.4 and f/1.7 are not uncommon and can be useful when you photograph in dim light.

A normal-focal-length (50mm) lens isn't always the one photographers normally use. Many photographers prefer the wider angle of view and greater depth of field provided by a slightly shorter focal length such as a 35mm or 28mm lens.

See for yourself What is a normal lens?

Why is the 50mm lens on a 35mm camera called the "normal" lens? The most common explanation is that lenses of this focal length are supposed to see the scene just as the human eye does. This description seems to violate common sense, because the eye's angle of view is much wider than that of a 50mm lens. However, you can demonstrate for yourself why the 50mm lens is "normal."

If you are a passenger in a car and have a variety of lenses with you, try changing them and then watching the traffic ahead of you, imagining you are driving. The longer focal lengths make distant cars appear right on top of you; in reaction you might even try to put on your brakes and then discover the cars are nowhere near as close as you thought. With shorter focal lengths, cars look far ahead, even when relatively close. A 50mm lens makes the cars appear in the same distance relationship as you perceive them ordinarily.

Another demonstration is to take two photographs of greatly different size and tape them to a wall. Look at one at a time through the camera viewfinder with a 50mm lens in place. Move close enough and focus so each fills the viewfinder frame. Take the camera from your eye without moving, and you'll discover you are at the correct distance for viewing the prints. With longer focal length lenses you would feel too far away from this distance and with shorter ones too close.

Normal-focal-length lenses are generally faster (have wider maximum apertures) than lenses of shorter or longer focal length, which makes a normal lens a good choice when light is dim.

Jonas Dovydenas

Ulrike Welsch

Wide-angle lenses: Short focal length

Lenses with a shorter-than-normal focal length are called wide-angle because they capture a wide expanse of a scene. A 28mm lens, for instance, has an angle of coverage of 75°. This wide angle of view makes a short-focal-length lens ideal for use in tight spaces, such as when photographing in small rooms where you can't position the camera a great distance from the subject.

Wide-angle lenses also have great depth of field. A 24mm lens will sharply focus all objects between 12 inches and infinity if it is set to even a moderately small aperture. This great depth of field makes short lenses good for street or action photography. They can be pre-focused (see p. 42) so that anything that happens within a deep range of distances in front of the camera will be sharp. This lets you photograph rapidly without taking time to focus for every shot.

Short lenses also let you focus very close to your subject, and the effect this can have on the perspective in your images can be dramatic. Objects very close to the camera loom much larger than those farther in the background. This distortion in the apparent size of objects can deliberately give emphasis and, when carried to an extreme, give an unrealistic appearance to a scene.

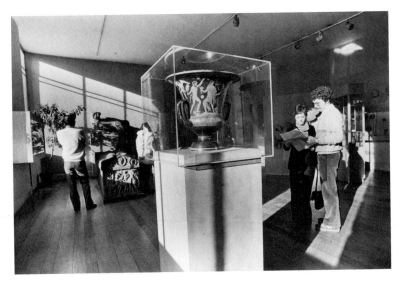

Wide-angle lenses show a wide view, ideal whenever space is tight and you can't move far back from a subject. Above, a wide-angle lens showed this museum room from wall to wall. Their great depth of field also keeps everything in the scene sharp, including both near and far objects. See also the photograph on the opposite page.

Wide-angle lenses can distort objects close to the lens and can exaggerate perspective. Objects closer to the lens appear much larger than objects farther away. With a wide-angle lens you can get so close to foreground objects that they can very easily be accidentally or deliberately distorted. Below, with the lens used close to the vase, it looms larger than the people nearby. Compare the size of the vase and people in the photographs.

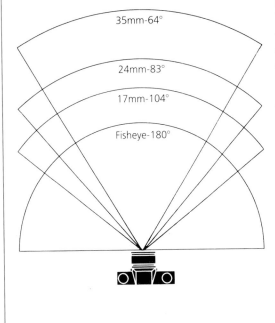

35mm-64°
24mm-83°
17mm-104°
Fisheye-180°

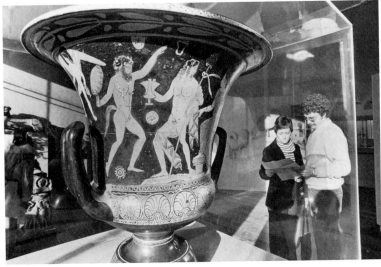

Donald Dietz

Ulrike Welsch

A telephoto view: Long focal length

A long-focal-length or telephoto lens, 85mm or longer, acts somewhat like a telescope: it magnifies the image of your subject. This lens is especially useful when you can't get close to your subject—or don't want to. Longer focal length lenses are ideal for wildlife, portrait, and candid photography, whenever your getting close to the subject might disturb it.

Long lenses have shallow depth of field and require careful focusing. Also, they visually compress space, making objects in a scene appear closer together than they actually are.

The primary drawback of long lenses is their relatively small maximum apertures, frequently f/3.5 or smaller. These small apertures may require a slower shutter speed and since a long lens magnifies movement, just as it magnifies the subject, you may have to use a tripod instead of being able to hand-hold the camera. Faster lenses are available but usually at a sizable increase in cost, size, and weight.

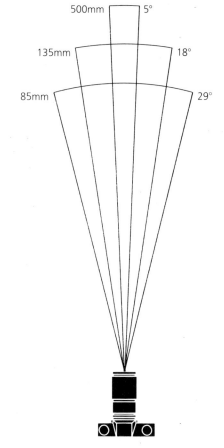

Portraits with a long lens

A medium-long lens (85mm to 135mm) is an excellent portrait lens, especially for head-and-shoulders portraits. You can photograph from about 6 ft. (1.8 m.) from the subject with a lens of this type and still fill the film frame with the subject. This distance eliminates the exaggerated perspective caused by working very close to a subject with a shorter focal length lens. It also helps relax your subjects if they get uneasy, as many people do, when a camera comes close.

Short lens

Long lens

Willard Traub

A long lens, which is commonly used from relatively far away, can make objects appear to be crowded together. This is actually due to the distance from the subject, not the focal length of the lens, but the effect is easy to get with a long lens.

Ulrike Welsch

110

Lens converters

Lens converters, sometimes called tele-extenders or tele-converters, can inexpensively double or triple the focal length of your lens. A 2X lens converter, when inserted between the camera body and the lens, doubles the focal length of the lens it is used with; a 3X triples it. With one 2X and one 3X converter, a single 35-50mm zoom lens would give you a range of focal lengths from 35mm to 150mm. Lens converters can be used with a variety of lenses, but the best ones are designed to match with certain specified lenses.

Lens converters do have a few drawbacks. Depending on their quality and your own criteria for sharpness, you may find that they soften the image slightly. You cannot use lens converters with shutter-priority or programmed automatic exposure because their placement between the camera body and the lens interrupts the camera's ability to set the lens aperture automatically. However, you can use lens converters in aperture-priority or manual mode.

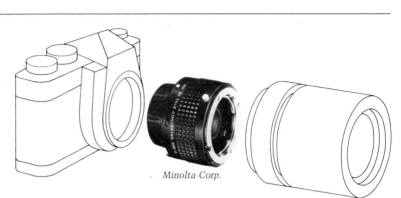

Minolta Corp.

50mm

With 2X converter

With 3X converter

Lens and lens converter combinations

Here are some examples of the effects lens converters can have when used in combination with common focal length lenses.

Lens focal length	With tele-converter	New focal length(s)
50mm	2X	100mm
50mm	3X	150mm
100mm	2X	200mm
100mm	3X	300mm
200mm	2X	400mm
200mm	3X	600mm
Zoom lenses:		
35-50mm	2X	70-100mm
35-50mm	3X	105-150mm
50-135mm	2X	100-270mm
50-135mm	3X	150-405mm
135-180mm	2X	270-360mm
135-180mm	3X	405-540mm

200mm

With 2X converter

With 3X converter

Fredrik D. Bodin

An extra lens and matched lens converters can relatively inexpensively increase the variety of focal lengths you have available. In this series of photographs the photographer used only one 50mm and one 200mm lens and a pair of lens converters (2X and 3X).

Zoom, macro, and macro-zoom lenses

One of the biggest advantages of the 35mm SLR can at times also be a disadvantage. It's great to be able to change lenses for different effects, but carrying an assortment of lenses can build up more bulk and weight in your camera bag than you may want to lug around. You can, however, add multi-purpose lenses to your system to increase your creative control without making your load excessive. For example, a macro lens combines the normal use of a lens with the ability to focus it very close to get large images of small subjects. A zoom lens allows you to choose any focal length within the range the lens is designed for. Macro-zoom lenses combine the freedom of changing focal lengths with the added advantage of close focusing, similar to macro lenses.

Zoom lenses have a collar you rotate or push to change the lens' focal length. Some zoom lenses have to be focused when you change focal lengths, but lenses of better design need be focused only once. As long as the distance doesn't change between you and your subject, they will remain in focus through their entire range of focal lengths.

Zoom lenses vary widely in their focal length ranges; some cover the short-to-normal focal length range (35-50mm), others the medium-long range (80-150mm), and still others the long-to-very-long focal lengths (200-600mm). Zoom lenses are somewhat heavier, bulkier, and more expensive than a single lens of fixed length, but obviously less so than the total of the several fixed-focal-length lenses needed to cover the zoom's focal length range.

With a zoom lens you can make a variety of views of the same scene without changing your position.

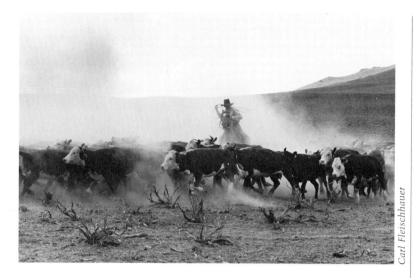

Carl Fleischhauer

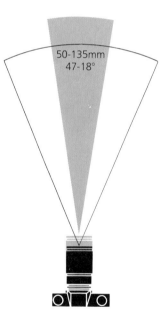

50-135mm
47-18°

Zooming during an exposure

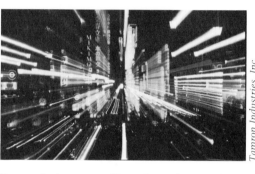

Tamron Industries, Inc.

One technique possible only with a zoom lens is to change the focal length of the lens during the exposure. The expanding blur that results can introduce an interesting feeling of motion, even in a non-moving scene.

Lens For maximum effect, use a lens that has a range of at least 2 times the shorter focal length, for example, a 75–150mm or 24–50mm zoom.

Shutter speed Make sure the shutter speed is slow enough for you to move the zooming ring a significant amount during the exposure. You might start with a shutter speed of 1/2 to 1/4 sec., then build up to faster speeds as you get comfortable with the maneuver.

Procedure Begin the zoom just before you release the shutter. Then continue smoothly zooming during the exposure. Mounting the camera on a tripod will help provide a steady support. Tripping the shutter with a cable release may make it easier for you to simultaneously release the shutter and zoom.

Do you want to be able to take an overall view of a scene, then move in close to isolate small details? **Macro lenses** are popular because they allow you this freedom without your having to change lenses. Macro lenses have a fixed focal length, usually 50-55mm or 100mm. They are mounted in a lens barrel that can be extended farther than normal; it is this extra extension that lets you focus close up if you want to. A macro lens of 50mm focal length will photograph an object so that it appears on the negative or slide up to 1/2 of actual life-size (1/2X). With a simple close-up extension tube, the magnification increases even more, to 1X (life-size). (For more on close-ups, see pp. 140-147.)

Macro lenses tend to be relatively slow speed; that is, they open to a relatively small maximum aperture. A typical maximum aperture for a 50mm macro lens is only f/3.5. Macro lenses are designed to eliminate the optical aberrations inherent at close focusing distances, and one way to do this is to utilize only the more optically perfect central portion of the lens, rather than opening wide across the entire lens diameter.

Macro-zoom lenses combine features of both zoom and macro lenses. These popular lenses have both close-focusing capability and a choice of focal lengths. One moment you can be photographing an overall landscape, the next isolating a building in the scene and the next a small detail that catches your interest—all without having to physically change your lens. Like zoom lenses, macro-zooms are available in a variety of focal length ranges. Some macro-zooms are more accurately "close-focusing" zooms. They produce magnifications of only about 1:3 to 1:4 (1/3 to 1/4 life-size), rather than the 1:2 (1/2 life-size) magnification of a fixed-focal-length macro lens.

Special-purpose lenses

Special-purpose lenses usually serve a specific application and are thus not in great demand except by photographers whose work in a given specialty warrants their use. This relatively small market restricts the large manufacturing runs that help reduce costs. Fish-eyes are probably the most popular and least expensive of these special-purpose lenses.

A **fish-eye lens** has an extremely short focal length (17-18mm) and a very wide angle of view (180°). Its depth of field is so great that you may not have to focus it at all; objects at virtually any distance from the lens are sharply focused. Due to unavoidable spherical aberrations in fish-eye lenses, all straight lines not radiating toward the center of the picture appear bent. This is what gives a fish-eye shot its characteristic look (see illustration this page, top). Some fish-eye designs produce a round image inside the rectangular film format; other designs produce an image that fills the rectangular frame. A fish-eye lens attachment turns an ordinary lens into one that gives a fish-eye view, if you prefer not to invest in a separate lens.

Perspective control or **shift-and-tilt lenses** can control the perspective in your images and are especially valuable in architectural photography. If you have ever tried to photograph a tall subject, like a building, from close up, you probably discovered that you either had to move back to get the entire building in the scene or you had to tip your camera back. Moving back makes the subject smaller and increases the amount of empty foreground in the scene. Tipping the camera back makes the vertical lines in the building converge toward the top of the image, an effect that can make the building appear to be leaning backwards. A lens with perspective control lets you keep the entire subject in the image and at the same time shift and/or tilt the lens relative to the image to eliminate empty foreground in the scene and prevent convergence of vertical lines.

Fredrik D. Bodin

Fredrik D. Bodin

Mirror or **catadioptric ("cat") lenses** (top) use glass lens elements and a mirror to focus the image. The resulting lens, usually of very long effective focal length, is smaller and lighter than a lens of a similar focal length using only glass elements.

Mirror lenses have a fixed aperture that cannot be changed. For this reason they cannot be used in shutter-priority automatic mode, where you choose the shutter speed and the camera selects the best aperture. With the mirror lens' fixed aperture the camera cannot vary the aperture to compensate for changes you make in the shutter speed. However, you can use the lens in aperture-priority automatic and manual modes. You can also decrease the aperture by adding neutral density filters, and some mirror lenses have a built-in filter slot for this purpose. This feature allows some exposure control, although a mirror lens already has a rather small maximum aperture to begin with, usually f/8 or f/11.

A mirror lens gives a ring shape to out-of-focus highlights rather than the disk shape produced by a normal lens. This is due to the front mirror that is part of the lens design.

Soft-focus lenses (bottom) produce soft, diffuse, relatively low-contrast images that give scenes and portraits, especially in color, a romantic, almost dreamlike quality. A UV or 1A filter with a thin layer of Vaseline or a soft-focus filter will give a somewhat similar effect at a much lower cost. A soft-focus lens, however, may let you vary the degree of softness. You cannot create a soft-focus effect simply by having the image out-of-focus. A soft-focus image has definition and detail that an out-of-focus one lacks.

Apochromatic lenses (not illustrated) produce a minimum of chromatic aberration and so an extremely sharp image. One of the main problems in lens design is color correction. Different colors are brought into focus at different points on the film, and the result is an image that is not perfectly focused. Using a smaller lens aperture is one way to reduce the effects of this chromatic aberration. But for exacting and critical results, photographers choose an apochromatic lens that contains elements made with calcium fluoride or lithium fluoride. When light passes through lens elements made from these materials, all colors of light in the image are focused closer to the same point on the film.

Ulrike Welsch

David B. Brooks

Perspective: How a photograph shows depth

A photograph can appear to compress space so that objects seem closer together than one expects. Another photograph of the same scene can seem to expand space so that objects appear farther apart than normal. These apparent distortions in perspective—the appearance of depth in a photograph—are often attributed to the focal length of the lens being used but are actually caused by the distance of the lens from the subject.

A view of a city photographed from a relatively far distance using a long-focal-length lens makes buildings, street signs, traffic, and so on, appear close together, the so-called telephoto effect. The same scene photographed up close with a wide-angle lens makes objects appear spread out, with near objects much larger than distant ones, so-called wide-angle distortion. Although these effects are named for the lenses that tend to produce them, they are not caused by the lenses themselves, but by the distances at which the lenses are typically used—a long lens from far away and a short lens from up close.

Ulrike Welsch

▲ Telephoto effect A long-focal-length lens used far from a subject compresses space. Size differences and the impression of depth are minimized because the lens is relatively far from both foreground and background.

◄ Wide-angle distortion A short-focal-length lens used close to a subject magnifies objects near the lens in relation to those that are far from it. The result can be a grotesquely —or here, humorously—distorted subject.

Ulrike Welsch

Focal length and perspective

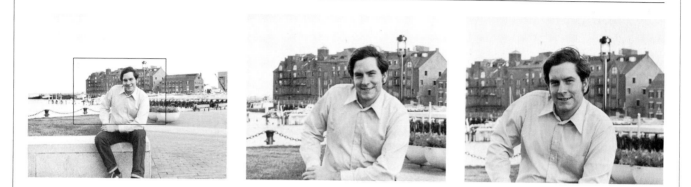

Changing focal length does not change perspective

Changing the focal length of the lens you use doesn't change the perspective (the relative size of objects) in your photographs, as demonstrated in this series of photographs. The same scene was photographed first with a short-focal-length lens (left) and then with a long-focal-length lens (middle). The central area of the first image (indicated by the dotted lines) was then enlarged (right) so that it matched the area contained in the picture taken with the long lens. The middle and right photographs show that the perspective is identical although the pictures were taken with lenses of different focal lengths.

Donald Dietz

Changing camera-to-subject distance does change perspective Camera-to-subject distance affects perspective, as shown here. The same lens was used for all three photographs. The camera was at the greatest distance from the subject in the first picture (left). The camera was moved closer for the second (middle) and even closer for the third (right) pictures. The subject appears to increase in size relative to the background as the camera is moved closer. This changing relationship between the size of objects in the foreground and background creates the difference in perspective.

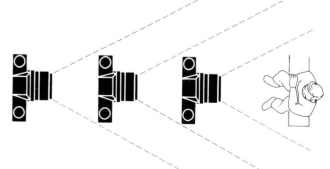

6 Filters and lens attachments

Every photograph is a record of reflected light. Film, however, doesn't always record the reflected light the same way we see it. For example, black-and-white film is more sensitive to ultraviolet light than the eye is. Filters and other lens accessories can be screwed into the threads in the front of the lens to change the light passing through the lens so that it has the effect on the film that you want. Filters can change the light so that it better matches the characteristics of the film being used, making the image look like the original scene. Or filters can be added to distort the light in such a way that the picture looks different from the scene, perhaps even unreal.

Filters and exposure

Many filters work by absorbing part of the light reflected by the subject. When this light is absorbed by the filter, the total amount of light available to expose the film is reduced. To keep the exposure correct, the shutter speed must be slowed or the aperture widened to compensate for the light absorbed by the filter.

Cameras with through-the-lens meters and automatic exposure systems meter the light after it has passed through the filter, so this exposure compensation happens automatically, perhaps without your even being aware of it. You should, however, remember that many automatic exposure systems increase the exposure either by lowering the shutter speed (in aperture-priority mode), which increases the likelihood of blur, or by opening the aperture (in shutter-priority mode), which reduces your available depth of field.

When you use a hand-held meter, compensation isn't automatic because you meter light before it passes through the filter. The exposure increase given for each filter tells you how much to change the exposure to keep it correct.

The information provided in instructions packed with the filter or elsewhere may be given in one of two ways: either as stops of additional exposure needed or as a filter factor which tells how many times the exposure must be increased. Stops of additional exposure are easy to use since a 1-stop increase means just that. For example, you might widen the exposure 1 stop, from f/11 to f/8, or slow the shutter speed 1 stop from 1/125 to 1/60 sec. (See pp. 14-15 if you want to review the relationship between stops and shutter speeds and aperture settings.)

Using the filter factor is slightly more difficult because it must first be translated into stops. A filter factor of 2 means that the exposure must be doubled, or changed 1 stop. A filter factor of 4 means that it must be quadrupled, a change of 2 stops. To make these translations from filter factors to stops, use the table at right. Note that when two filters are used together, their filter factors are multiplied, not added. For example, if you use a filter with a factor of 2 plus a filter with a factor of 4, the new factor is 8, not 6.

Filter factor	Number of stops increase	Change in aperture	Change in shutter speed
1	no change		
1.5	2/3	Open 2/3 stop. For example, from f/8 to not quite f/5.6	
2	1	Open 1 stop or	Change to next slowest speed.
3	1 2/3	Open 1 2/3 stop. Or, open 2/3 stop and	Change to next slowest speed.
4	2	Open 2 stops. or Or, open 1 stop and	Change to two settings slower. Change to next slowest speed.
6	2 2/3	Open 2 2/3 stops. Or, combine shutter speed and aperture changes as above.	
8	3	Open 3 stops. Or, combine changes as above.	
16	4	Open 4 stops. Or, combine changes as above.	

A lens hood prevents flare

When light enters a lens most of it goes where it should, directly to the film where it forms the image. However, if a strong light source, like the sun, is included in a picture or if light from such a source strikes the lens directly, part of this light scatters, bouncing off the interior walls of the lens. In extreme cases, it creates a light area shaped like the lens diaphragm in the image. More often, the effects are less obvious but still harmful by weakening colors and lowering contrast. You can greatly reduce the effects of lens flare if you use a lens hood.

Donald Dietz

This photograph shows the effects of lens flare caused by light shining directly on the lens surface. The more common effect is lowered picture quality due to loss of color saturation and contrast.

A lens hood blocks stray, nonimage-forming light that might otherwise enter the lens and reflect off the interior walls onto the film. Lens hoods are helpful at all times but are needed most when the camera is pointed in the general direction of a strong light source.

Willard Traub

Be sure the lens hood you use matches the focal length (and so the angle of view) of your lens. One that is too narrow can cause vignetting. Often the vignetting isn't this noticeable, but the corners of the image may still be slightly darker than they should be.

Tips Using filters and lens attachments

Using filters and other lens attachments is very simple, because through-the-lens metering simplifies exposure control. However, keep in mind the following:

Filter size is important for two reasons. In many cases different focal length lenses have different thread sizes so the same filter may not fit all of your lenses. Try to plan ahead and anticipate the largest filter size you will need and buy that size. With a set of step-down rings you can adapt the larger filter to smaller lenses. Using lens attachments that are too small may cause vignetting, blocking light from the corners of the image so corners appear dark in the print or slide. Some filter systems use unthreaded glass or plastic filters that slide into a mount attached to the lens.

Keep the number of filters you use at any one time to a minimum. Each filter adds air-to-glass surfaces that cut the quality of the image and increase the likelihood of flare, an overall and usually unwanted fogging of the image. Using combined filters may also require an exposure increase that reduces your shutter speed or increases your aperture drastically. For instance, a red filter and a polarizing filter in combination may require an exposure increase of as much as 4 stops.

Colored filters designed for black-and-white film can also be used with color film if you want to change the overall color cast of the photograph. An orange filter used when photographing a landscape will give an orange landscape which might be an interesting effect, for example, in a desert scene.

The effect of filters can be a little hard to anticipate. It helps to look at the scene through the filter before mounting it on the camera. Although the film will respond to the light somewhat differently than your eye does, you will at least get an idea of the effect the filter has.

Filters are in the image light path so they affect the quality of the image just as the lens does. An expensive lens with a cheap filter is a waste. Buy the highest quality filters you can afford and keep them clean and unscratched.

Filters for black-and-white film

Modern panchromatic black-and-white film is sensitive to all colors of light, but does not respond exactly as the eye does. The human eye, looking at a colorful scene, separates objects based on their tones (lightness or darkness) and color, but film sees only the tones. This loss of color can produce photographs in which objects do not appear similar to the way we see them in the real world. Filters can help adjust this effect by controlling the portions of the light spectrum reaching the film.

Contrast filters are used when objects of different colors would otherwise record as the same tone in a black-and-white photograph. Red apples and green leaves, for instance, are easily separated visually by the human eye even though they are of equal brightness. In black-and-white film the tonal distinction between the two can be less clear. Filters can make one or the other lighter or darker to restore the visual separation (see opposite).

Correction filters correct the overresponse of film to certain colors, so that the scene on film looks more like that perceived by the eye. Panchromatic film records all colors but is more sensitive to ultraviolet (which is unseen by the eye) and to the blue end of the spectrum. A clear blue sky, for instance, reflects a great deal of blue and ultraviolet light, causing it to overexpose the film relative to other portions of the scene. A blue sky photographed in black-and-white without filtration may be overexposed and too light, not at all the way it appears in nature. Using a filter to cut the blue and ultraviolet light gives a photograph a darker, more natural-looking sky and makes clouds stand out more clearly (see right).

When determining the right filter to use with black-and-white film, try looking at the scene through the filter you are considering. Objects in the scene that are lightened or darkened by the filter will most likely be lightened or darkened in the photograph.

Darkening the sky

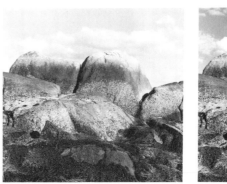
Without filter

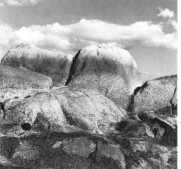
With red filter

Sam Laundon

To darken the sky in a black-and-white photograph, add a yellow, orange, or red filter (see chart below)—if the sky is blue. These filters work by absorbing some of the blue light in the scene and so darkening blue tones in the picture.

Clear blue skies can be darkened more than those obscured by whitish haze, mist, or heavy clouds. The sky is often almost white at the horizon, even if quite blue overhead; filtration affects the blue, not the white. Overcast skies cannot be darkened at all with ordinary filters.

Exposure also affects the way filters darken the sky. Often slight underexposure increases the effect of a filter used with black-and-white film, while slight overexposure decreases the effect. The reason is that filters don't block or absorb all of the light they are designed to reduce. Longer exposures allow more of this light to reach the film, reducing the filter's effect on the image.

Polarizing filters can darken the sky in either a black-and-white or color picture but are affected by the direction in which they are used relative to the sun. They work best at right angles to the sun. They are least effective when pointed toward or away from the sun. More about polarizing filters on pp. 124-125.

	Type of filter	Exposure increase
To darken blue sky, reduce bluish haze (in order of increasing effect)	Yellow (#8)	1 stop
	Deep yellow (#15)	1 2/3 stops
	Red (#25)	3 stops
	Deep red (#29)	3 2/3 stops
	Deep red (#29) with polarizing filter	Varies
For portrait with blue sky background, darkens sky but maintains natural skin tones	Yellow-green (#11)	2 stops

Controlling contrast with filters

Objects of different color but of equal brightness in a scene will not necessarily be recorded the way you want in a photograph. A filter can lighten or darken part of a scene, either to record it naturally, the way the human eye sees it, or to change it for impact.

Very rarely are colors in nature pure; usually they are a mixture of colors. A leaf, for instance, isn't pure green, but may be a combination of green, brown, red, yellow, and other colors. For this reason, filter effects are not entirely predictable, but you can make close approximations once you understand the basic principles. The most basic of all principles is that filters will lighten a color similar to the color of the filter and darken the color that is opposite to it. The filter does this by absorbing the color in the scene that is the opposite of its own color. Here is the way filters affect common colors and situations.

Blue colors Panchromatic film is more sensitive to colors at the blue end of the color spectrum and for that reason overresponds to parts of a scene reflecting ultraviolet and blue light. Objects that reflect these colors will appear in the photograph lighter than they appear to the eye. Filters can partially absorb these colors, darkening them in the photograph. The darker the filter, the more light it will absorb and the more it will darken objects in the photograph.

Green colors Often foliage appears slightly darker than we would expect when it is photographed on black-and-white film without a filter. A yellow or yellow-green filter absorbs the red and blue portion of the reflected light, making the foliage appear more natural in the photograph. If you want to lighten the foliage more, try a green filter.

Differentiating colors Sometimes you may want to change the contrast between two objects of different colors. For example, a red flower and a green leaf are clearly of different colors in nature but will record on black-and-white film as very similar tones. A filter can darken or lighten one of the two objects. Use a filter of the same color as the object you want to lighten (or use a color opposite to the color you want to darken).

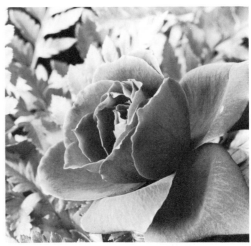

Without filter

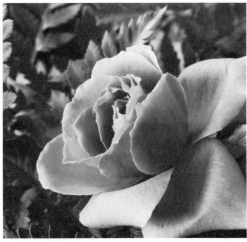

With red filter

With green filter

Sam Laundon

Filters for black-and-white film

	Type of filter	Exposure increase
For blue subjects, such as marine scenes under blue sky:		
Darken slightly	Yellow (#8)	1 stop
Natural	Deep yellow (#15)	1 2/3 stops
Darken more	Red (#25 or #29)	3 (to 3 2/3) stops
Lighten	Blue (#47)	2 2/3 stops
For green subjects, such as foliage, grass:		
Natural	Yellow (#8) or Yellow-green (#11)	1 or 2 stops
Lighten	Green (#58)	2 2/3 stops
For red subjects, such as red flowers or fruit:		
Darken	Green (#58)	2 2/3 stops
Lighten	Red (#25)	3 stops

Filters for color film

Filters can be used with color film to increase color saturation, match film to different light sources for natural effects, remove distracting color casts or reflections, and alter the colors or the image itself for unusual effects. The range of applications is limited only by your imagination and willingness to experiment.

UV or skylight filters remove excess ultraviolet light that weakens colors, creates a hazy appearance in landscapes, and causes blue casts in color pictures taken in open shade or on overcast days. Some photographers always leave one in place on the lens because it also protects the sensitive surface of expensive lenses from accidental damage.

Color correcting filters (see chart at right) match films to different lighting situations. Tungsten-balanced film used outdoors will be too red, daylight film used under tungsten light will be too blue, and any film used in fluorescent light will be too green unless you use a correcting filter.

See also neutral density filters (opposite) and polarizing and special effects filters on following pages.

Filters for color film

	Type of filter	Exposure increase
To get a natural color balance with daylight-balanced film exposed in tungsten light.	80A (blue) with photolamps	2 1/3 stops
	80B (blue) with ordinary tungsten bulbs	2 stops
To get a natural color balance with tungsten-balanced film exposed in daylight.	85A (amber) with Type A film	2/3 stop
	85B (amber) with Type B film	2/3 stop
To get a natural color balance with fluorescent light.	FL-B with tungsten-balanced film	1 stop
	FL-D with daylight-balanced film	1 stop
To reduce the bluishness of light on overcast days or in the shade. To penetrate haze. Used by some photographers to protect lens.	1A (skylight) UV (ultraviolet)	no increase no increase
To decrease the bluishness more.	81A (yellow)	1/3 stop
To decrease the red-orange cast of light at sunset and sunrise.	82A (blue)	1/3 stop
To balance film precisely as recommended by film manufacturer.	CC (color compensating): R (red), G (green), B (blue), Y (yellow), M (magenta), C (cyan)	Varies. See manufacturer's instructions.
To experiment with color changes.	any color	Varies according to effect desired

Marine scenes photographed in color may appear too blue due to the large amount of bluish reflections from water and sky. A 1A skylight or UV ultraviolet filter will remove some of these blue tones so that colors look natural.

Ulrike Welsch

Special-purpose filters

Most filters absorb some of the colors of the light spectrum while passing others unchanged. This unequal absorption changes the way the colors are recorded by the film. Sometimes, however, you may want a filter that reduces the amount of light entering the camera while leaving the color balance unchanged: use a neutral density filter. These filters, used with either color or black-and-white film, allow you to use larger apertures or longer shutter speeds without overexposing the film. Larger apertures reduce depth of field for selective focus and the longer shutter speeds deliberately blur motion.

Neutral density filters are available in a variety of densities which, when used singly or in combination, allow for a great deal of control over exposure settings.

▶ *This Nova Scotia water wheel was recorded with the aid of a neutral density filter. The photographer had made an exposure at 1/30 sec. but wanted to use an even slower shutter speed. He was already using his lens' minimum aperture, so he couldn't stop down the lens aperture any more to compensate for a slower shutter speed. A 0.60 neutral density filter on the lens decreased the brightness of the light reaching the film and required a 2 stop increase in exposure. The photographer slowed the shutter speed 2 settings (2 stops) to 1/8 sec., and got the effect of a racing blur that he wanted.*

Previsualizing colors in black-and-white

It is often difficult to imagine what a scene that is bright with color will look like when reduced to tones of gray in a black-and-white photograph. Some colors will look darker than they actually are, while others will look lighter.

If you like, you can use a Wratten #90, dark grayish-amber, monochrome viewing filter as a guide to visualizing how a scene will look in black-and-white. When a scene in daylight is viewed through this filter, the colors are reduced to tones that visually approximate those that will be in the black-and-white final print. Buy the filter at your local camera store or order it directly from the Eastman Kodak Company.

Neutral density filters

Filter density	% of light absorbed	% of light transmitted	Increase in stops of exposure required
0.10	20	80	1/3
0.20	37	63	2/3
0.30	50	50	1
0.40	60	40	1 1/3
0.50	68	32	1 2/3
0.60	75	25	2
0.70	80	20	2 1/3
0.80	84	16	2 2/3
0.90	87	13	3
1.00	90	10	3 1/3
2.00	99	1	6 2/3
3.00	99.9	.10	10
4.00	99.99	.01	13 1/3

Fredrik D. Bodin

Polarizing filters

Polarizing filters are one of the most useful filters used in photography. They will darken a blue sky when used with either black-and-white or color film. They can also remove obscuring reflections from nonmetallic surfaces such as windows and water, allowing the camera to show what's behind these surfaces. When used with color film they enrich the color saturation in a scene by reducing minute reflections that soften colors in the photograph.

Increasing color saturation

If you were to look carefully at a subject you were about to photograph and examine small portions of it close up, you might notice that some points are shinier than others. Drops of moisture or sap, blades of grass or leaves at certain angles to the sun, glossy paint, and many other small shiny surfaces all reflect more light than other areas of the scene. In certain situations, reflections can adversely affect the intensity and richness of colors in a photograph, giving them a washed-out look. A polarizing filter can reduce the amount of this reflected light, allowing the film to record more saturated and brilliant colors.

See for yourself Polarizing filters and exposure

Since a polarizing filter works by blocking light not aligned in the plane that the filter passes, the total amount of light entering the camera is reduced. The amount of reduction varies with the orientation of the filter. To see this effect, hold the filter up to a blue sky while standing at right angles to the sun (with it over one of your shoulders). Rotate the filter and you will see the sky darken as the amount of light passing through the filter is reduced. If you do the same thing with the filter mounted over the lens and watch through the viewfinder, you will not only see the sky darken but also see the exposure indicators in the viewfinder display change settings as the camera opens up or stops down to compensate for the changing light levels passing through the filter.

How a polarizing filter works

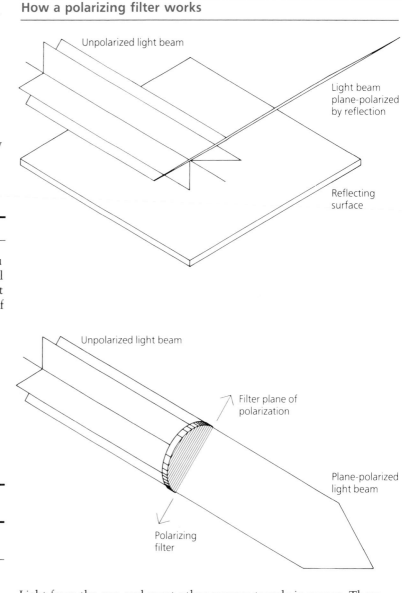

Light from the sun and most other sources travels in waves. These waves are numerous, intermixed, and not aligned along any single plane. When they strike a highly reflective surface (other than a metallic one) most of the waves that are reflected are oriented along the same plane. Most of the waves oriented in other planes are absorbed or transmitted. Since the reflected light is almost all oriented in the same plane, the light is called *polarized*.

A polarizing filter is something like a fence with narrow slots between the slats. Light waves oriented in the same plane as the openings can easily be passed through, but light oriented in other planes will not do so. This ability to block light traveling in all but one plane gives the polarizing filter the ability to remove reflections, darken skies, and improve color saturation. If you rotate the filter, so that its screen is at right angles to the plane in which the reflected light is traveling, the polarized light from the reflections is blocked and cannot reach the film. Enough unpolarized light reflecting from other surfaces is unaffected to expose the rest of the image.

Darkening the sky

Without polarizing filter

Donald Dietz

With polarizing filter

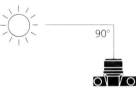

90°

Removing reflections

Without polarizing filter

Alan Oransky

With polarizing filter

30-40°

The sky, even when it is at its clearest, is full of water vapor and small dust particles that reflect and partially polarize light passing through the atmosphere. You can darken blue sky, without affecting the tones or colors of other parts of the scene, by using a polarizing filter to block the polarized portion of this reflected light. The remaining light reaching the film will produce deeper and more saturated colors, free from the glare caused by reflected light.

A polarizing filter has the most pronounced effect on the sky when used at right angles to the sun, rather than pointed toward or away from the sun. You can see this for yourself by rotating the filter as you look through the viewfinder at a scene and point the camera at different portions of the sky. The effect will be greatly diminished if the sky is overcast or hazy.

When sunlight reflects off a nonmetallic, shiny surface it becomes partially polarized. Only waves vibrating in one plane are reflected; those vibrating in other directions are partially absorbed. When a polarizing filter is positioned at about a 30-40° angle to the reflecting surface, it will block most of the reflected (polarized) rays. Light waves vibrating in different directions are allowed to pass through to the film. Reflections from the shiny surface are reduced, allowing you to see behind the surface of glass and water.

You can explore the effects of a polarizing filter on a particular scene by looking through it while rotating it and changing your position. You will find some positions and filter angles where the reflections are almost entirely eliminated. In other positions or with other filter angles, the reflections will not be greatly affected.

Lens attachments for special effects

Pink elephants or green skies, rainbows you create or multiple repeating images—and no morning-after hangover. Almost no image distortion is beyond your reach if you have an assortment of inexpensive special effects attachments.

High-quality lenses are designed to focus light from a scene onto the film as sharply as possible by refracting (bending) all portions of the light spectrum equally so that all of the colors come to focus at the same point on the film. The purpose of most special effect filters is to refract the light differently so the character or color of the image changes.

Effect		Without attachment	With attachment
Prism 6X (parallel) The subject is repeated six times with one large image and five adjacent, parallel ones.			
Close-up prism Makes a close-up of a small object while at the same time doubling it—side by side, one above the other, or at parallel angles.			
Split field or bifo Part of the filter surface is a close-up lens and the rest is clear glass. Thus objects at close range (approx. 24 cm or 10 in.) and those far away can be focused sharply at the same time.			
Eccentric spot lens An off-center split field allows both a distant object and a close one to be focused sharply.			
Cross screen (four-ray, six-ray, eight-ray) Each point source—a point of bright light or bright reflection—radiates rays of light.			
Spectra (4X, 8X) Each point source of light radiates starlike beams in three spectral colors. Especially visible in night scenes.			
Spectra (2X) Parallel beams of spectral colors emanate from every point light source.			
Spectra (48X) Petal-shaped spectral beams around each point light source.			
Spectra (72X) Color spectra emanate from each point light source.			

126

Do-it-yourself filters

You can make your own special effects filters from simple materials. The results aren't as predictable as well-made lens attachments, but they are fun to experiment with. Here are some ideas to try.

• For soft-focus effects use a piece of nylon stocking tightly stretched over the lens and held in place with a rubber band.

• Lightly coat a UV or 1A filter with a very thin layer of Vaseline to diffuse the image. Leave an uncoated clear area in the middle of the filter so the image is sharp in the center and gradually gets softer toward the edges.

• Photograph a portrait or still life through a window screen for similar soft-focus effects. Experiment by using selective focus to keep the screen either sharp or out of focus.

Effect		Without attachment	With attachment
Soft focus Softens details and can make bright highlights shimmer and gleam.			
Spot lens A sharp central field becoming progressively hazy at the edges. For emphasizing details of a subject.			
Prism 3X (triangular) Triangular prism without a central image.			
Prism 3X (parallel) Multiple prism with three parallel fields. Reproduces the subject side by side, tilted, or one above the other.			
Prism 5X A central field and four marginal sectors give a five-image reproduction.			
Prism 6X Image is reproduced six times with five images arranged around a central field.			
Color prism 3X (parallel) Three parallel fields with colors changing gradually from yellow to green, blue, and purple.			
Color prism 6X Pentagonal arrangement of five fields around the center field, with same color changes as above.			

B + W Filterfabrik

7 Automatic flash

Automatic electronic flash is so convenient and easy to use that you usually have to do little more than attach it to your camera, make a few minor adjustments (sometimes none at all), and shoot. Flash lighting has certain characteristics that can make a difference in the way your pictures look. For example, if you make all your flash pictures with the flash unit attached to the bracket on the top of your camera, all the pictures will have the "flat" lighting typical of flash-on-camera shooting (see photo at right, top). Other options for positioning the flash, however, may produce more interesting results. You will be able to use flash to better advantage as you become more familiar with its characteristics.

Ulrike Welsch

Top: Flash on camera, such as a flash unit attached to the camera's hot shoe, is convenient to use: everyplace you and the camera move, the flash moves with you. All flash-on-camera lighting looks very much the same—a flat, relatively shadowless light that minimizes surface textures and volumes. There is nothing wrong with this type of lighting; in fact, people who are concerned about their facial wrinkles will like the way it seems to make their skin look smoother. However, you can position the flash in other ways to produce a more rounded and textured effect, which often looks more attractive.

Bottom: Although the camera shutter speed used with flash is only 1/60 sec. (1/125 sec. with some cameras), the flash of light itself is so fast that it will easily record almost any moving subject sharply—even this bat feeding while in flight.

128

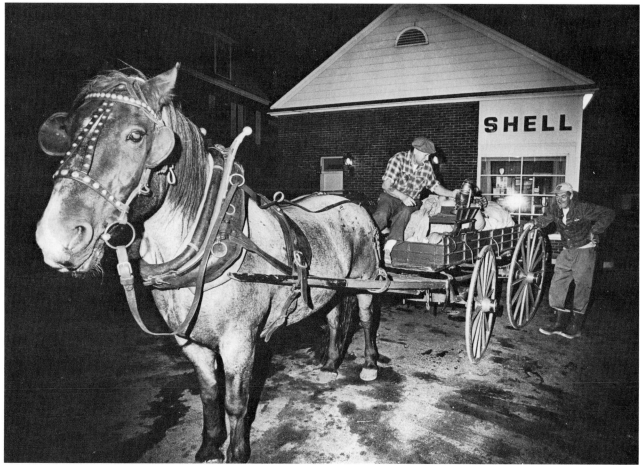

Ulrike Welsch

Flash light falls off (becomes dimmer) the
farther it travels. You can't see this when
the flash goes off—but you will when you
get your pictures back. Objects near the
flash will be lighter in a picture than objects
farther away. You can use this to advantage:
for example, at night you can isolate a sub-
ject against a dark background.

How automatic flash works

Flash photography has come a long way since the 19th century when a photographer had to ignite a tray filled with gunpowder to illuminate a scene. A modern automatic flash unit uses a permanent electronic tube that emits a short, intense burst of light. It combines this reuseable light source with a sophisticated light measuring and exposure control system.

Many electronic flash units are designed to mount into a hot-shoe bracket on top of the camera that supports the flash and connects the flash to the camera's shutter release. When the shutter release is depressed, the flash delays firing until the shutter is all the way open. Some units can be coupled to the camera with a synch cord, which makes the same electrical connection that the hot shoe does but lets you take the flash off the camera.

How a flash sensor works

There are two ways automatic flash exposure can be controlled. One system uses the camera's built-in light meter and automatic exposure system to measure light reflecting from the scene. The other system uses a sensor built into the flash unit itself. In either case, the flash unit stops emitting light as soon as the sensor registers enough light reflecting back from the subject to produce a correct normal exposure.

A system metering through the lens reads the area seen by the lens and so changes when lens focal lengths are changed.

A sensor built into the flash reads an area that is narrow and fixed regardless of the lens focal length being used. For this reason it reads only subjects located in the center of the viewfinder, especially with wide-angle lenses. Objects off to either side may be under- or overexposed since they are not metered by the exposure system.

Test button and light on some models can check if the subject is close enough to be adequately illuminated by the flash. When the test button is pushed the flash fires; the test light indicates if the light reflecting from the subject is sufficient.

The anatomy of your flash

Movable head can be tilted to bounce the light from the flash off a ceiling or an umbrella reflector. On some models the head can be swiveled to the side for bounce lighting from a wall.

Flash tube emits light and the **reflector** directs the light toward the subject. The reflector is usually designed to spread the light over a slightly wider area than that seen by normal 50mm focal length lens. If you want to use the flash with a shorter focal length than 50mm check your owner's manual to see if the flash has sufficient coverage or if you need to put a **diffuser** over the flash tube and reflector to spread the light over the larger area seen by the lens. If the flash coverage isn't sufficient, your photographs will have dark corners. Some flash units also have a **telephoto adapter** that narrows the beam of light to the smaller area seen by long-focal-length lenses. If you want to alter the color of light from the flash, you can sometimes buy ready-made colored **filters** to fit over the flash tube and reflector or you can construct them yourself from colored acetate.

Hot-shoe connection slips into the hot-shoe bracket on top of the camera. It physically supports the flash on top of the camera and also electrically links the two. With all units the hot shoe automatically connects the flash with the shutter release so that the flash does not fire until the shutter is open. With some flash units (called **dedicated** or **designated**), the connection may also set the shutter to the correct speed for use with flash and indicate in the viewfinder display when the flash is fully charged.

Sensor cell measures the light reflecting from the subject. It is connected to an automatic exposure system that shuts off the flash when the subject has been illuminated with sufficient light for a good exposure. Some cameras don't use a cell built into the flash; they use the metering cells and automatic exposure system built into the camera.

Synch cord connection allows use of a synch cord to connect the flash to the camera, so the flash can be used even when off the camera.

Exposure calculator determines the proper lens aperture to use in manual operation for various camera-to-subject distances or in automatic operation if the flash gives you a choice. Once you enter the film speed and esti-mate camera-to-subject distance, apertures are given for a variety of distances. The more powerful and sophisticated the model, the more aperture choices and distance possibilities there will be in automatic operation.

Battery compartment is opened to insert or remove batteries, which should always be removed when the unit is stored for a prolonged period. Alkaline batteries must be replaced periodically. Rechargeable nickel-cadmium batteries are available as an option with some units.

Thyristor circuitry recycles unused power, which conserves energy and shortens the time you need to wait between flashes.

Mode selector on some units selects either manual or automatic exposure control. On more sophisticated models there may also be a choice of power levels for different camera-to-subject distances.

Ready light indicates when the flash is charged and ready to be used.

Why shutter speed is important with flash

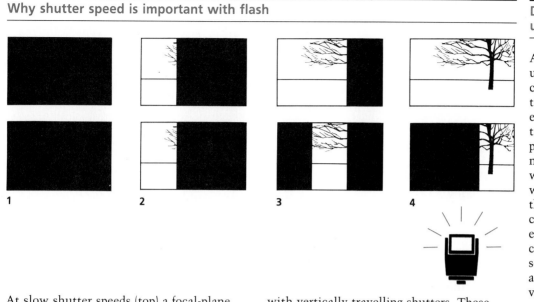

1 2 3 4

At slow shutter speeds (top) a focal-plane shutter first opens completely, then closes. At faster shutter speeds (bottom) it operates like a slit moving across the film. The burst of light from an electronic flash is so brief that it will expose the entire film image area only if the shutter is wide open when it fires. The fastest shutter speeds where the film is completely rather than partially uncovered during an exposure are usually 1/60 sec. with horizontally travelling shutters or 1/125 sec.

with vertically travelling shutters. These synchronization or synch speeds are the ones normally used with electronic flash. Faster speeds cause a black, unexposed area along the edge of the picture where it was covered by one of the shutter curtains when the flash went off. You can use slower shutter speeds but you risk a blurred exposure due to both ambient light and flash light illuminating the subject sufficiently to expose the film.

Dedicated flash units

A dedicated flash unit is designed to couple with one particular manufacturer's cameras, sometimes with one particular camera model. When used with the camera for which it is designed the flash automatically sets the camera's shutter speed control to the correct setting and lights up a ready light in the viewfinder display when the flash is charged and ready to be fired.

Step by step Using flash on automatic

Using an automatic electronic flash is very simple, but since operating details vary from unit to unit, check your unit's instruction manual before you shoot.

1 Mount the flash on your camera's flash hot shoe bracket. Set your camera shutter speed selector to its correct position for flash operation (certain flash units will do this automatically).

2 Set the applicable film speed into the flash unit.

3 Set the flash unit's mode selector (if it has one) to automatic.

4 Turn the flash unit on. When the camera viewfinder or flash unit's ready light signals ON, release the shutter. The flash will correctly expose the subject as long as it is within the flash unit's distance range.

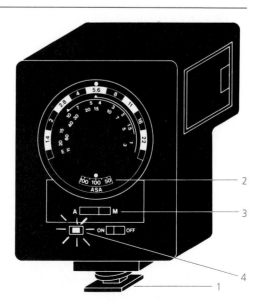

131

Manual control of flash exposures

How bright the light from a flash is when it reaches a subject depends on how far the light has to travel from the flash to the subject. The farther the subject is from the flash, the less light will reach it and so the less light will be reflected from the subject back toward the camera. The *inverse square law* describes the relationship between a subject's distance and how much light will fall on it from the flash. If the distance is doubled, only one-quarter the amount of light will reach the subject.

Flash exposures based on the inverse square law are affected only by the distance of the flash (not the camera) from the subject. Professionals often use either a very long synch cord or a flash slave unit (see p. 153) to position the flash closer to the subject. This illuminates the subject with more light and reduces the aperture size required to take the picture. All exposure calculations are based on the distance from the flash unit to the subject, regardless of where the camera is positioned.

The way it was Early flash

Early flash devices, used around the turn of the century, provided illumination by igniting flash powder, an explosive mixture of magnesium and other chemicals. The device shown here incorporated a container for the flash powder and a blower for dusting the powder across an open flame.

The inverse square law

The inverse square law describes changes in how much light will fall on the subject as the distance between the flash and subject changes. Because the light emitted by the flash expands as it moves farther from the camera, the same amount of light is spread over a larger area. Less light therefore falls on a subject of fixed size as the subject moves farther from the flash. As the distance is doubled, the amount of light falling on a given area is only one-quarter of the original amount. Conversely, when the distance is halved, four times as much light falls on a given area.

Because light gets dimmer the farther it travels from a flash unit, if the distance between flash and subject changes, you must also change your camera's lens aperture to get a good exposure. If the distance is doubled, open the aperture 2 stops to keep the exposure constant. If the distance is halved, stop down the aperture 2 stops to compensate. In automatic operation, the flash does this by itself. In manual operation, you must change the lens aperture before taking the picture.

When subjects in an image are located at different distances from the camera, the exposure will be correct only for those at one distance. If you are using your flash on automatic, it will normally expose the closest object best if that object is located more or less in the middle of the area metered by the automatic exposure system. Subjects located farther from the flash will be increasingly darker the farther they are from the flash. In some situations, manual operation of the flash may be best because you can set the correct exposure for objects at the distance you choose.

Fredrik D. Bodin

Step by step **Using a flash exposure calculator**

There is no standard exposure calculator design. Some are dials and others are sliding scales, but all work on the same general principles. One part of the calculator moves so that you can enter the film speed (ISO, ASA, DIN) being used. Then, the two scales are aligned to indicate the proper aperture to use depending on the distance of the subject. In a simpler type of calculator, you find your film speed on a fixed chart, then locate the correct aperture listed for various distances. Here is how to use the moving type of calculator step by step:

1 Align the movable part of the calculator so that the indicator points to the ASA of the film you are using.

2 Estimate or measure the distance of the subject from the camera. You can measure the distance by focusing on the subject and then reading the distance off the distance scale on the lens barrel.

3 Find this distance on the calculator scale and note the aperture opposite it.

4 Set this aperture on the lens and fire away. (Don't forget to set your shutter speed for flash. See p. 131.)

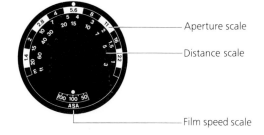

— Aperture scale

— Distance scale

— Film speed scale

David Dubuque

The "correct" exposure for a photograph may not be the one you want. Here the photographer set the flash for manual operation and massively overexposed the foreground subject (a man and the smoke from his cigarette) so that they became a strange poolside sight.

Using flash creatively

Your choices with flash may be to make its illumination obvious and noticeable in the print (right and below) or to unobtrusively raise the level of illumination in a scene that would otherwise be too dark for easy shooting (opposite).

Right: The photographer removed the flash from its hot-shoe bracket on the camera and positioned it below and to the right of the subject's face. The prominent shadow on the wall adds interest to the picture, and the light tones of the woman's face stand out against her dark hair and clothing and the shadow on the wall. A synch cord was used to make the electrical connection between the flash and camera.

Below: Most flash units illuminate an area about as wide as that seen by a 35mm lens. Here, the photographer used an even wider angle lens and, in addition, deliberately aimed the flash low in order to underexpose and darken the background.

Jean Shapiro

Colleen Chartier

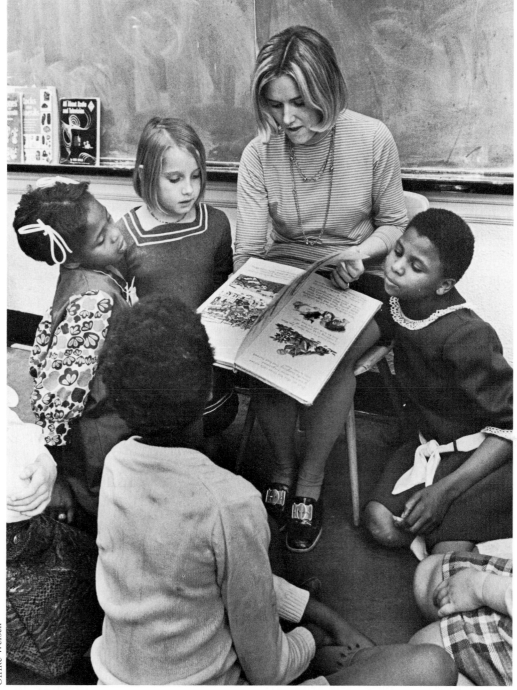

Ulrike Welsch

The light in this classroom was not quite bright enough to shoot at the fast shutter speed the photographer wanted to use to make sure that the children would be sharp even if they moved during the exposure. Rather than using direct flash on camera, the photographer bounced the flash light off the ceiling so that it resembled the existing room light. You can still use your flash on automatic with bounce lighting if the flash has a sensor that remains pointed at the subject while the flash head is tilted up.

Portraits with flash

Flash is a good source of light when you want to make portraits, particularly of children. The light from the flash is so fast that you never have to worry about your subject moving during the exposure and so blurring the picture. For the same reason you don't have to be careful about camera motion blurring the image; you can hand-hold the camera and shoot as rapidly as the flash will recycle.

You may want to choose carefully the position of the flash, however. Light from a flash mounted on the camera's hot-shoe bracket often produces less attractive results than if you bounce the light onto the subject off a wall, ceiling, or umbrella reflector. See illustrations below.

Portraits with flash

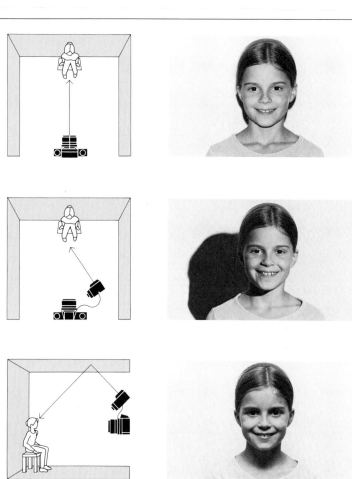

Flash on camera This is the easiest way to use flash for portraits, but does not necessarily produce the most attractive results. The flash sits in the hot-shoe bracket on top of the camera, pointing directly at the subject. The resulting lighting may remind you of a news photo: thin-edged shadows, bright, often shiny, highlights, with volumes and textures minimized.

Direct flash off-camera Flash pointing directly at the subject, but with the flash unit off-camera (connected to the camera with a synch cord) will produce more apparent volume and texture. To avoid a distracting shadow on the wall, move the subject so that he or she is farther from the background (the background will now be uniformly dark). You can also raise the flash higher, which will make the shadow fall lower and out of the image area.

Flash bounced from ceiling Aiming the flash at the ceiling so the light bounces down from overhead produces a soft and natural light rather like illumination outdoors on an overcast day. See Tips box opposite for exposure information.

Flash bounced from wall Aiming the flash at a wall near the subject also gives a soft, natural looking light. It often looks even better than ceiling-bounced light because it does not create dark shadows in your subject's eye sockets. To avoid a shadow on a wall behind your subject, move him or her farther from that wall. See Tips box opposite for exposure information.

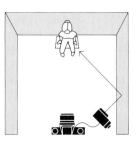
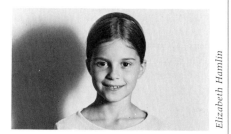

Elizabeth Hamlin

Step by step **Using flash outdoors**

Donald Dietz

When photographing subjects in the bright sun, shadow areas can be so dark in the image that they show no texture or detail at all. If the shadow covers a large part of the subject, the effect can be distracting and unattractive (left). You can lighten such shadow areas by using flash to "fill" the shadows, that is, illuminate them (right). Here is how to use fill flash step by step:

1 Use the camera's automatic exposure system to determine the proper exposure as if you were not going to use flash. If your camera is operating in shutter-priority mode, set in the correct synch speed for your camera. If you are in aperture-priority mode, find an aperture that will give you the correct synch speed. In some cases you may need a neutral density filter to find an aperture that will work in combination with the synch shutter speed without overexposing the film. In a pinch, a polarizing filter or a colored filter with black-and-white film will serve the same purpose.

2 Note the aperture the camera is using and find that aperture on the flash calculator dial. (Make sure the ASA dial is set to the ASA of the film in the camera.) Note the distance indicated on the calculator opposite the aperture you're using.

3 Assuming you have the flash mounted on the camera's hot-shoe bracket, position the camera at the distance noted above for a 1:1 lighting ratio (the shadows will be almost completely eliminated). For a lighting ratio of 2:1 (the shadows will be lightened but not eliminated), drape a white handkerchief over the flash. This will cut the brightness of flash light reaching the subject by about 1 stop (that is, by one-half). Or, refer back to the calculator dial and find the distance recommended for the next larger f-stop. Position the camera that distance from the subject, but leave the camera set to the smaller aperture.

Tips **Using bounce flash**

Flash head To bounce light from a flash requires that you be able to point the flash in a different direction from the camera lens. If your flash has a head that tilts or swivels you can mount the flash on the camera's hot-shoe bracket and move the head of the flash until you get the angle you wish. If your flash head does not move independently, you will have to take the flash off the camera, making the electrical connection between flash and camera with a separate synch cord.

Reflecting surface An umbrella reflector is the most versatile of surfaces for bouncing light onto your subject. You can position the reflector at almost any angle or distance relative to your subject. It also gives you a choice of surfaces, silvered for maximum reflectivity, warm-toned for better skin tones in color portraits, and so on.

You can also bounce light from a wall or ceiling if you can position your subject at a reasonable distance from one. Since light gets dimmer the farther from the flash that it travels, in most cases you won't be able to use a ceiling higher than one in an average home room or a wall farther away than about 10 ft. The surface should also be neutral in tone if you are shooting color; a green wall, for example, will reflect a greenish light on your subject, not usually a pleasing effect.

Exposure Automatic exposure will work well if your flash has a sensor that remains pointed at the subject when the head is tilted. You will have to use the flash on manual if the sensor points away from the subject. Estimate the distance that the light travels from flash to reflecting surface to subject. Then use your flash unit's calculator dial to find the correct lens aperture, but set the aperture 1 or 2 stops wider than the recommended one to compensate for light absorbed by the reflecting surface.

Common flash problems

Subject too dark | Cause/Solution

Flash pictures that are too dark will have little or no detail in shadow areas and an overall dark, dense appearance.

Elizabeth Hamlin

Wrong film speed entered into flash unit. If the film speed entered on the dial is higher than the speed of the film in the camera, the exposure will be calculated by the flash to give less light than the film requires.

Wrong aperture set on lens. If the aperture set on the lens is smaller than the aperture at which the flash is designed to work, the picture will be too dark.

Subject too far from camera. Automatic flash units are designed to give good exposures within a given range. If the subject is farther from the camera than the maximum range, the picture will be too dark.

Flash bounced but with automatic flash sensor pointed at the reflecting surface instead of at the subject. Or flash bounced in nonautomatic operation without extra exposure added; about 1 stop additional exposure is required for average bounce situations. Or flash bounced from a surface too far away or too dark to reflect enough light.

Part right/part too dark | Cause/Solution

Objects that are relatively close to the camera are correctly exposed, but those that are much farther away are underexposed and too dark.

Margaret Thompson

All of the important subjects are not at the same distance from the flash. If some subjects are farther away than others, those will be darker. Try arranging your subjects or positioning your camera so that all subjects are equally distant from the flash. Bounce flash also helps because it tends to spread the light more evenly.

Main subject is off center. The automatic sensor on some flash units is designed to read and compute the exposure based on an area smaller than the entire image area. Your main subject may be too dark if it is off center and farther away than a subject of less importance that is in a central position.

Part of the scene is farther away than the maximum recommended distance for the flash.

Subject too light | Cause/Solution

Images that are too light are characterized by washed-out looking colors, loss of details in highlight areas, and an overall weak appearance.

Elizabeth Hamlin

Wrong film speed entered into flash calculator. If you set the flash for a film speed lower than the film in the camera, the flash will increase the exposure for what it thinks is a less sensitive film.

Wrong aperture set on lens. Flash units require a specific aperture for a given distance range and if you set the lens at a wider aperture, pictures will be overexposed.

Subject too close to camera. Automatic flash units are designed to work at a specific range of distances from the subject. If you are closer than the minimum distance, the picture will be overexposed and too light.

Part right/part too light

Rick Ashley

Objects that are relatively far from the camera are correctly exposed, but those that are much closer are overexposed and too light.

Cause/Solution

All of the important subjects are not the same distance from the flash. If you are photographing a group of people, for instance, and some are closer to the camera than others, those who are closer may appear too light and overexposed. Try to align all the subjects more or less at the same distance from the camera, or use bounce flash to diffuse the light over a wider area.

Part of the scene is closer than the minimum distance at which the flash should be used.

Main subject is off center. If the main subject is close to the camera but off center, the sensing cell may compute the exposure for a more distant subject, perhaps a wall, leaving the main subject overexposed and too light. Many sensors read only the central portion of a scene, about a 15°-20° angle.

Reflections of flash light

Donald Dietz

A reflection of the flash light from a mirror, window, or other shiny surface appears in a photograph as a white area, one that can be quite large.

Cause/Solution

Any flat, smooth surface—such as a mirror, glass window or display case, eyeglasses, wood paneling, metal, or plastic—can reflect enough light to be distracting. (Light can also be reflected from the blood-rich retina of the eye, causing it to appear in a color photograph, the so-called redeye effect.) If such a surface is in the background (or is part of the subject itself), see that the light from the flash does not strike the shiny surface at a 90° (right) angle. This way the light will reflect away from the camera, instead of into the lens.

Move the camera and the flash to one side or move the subject.

Use the flash off camera. An electrical wire connection called a synch cord is required. Make sure your camera and flash have outlets for such a connection.

Use bounce flash. Some units allow you to swivel the flash so the light bounces off another surface before hitting the subject. This softer, less direct light should reduce reflections from shiny surfaces.

Only part of image exposed

Ron Carraher

Only part of the film frame is exposed. The other part of the frame is underexposed and appears black in a slide or print, clear in a negative. (A partial exposure may register if the existing light on the scene is very bright.)

Cause/Solution

Flash not synchronized with shutter, leaving the film partially covered when the flash goes off. The burst of light from an electronic flash is brief—1/1000 sec. and often less—and for a proper exposure it must be synchronized with the moment that the camera shutter is fully open. Some automatic flash units automatically set your shutter so it synchs with the firing of the flash; you just attach the unit to the camera. With other flash units you must manually set the shutter to the correct speed for flash. Often the correct flash setting is indicated by an "X" (100X, for example), but check your owner's manual to be sure.

8 Close-up photography

Nothing is quite so fascinating as a photograph of a small object enlarged much bigger than life size. Objects that appear ordinary at their real size take on a startling and often abstract appearance when photographed close up.

You can begin exploring this exciting area with an inexpensive set of supplemental lenses or a reversing ring for a wide-angle or normal lens. If you already own a zoom lens it may have a close focusing capability that will let you shoot relatively close without the need for additional equipment. The equipment you use need not be expensive, but in general the greater the desired magnification the more demanding are the techniques.

Determining exposures is simplified greatly with an SLR's through-the-lens meter and even more so with automatic exposure control. However, automatic exposure control cannot be used with some close-up accessories which interrupt the linkage between lens and automatic exposure circuitry. See opposite.

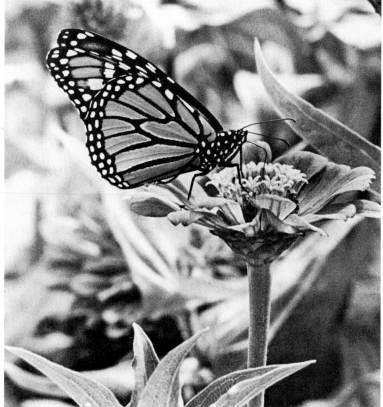

Ulrike Welsch

What is close-up magnification?

To make close-ups, you have to be able to focus the lens very close to your subject, which you can do optically with supplemental lenses. You can also decrease the distance from lens to subject if you increase the distance between lens and film, such as by inserting extension tubes or a bellows between the camera body and lens.

The standard way to describe close-up enlargement is by relating the size of the actual object to the size of its image on the film, stated as:

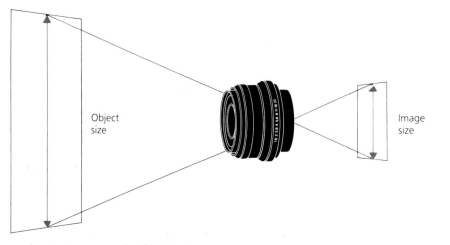

Object size

Image size

$$\frac{\text{Image size}}{\text{Object size}}$$

If an object 1″ high is photographed so that its image on the film is 1″, the magnification is 1/1 or 1X (also referred to as an image ratio of 1:1 or life size). If the same subject is photographed so that its image on the film is 1/2″, its magnification is 1/2X (1:2 or 1/2 life size). If its image on film is 2″, its magnification is 2X (2:1 or twice life size). You can increase the magnification even more if you make an enlarged print of the image you have on film.

Close-up equipment

Supplemental close-up lenses screw into the accessory threads on the front of the lens exactly like a filter. They are available in a variety of strengths called diopters: +1, +2, and so on. The greater the diopter the closer you can focus to a subject and so the greater the magnification. Supplemental lenses don't magnify as much as other accessories can, but they are inexpensive and work in any automatic exposure mode.

1:10 (1/10 life size) on film, enlarged to about 1:6 here

Macro lenses, including macro-zoom lenses, can be used at ordinary focusing distances or can be focused close to the subject to get an enlarged image on the film. A true macro lens can produce about a 1:2 (1/2 life size) image on film without the aid of any other device and is optically designed to perform well at close-focusing distances. A macro or macro-zoom lens works in any automatic exposure mode.

1:5 on film, enlarged to about 1:3 here

Reversing rings are inexpensive and give sharp images and good magnification when used with a suitable lens (in general, most wide-angle lenses and some normal-focal-length lenses). When the lens is mounted backwards on the camera using one of these rings, the image is enlarged but the automatic exposure controls are interrupted. The through-the-lens meter will still work, so exposures can be determined manually.

1:2 on film, enlarged to about 1:1 here

Extension tubes are inserted between the lens and the camera body to physically move the lens farther from the film. Certain extension tubes maintain the automatic linkage between lens and camera, so you can use them in any automatic exposure mode. Most, however, interrupt automatic operation in shutter-priority mode. Aperture-priority automatic and manual exposure modes will still function.

1:1 on film, enlarged to about 1.5:1 here

Bellows units perform the same task that extension tubes do: they extend the distance between lens and film, allowing you to focus closer than normal to the subject. Although more expensive than extension tubes and bulkier, they allow for a continuous range of magnifications, unlike most extension tubes which have only a fixed number of steps. Like extension tubes, they will not work on shutter-priority automatic mode.

Alan Oransky

2:1 on film, enlarged to about 3:1 here

Close-up trade offs

Until the development of the automatic SLR camera, close-up photography was relatively demanding. Distances had to be carefully measured, exposures calculated for bellows extension and other factors, and the camera's exposure manually set. The automatic SLR has eliminated much of the detailed work required to photograph up close successfully, but it still can be an exacting form of photography.

At close ranges, where you are pushing the limits of your equipment, certain things become more important than in general photography. Subject and camera motion are easily visible in the final image because of the high magnifications involved. Depth of field is quite shallow, sometimes only a fraction of an inch deep.

The table opposite describes some of the most common trade offs you will have to make when photographing up close.

Tips **Depth of field in a close-up**

If you look at some close-up photographs, you will notice that very few of them appear to be completely sharp from foreground to background; in other words, the depth of field in a close-up tends to be shallow. Depth of field in any photograph decreases as you bring the lens closer to your subject. A 55mm macro lens set to f/32 and focused on an object 10 feet away will give you an image with everything sharp from about 5 feet to infinity. The same lens focused on an object 9 1/2 inches from the lens will give you an image where only objects between 9 1/4 inches and 9 3/4 inches will be sharp, a grand total of 1/2 inch of depth of field. It is true that you maximize depth of field by using a small aperture, but at close focusing distances you have to remember that depth of field is always very shallow.

To use your smallest aperture, so that you take advantage of all the depth of field that you can, a fast film (ISO/ASA 400, DIN 27) helps, because less light is required for a good exposure. A tripod will keep the camera steady at the correspondingly slow shutter speeds that go with small apertures. Lighting the subject with flash may be advantageous; you can use a small aperture, and the light from the flash is so fast that you don't have to worry about camera or subject motion blurring the picture.

Shallow depth of field has its own benefits, so you don't necessarily have to think of it as a problem. An out-of-focus background can help isolate a small subject, making it stand out sharply.

Shallow depth of field in a close-up

Depth of field is easily seen in the photograph at right. The nuts closest to the camera are definitely out of focus. They gradually become sharper as they approach the plane of critical focus—the point focused on.

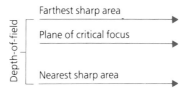

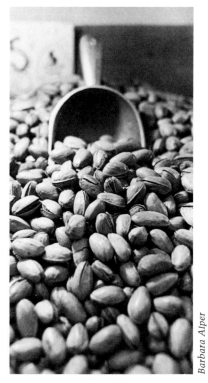

The nuts become out of focus again as they move farther from the camera. At close focusing distances, the depth of field extends about halfway in front and halfway behind the plane of critical focus.

Barbara Alper

The choice	Advantages	Disadvantages
Fast shutter speed	Fast shutter speeds freeze the motion of moving objects and help reduce blur caused by camera movement, which becomes very noticeable at high magnifications.	Unfortunately, fast shutter speeds also require larger apertures unless the light is very bright. The larger the aperture, the less depth of field you will have, and depth of field is already very limited at the camera-to-subject distances used in close-up photography.
Small aperture	Small apertures give you greater depth of field (compared to larger apertures).	Small apertures also require longer shutter speeds for a good exposure. At longer shutter speeds, you are much more likely to encounter blurred images from camera or subject movement.
Short-focal-length lens	Short-focal-length lenses let you focus relatively close to a subject, even before you add close-up accessories such as an extension tube or bellows.	But short-focal-length lenses may require you to work at such close camera-to-subject distances that you or the camera may throw a shadow on the subject or disturb a living subject.
Long-focal-length lens	Long-focal-length lenses when used with close-up accessories give you greater camera-to-subject distances, which makes lighting easier to adjust.	But long lenses tend to have less depth of field and a smaller maximum aperture than shorter focal length lenses.
Electronic flash	Electronic flash increases depth of field because it often allows you to use smaller apertures. The speed of the burst of light from the flash prevents camera or subject motion from blurring the picture.	If the subject occupies only a small area of the image, the automatic exposure mechanism may respond more to the background than to the subject, making the most important area either over- or underexposed. Using an electronic flash unit on manual is somewhat more complicated than on automatic operation.

Close-up exposures and lighting

The exposure procedure for close-up photographs depends on your equipment and the size and brightness of the subject relative to the background.

Supplemental close-up, macro, and macro-zoom lenses let you use automatic exposure control, either aperture-priority, shutter-priority, or fully automatic. Extension tubes or bellows usually can be used on automatic only with aperture-priority exposure mode. A lens reversing ring requires manual exposure operation. One difficulty may arise with either automatic or manual exposure operation. Many close-up photographs are of small subjects that don't entirely fill the viewfinder frame. Through-the-lens meters and automatic exposure systems can be fooled if the brightness of the small subject is very different from the brightness of the larger background. The meter averages all of the light reflecting from the scene and may select an aperture/shutter speed combination that over- or underexposes the main subject. One solution is to make a substitute reading of a gray card and then use exposure compensation or manual operation to get the right exposure settings.

The lighting of small objects is just as important as it is for normal subjects. Making something bigger than life isn't enough by itself—it needs to be illuminated properly to bring out details and colors well. You can light a subject in several ways, depending on your objectives. A flat object needs to be illuminated evenly; an object with low relief, such as a coin, needs to be cross-lit to bring out details; some objects might look better with the diffuse lighting provided by a light tent or a ring flash. Electronic flash can freeze action and increase depth of field. Your options are varied, limited only by your willingness to experiment.

Using a reflector to lighten shadows

When the light illuminating a small subject casts hard, dark shadows, you can lighten the shadows by arranging reflectors around the subject to bounce part of the light back into the shadowed area. You can use almost any relatively large, flat reflective object, including cardboard, cloth, or aluminum foil (crumpling the foil to wrinkle it, then opening it out again works best). Position the reflector so that it points toward the shadowed side of the subject. As you adjust the angle of the reflector, you will be able to observe its effect on the shadows. Use a neutral-toned reflector if you are photographing in color.

Using a light tent

One way to bathe a subject in soft, even lighting, particularly useful for highly reflective subjects like jewelry, is by using a simple light tent. The object is surrounded by a translucent material which is lit from the outside. If the object is small enough, you can use a plastic gallon milk bottle with the bottom cut out and the top enlarged for the camera lens. When positioned over the subject and illuminated by a pair of floodlights, the light inside the bottle is diffused by the translucent sides of the bottle. The result is a very even lighting of the subject.

Larger subjects require larger light tents. You can construct a wooden frame and cover it with

cloth or plastic sheets. When illuminated from outside by two or more floodlights, the light within the tent will be diffuse and nondirectional.

Determining exposure with a gray card

When the subject being photographed is much brighter or darker than its background, or when it is overall very light or very dark in tone, a substitute reading is a good way to determine the best exposure. Gray cards, available from your camera store, are usually white on one side, gray on the other. The gray side reflects 18% of the light falling on it, the same percentage of light that your camera's exposure mechanism expects an average scene to reflect. In other words, the gray card produces the amount of reflectance the meter needs to calculate a correct exposure.

Here's how to meter the card:

1 Position the card so that the same light falls on it as on your subject when seen from the angle at which you will be shooting. You can usually do this by positioning the card parallel to the film plane in the camera (the back of the camera).

2 Focus through the viewfinder. Move close enough so that the card fills the entire image area.

3 Meter the card and note the aperture and shutter speed indicated in the viewfinder (or on the controls themselves) and use these settings to take the photograph. If they are different from the settings indicated from the shooting position, use manual operation or exposure compensation to override the automatic exposure system.

Flash in close-up photography

There are two important reasons to use flash in close-up photography. With flash, you can use smaller apertures for greater depth of field, and the extremely short burst of light at close distances prevents camera or subject movement from causing blur. To use electronic flash with predictable results takes a little effort since you may not always want to use the flash on automatic exposure control, but the advantages are often worth the small amount of extra trouble.

Side-lighting brings out texture

Ulrike Welsch

Direct on-camera flash doesn't give a picture the feeling of texture and depth that you can get from side-lighting. Try using a synch cord to connect your flash to the camera so that you can position flash and camera independently. For different effects, take a variety of pictures holding the flash in different positions relative to the subject. If the flash has a sensor built in, always keep it pointed directly toward the subject when using flash on automatic.

Exposure control with automatic flash

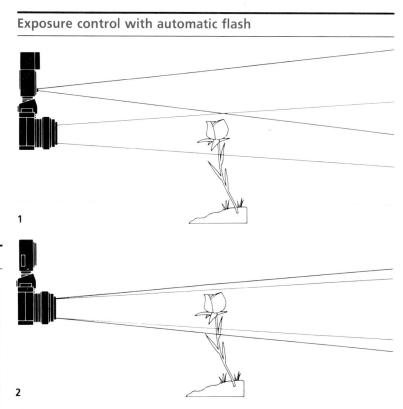

1

2

If you use an on-camera flash for close-ups, exposure may not be correct if the flash meters the exposure using a built-in sensor. The sensor measures a small field of view and with the flash on camera will be a few inches above the lens. The sensor and camera lens see two separate views when used very close to the subject.

1 In this illustration the coverage of the lens and the coverage of the flash sensor don't overlap on the subject. When the flash is mounted on the camera, it will read the background rather than the subject and the image will most likely be overexposed. You can solve this problem by using a synch cord, which allows you to hold the flash independently of the camera so that its sensor is pointed directly at the subject.

2 This illustration shows how a camera that meters flash through the lens is easier to use with close-ups. The view the meter sees and the view the lens sees are almost identical.

Ring flash

Ring flashes are ideal for certain kinds of close-ups. These donut-shaped flash units encircle the front of the lens and give a soft, even illumination somewhat like that achieved by using a light tent. Contrast between highlights and shadows is eliminated, giving small objects shadowless illumination. You can also use a ring flash off camera.

Using flash with a bellows or extension tubes

To explore the advantages of close-up flash photography, experiment. Here is one way to begin step by step.

1 Use a synch cord to connect the flash to the camera and set both the camera and flash to manual exposure. Do not mount the flash in the hot shoe because doing so generally points the flash above the subject at close distances and limits the ability to side-light the subject to bring out texture.

2 Select a subject and determine the magnification of your image. To do this, compose and focus the image through the viewfinder. Note the extent of the field that is covered (the area that is seen within the viewfinder) and measure the shorter side of this field. The numeral 1 (the length of the shorter side of the 35mm film image) over the length of the shorter side of the field will give the image magnification. For example, a subject might be framed in a field measuring 2" by 4". The numeral 1 over the short side of this field (2) gives an image magnification of 1/2X.

3 Set the lens aperture to its smallest aperture (for greatest depth of field) or any other aperture you wish. If your camera has a depth-of-field preview button you can estimate the effects of various apertures on depth of field.

4 Calculate the effective aperture. To do so, find your image magnification on the following chart and note if your effective aperture is smaller than the aperture you have set:

Image magnification	Effective aperture
1/4X	1/2 stop smaller
1/2X	1 stop smaller
3/4X	1 1/2 stops smaller
1X	2 stops smaller

Use this number for calculation purposes only. Leave the lens aperture set where it was. Exposure will be controlled by positioning the flash at the right distance. In this example, the effective aperture is f/22, 1 stop smaller than f/16.

5 Determine your flash unit's guide number for the film speed you are using. It will be given in the owner's manual packed with the flash. If not, you can approximate it quickly. Set the ASA of the film being used into the calculator dial on the flash. To find your approximate guide number multiply by 10 the aperture indicated opposite the distance of 10' on the dial. In this example, 10 × 8 gives a guide number of 80.

6 Calculate the needed flash-to-subject distance. To do this divide the guide number (determined in step 5 above) by the effective aperture (determined in step 4 above).

$$80 \div 22 = 3.6$$

7 Position the flash the correct distance from the subject (determined in step 6 above). Take several pictures moving the flash to different angles to vary the lighting effects on the subject, but try to keep it the same distance from the subject. Then take several pictures varying the flash-to-subject distance to do the equivalent of bracketing the exposure.

Cameras and camera accessories

✓ Camera buyer's checklist

The modes of operation available in automatic cameras are:

Aperture-priority You select the aperture and the camera will choose the shutter speed for a correct exposure. Preferable for close-ups, studio work, and whenever it's important to control depth of field.

Shutter-priority You set the shutter speed and the camera sets the aperture. Preferable for sports and other action scenes.

Programmed mode The camera selects both aperture and shutter speed for you. This is ideal when you don't have time to adjust the camera controls. It also improves results for beginners.

Manual mode You have complete control over both shutter speed and aperture. This is a must for a professional photographer and it's helpful for the beginner who wants to learn more about camera controls.

Multimode You can choose among one or more automatic modes or manual mode depending on the situation. This insures the best possible exposure system for shooting a variety of subjects.

Shutter speeds The standard range of shutter speeds is from 1 or 2 sec. to 1/1000 or 1/2000 sec. Very slow or fast speeds are needed only in special situations, such as extreme low-light photography or freezing extremely fast action. *Stepless shutter speed controls* allow you to set the shutter between the marked speeds for exact exposure. This is especially useful in aperture-priority mode.

Meter Through-the-lens metering is a standard feature on new cameras. A *center-weighted meter*, which gives prefer-ence to the center of the frame where the subject is more likely to be, will give accurate results more often than an *averaging meter*, which gives equal weight to all parts of the scene. Either type of metering system may under- or overexpose if a large area in the picture is much brighter or darker than the subject, so most cameras have *exposure compensation*, which allows you to adjust the automatic exposure by a stop or two in either direction. An *exposure lock* also helps you achieve accurate exposure when the area surrounding the subject is much lighter or darker. This feature allows you to take a close-up reading of the subject and then back away to make the exposure.

Viewfinder When you look through the viewfinder, the scene should be bright and easy to focus. *Focusing screens* differ slightly from one camera to another. Most have a split-image central spot, surrounded by a microprism collar in a ground glass field (see opposite).

Viewfinder displays also differ. Information may include any or all of the following: indicators for correct exposure, overexposure, or underexposure; shutter speed and aperture settings; camera-shake warning at slow shutter speeds; manual mode indicator; flash-ready light; flash distance check; and battery check. This information may be in the form of needle indicators, light-emitting diodes (LED's), digital displays, audible signals, or a combination of these. Check to be sure the viewfinder display is easy to read and understand, even in low light.

Most viewfinders show about 90–97% of the image that will appear on the film depending on the camera. If the edges of the frame are important to you, look for a camera that shows a high percentage of the scene.

Flash capabilities A *hot-shoe bracket* on top of the viewfinder mounts the flash and connects it to the shutter release. On most cameras, the *flash synchronization speed* is between 1/60 and 1/100 sec. A camera with *dedicated-flash capability* has circuitry that enables a dedicated flash unit to set the camera to the synch speed.

Camera body New 35mm single-lens-reflex cameras are smaller and more compact than older models. Some models feature heavy-duty construction for professional use and a built-in grip that makes holding the camera easier.

Depth-of-field preview When you look through the camera, you view the scene through the widest lens aperture, that is, with the shallowest depth of field. The depth-of-field preview button stops the lens down to the selected aperture so you can see how much is in focus in front of and behind the main subject.

Multiple exposure capability Cameras are designed with safeguards to prevent accidental double exposures. When you intentionally want to double expose, a multiple exposure lever holds the film in the same place for the next exposure.

Self-timer A timer delays the shutter release for 20 to 30 seconds so that you can get in the picture, too. It also helps avoid camera shake when the camera is on a tripod and you don't have a cable release.

Battery check This indicator in the viewfinder or on the camera body tells you when the batteries are getting low. An automatic and continuous battery check warns you of its own accord. One that is not automatic warns you only if you remember to check.

To the stripped-down camera and lens you can add accessories such as a flash unit, power winder, interchangeable lenses, special-purpose viewfinder, alternate focusing screen, or close-up equipment. The most flexible camera in a manufacturer's system, the "professional" model, has the largest number of interchangeable parts and the largest selection of accessories. Shown here is the Canon AE-1 Program.

Viewfinder accessories

Your viewfinder can be adapted with add-on accessories for specific uses or individual needs. See also interchangeable viewfinders, some of which have similar functions to these viewfinder accessories. Common viewfinder accessories are:

Right-angle finder Sometimes it is awkward to look directly through the viewfinder, such as when you are using a copy stand or taking close-ups in low positions. A right-angle finder allows you to view and focus looking down at the camera top instead of straight ahead. It mounts over the existing eyepiece and most models rotate 90° so that you can view from the top or side of the camera. Some right-angle finders show the image reversed left to right, others include a pentaprism that corrects the image. Many can be adjusted for individual eyesight.

Canon Right-Angle Finder

Dioptric correction lens Eyeglass wearers can photograph without glasses if the viewfinder is fitted with the correct dioptric correction lens. They are available in several powers and are easy to install.

Eyecup A rubber eyecup attached to the viewfinder fits around your eye and makes focusing easier by blocking stray light.

Interchangeable viewfinders

Some camera models have interchangeable viewfinders that adapt the camera for viewing and focusing in different situations. You may be able to change these finders yourself. The most common finders are:

Waist-level finder When eye-level viewing is difficult, a waist-level finder facilitates viewing with the camera at low levels or overhead. It is often used for close-ups, copy work, or other critical focus work. Most waist-level finders fold

when not in use and include a flip-up magnifier to aid in focusing. They often show the image right side up, but reversed left to right. Some include viewfinder data. Others don't and require metering through a different viewfinder or with a hand meter.

Pentax Waist-Level Finder

High-magnification finder Viewfinder magnification is most often used in close-up, micro, or astronomical photography where focus is critical. A high-magnification finder shows the entire image magnified several times. Some include the viewfinder data display, others don't. The image may be reversed left to right.

Action finder When wearing glasses or sports goggles, you obviously can't put your eye right up to the viewfinder. An action finder permits full viewing with the camera 1 to 2½ in. from your eye so that you can take pictures without removing your glasses. It is also useful for quick coverage of sports events and for underwater photography when the camera is inside a waterproof housing.

Focusing screens

The general purpose focusing screen that comes with a new camera will work for just about any kind of photography. However, different types of screens are made for specific uses. Most cameras can be fitted with an alternate screen at an authorized service center, and some cameras have interchangeable screens that you can change yourself.

Motorized film advance

A motor drive automatically advances the film each time you take a picture. You can use it to shoot one frame at a time or set it for continuous fire. Many motor drives have more than one speed and top speed varies from 2 to 6 frames per second. Most units provide automatic film rewind as well. Some include a hand grip with shutter release button.

Power winders, which are less powerful than motor drives, offer automatic film advance at speeds up to about 2 frames per second. Some power winders have some of the additional features that are available on motor drives.

Both motor drives and power winders are useful for shooting rapid action or for capturing fleeting expressions. Remote-control adaptors, available for some units, extend the range of subject possibilities even further. With an accessory called a variable interval timer, time-lapse sequences are also possible. Cameras that accept motorized film advance may have interchangeable backs so that the standard back can be replaced with a bulk film magazine.

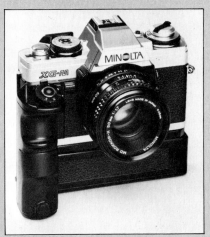

Minolta XG-M with motor drive and hand grip

Here are some of the most common focusing screens. The first four are general purpose screens with a matte field. The center focusing device is a microprism in screen A, a split-image spot in screen B, and a combination split-image spot with ground glass collar in screen C. Some photographers prefer a plain matte field without a central focusing device such as screen D. Cross hairs make screen E suitable for close-up, microscope, and astronomical photography. Screen F has a grid to aid exact subject alignment.

◄

Lenses and lens accessories

Lenses of different focal lengths render a subject differently, and a collection of interchangeable lenses will make your camera a more versatile tool. Lenses also represent a major portion of the cost of camera equipment, so it is wise to build your collection of lenses slowly and with care. Once you decide you need a particular focal length lens, consult the checklist below before buying.

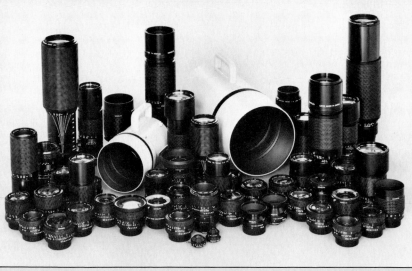

Minolta Corp.

✓ Lens buyer's checklist

Lens speed The widest aperture of a lens indicates the lens speed. There are two advantages to a fast lens: it is easier to focus since it lets in more light than a slower one, and it allows you to use faster shutter speeds when photographing in low light. However, extra speed increases the size, weight, and cost of a lens, particularly in wide-angle and telephoto lenses. Speeds between f/1.2 and f/2 are typical for normal-focal-length lenses, speeds of f/2.8, f/3.5, and f/4.5 for wide-angle and telephoto lenses.

Minimum aperture The smaller the lens aperture, the greater the depth of field possible with a given lens. In brightly lit situations, the minimum aperture also determines how much flexibility you have to use slow shutter speeds. Common minimum apertures are f/22 and f/32.

Type of mount All new cameras have bayonet mounts, but the design of this mount varies from one manufacturer to another. In addition to holding the lens on the camera, the mount provides connections for automatic metering and exposure. So, whenever you buy a new lens, be sure that it is designed to work with your camera. Adaptors, made by certain camera and lens manufacturers, increase the possibilities for interchanging lenses.

Automatic diaphragm The lens stays at its widest aperture while you compose the picture and stops down to the selected aperture when you take the pic-

ture. This gives you the brightest possible viewfinder image at all times, and it is a standard feature on modern lenses.

Minimum focus distance The point of closest focus, the closest that you can come to an object and still have it in focus, increases with the focal length of the lens. Wide-angle lenses focus as close as 1 ft. or less, normal lenses can focus as close as 18 to 24 in., telephoto lenses focus no closer than 3 ft. Macro lenses let you focus closer than normal.

Filter size and type Screw-in filters and lenses come in several standard size diameters (49mm, 52mm, 58mm, etc.), and it's best, though not always possible, if all of your lenses accept the same size filters. An accessory step down ring may be used to adapt a larger filter to fit on a smaller diameter lens, but a smaller filter adapted to a larger diameter lens may cause vignetting.

Depth-of-field scale Engraved on the lens next to the focus ring, this set of lines (and sometimes numbers) tells you which camera-to-subject distances will be acceptably sharp when the lens is set at different apertures.

Aperture direct readout scale In some cameras, the aperture indicator in the viewfinder is actually a tiny window that lets you read the aperture directly off of the lens. This is called aperture direct readout, and for it to work, the lens must have a secondary aperture scale on the end nearest the camera body.

Size and weight A lens often weighs as much as, or more than, the camera body. A collection of lenses will add significantly to the bulk and weight of your camera equipment. The following characteristics affect lens size and weight:

Focal length Telephoto lenses are larger and heavier than wide-angle ones. Extreme telephoto and wide-angle lenses are often heavier than more moderate focal lengths. Normal lenses (50mm or so) weigh the least of all.

Lens speed Wider apertures increase lens diameter and weight.

Zoom or macro capability also increase weight.

Compact lenses are smaller versions of regular lenses, specially constructed to keep size and weight to a minimum.

Coating All high-quality new lenses are treated with an anti-reflective coating which improves the light-gathering ability, reduces flare, and enhances color rendition.

Zoom-focus controls Traditionally, zoom lenses have had the zoom control (to change focal length) on one ring and the focus control on another. However, many new zoom lenses have both controls on one ring (turn to focus, push or pull to change the focal length). The one-touch control is quicker, although it's easy to change the focus accidentally when zooming in or out.

Focal length

The focal length, more than any other lens characteristic, affects the way your pictures look because it determines how much of a scene will be included in the photograph and how large the subject will be on the film. Choose the focal length according to the kind of subjects you want to photograph. Choices are:

Normal lens 40 to 55mm (see pp. 106–107)

• Angle of view resembles human vision

• Most versatile, least expensive of all focal lengths

• Uses: landscape, travel, people, nature—and with accessories, close-up

Wide angle 35mm and less (see pp. 108–109)

• Considerable depth of field

• Wider than normal angle of view

• Can focus very close to subject

• Possible wide-angle distortion

• Uses: architecture, interior, scenic, close-ups, industrial, special effects

Telephoto 70mm and longer (see pp. 110–111)

• Minimum focus distance is relatively far from subject

• Shallow depth of field

• Narrow angle of view, high magnification

• Uses: portraits, landscape, nature, wildlife, sports

Zoom Adjustable focal length (see p. 112)

• More expensive and may be less sharp than conventional lenses

• Useful when shooting a variety of subjects

Macro Close focus capability (see p. 113)

• Uses: all types of close-ups including nature and copy work

Buying used lenses

Second-hand lenses are widely available and they can be a good buy if you check them carefully. Inspect the lens for signs of hard use such as dents or scratches on the lens barrel or scratches on the lens surface. Shake the lens and listen for loose parts. Check to see if the diaphragm opens and closes smoothly by moving the aperture ring over the entire range of f-stops while looking through the lens. Finally, test the lens on your camera.

Lens accessories

Tele-converters You can double or triple the focal length of a lens by using a tele-converter between the lens and camera body. This is a convenient low cost way to extend your lens possibilities, but keep in mind that it will decrease the speed (widest f-stop) of your lens and it may affect the optical quality. If you can, buy one designed to retain full automatic operation in your camera.

Minolta Tele-Holder

Tele-holders and tripod mounts Long telephoto lenses are noticeably heavier than the camera body, and so they are somewhat difficult to handle. If you must hand-hold an extremely long lens, the best support is a platform mount (also called a shoulder stock) which includes a shoulder brace, hand grip, and cable release. Some very long telephotos come with a tripod mount so that the lens rather than the camera body is mounted on the tripod. These mounts usually have a rotating collar with click stops every 90° so that you can turn the camera for vertical photos.

Lens hoods A lens hood has two functions—to shield the lens from extraneous light that would fog the image and to protect the lens from dents, scratches, and dust. Some lenses have built-in hoods, but most are made to take screw-in or clip-on hoods.

Lens caps and cases Lenses are fragile—the glass surfaces, the mount and connector pins, and the focus and aperture rings can be damaged. The cheapest and best way to protect the surfaces of your lens is to use lens caps. Keep the front lens cap in place whenever you're not taking a picture, and add the rear lens cap as soon as you take the lens off the camera. Store your lenses in individual cases—hard cases with snap-on or screw-on lids or soft, cushioned, drawstring pouches.

Nikon lens cases

Flash

Types of flash

Hot-shoe flash units are good for general use. They are relatively small and lightweight. Most can either be mounted directly on the camera's hot-shoe bracket or used off camera. Many of them feature automatic operation, and some take accessories that adapt them for a wider range of uses.

Head-and-handle units combine the advantages of portable, battery-operated flash with the extra power required for many professional assignments. They are larger and heavier than hot-shoe units and they can be attached to the camera with a bracket or used off camera.

Professional portable flash units can be mounted on camera, but the power comes from a separate battery pack that is usually carried over the shoulder. These units are larger and more powerful than any of the other units mentioned here. They are often used by wedding, sports, magazine, and news photographers.

Ring flash is a small but powerful unit that circles the camera lens and provides shadowless illumination for small, close-up subjects. It is often used in medical, dental, scientific, and macro photography.

The Minolta Auto-Electroflash 132X

✓ Flash buyer's checklist

Guide number This measure of light output compares the power of different flash units. A higher guide number means a brighter flash and a longer possible flash-to-subject distance. If the guide number is not listed in the owner's manual, you can figure it out using the flash's exposure calculator. Set the calculator at the ASA you expect to use. Then multiply the aperture opposite the 10-ft. mark on the distance scale by 10 (for instance, if the aperture opposite 10 ft. is f/8, the flash guide number is 80 with that ASA film). When comparing the power of different flash units, be sure to use the same ASA setting.

Angle of coverage Most flash units will illuminate the area covered by a 35mm-focal-length lens, and can be used with lenses of 35mm focal length or longer. Some flashes will accept a wide-angle adaptor that increases the angle of coverage for lenses as short as 24mm or 28mm focal length, or a telephoto adaptor that increases flash power at long distances. Some flashes have built-in zooms and can adapt the angle of coverage without attachments.

Choice of power levels Full flash power isn't needed for photographing at short distances, so a unit that has a low setting will save on batteries.

Automatic flash exposure In autoexposure units, a photo-electric sensor regulates the length of the flash discharge. This keeps you from having to calculate distance and f-stop settings, and it results in more flashes per battery since the flash fires at full power only when necessary. Automatic flash exposure works only at designated apertures, and units with more autoexposure f-stop settings provide more control over depth of field.

Dedicated flash When used with the camera models for which it was designed, a dedicated flash unit automatically sets the camera shutter to the correct synch speed for flash. Many dedicated units also trigger a ready light in the viewfinder when the flash is charged and ready to fire.

Recycle time This is the amount of time it takes for a unit to accumulate enough charge for the next flash after a picture is taken. Recycle time varies from a fraction of a second to several seconds, and it is important when you shoot flash exposures in rapid succession. Units with thyristor circuitry tend to have shorter recycling times because unused flash energy is fed back into the power system.

Tilting head for bounce flash A flash unit with a tilting head can bounce the light off a ceiling or other reflecting surface as well as be used for direct flash. Most tilting heads have click stops at several angles and some swivel from side to side for added light control. Ideally the light sensor on the flash should remain pointed at the subject when the head tilts.

Calculator dial This is an easy way to figure out the correct flash exposure if your flash doesn't have automatic exposure or when your autoexposure unit is set on manual. Dial in the ASA of the film you're using, then look under your camera-to-subject distance to find the correct aperture. Lighted dials are helpful in low light.

Flash-distance checker This is simply a light that comes on after exposure to indicate whether enough light was present for proper exposure. It can also be used as a pre-test to tell you if the controls are properly set.

Flash accessories

Synch cord When the flash is used off camera, a synch cord (also called synchronization cord or PC cord) provides the electrical connection between flash and camera.

Remote sensor Attached to the on-camera flash unit, a remote sensor computes exposure for direct or bounce flash. When the flash is positioned remotely, mount the sensor on the hot shoe for exposure readings.

Slave eye This is a cordless remote trigger activated by light from the primary flash. Mount one on each remotely positioned flash and all units will fire in synch. Not all flash units accept a slave eye.

Bounce diffuser Some units have a holder that positions a white card at an angle to the tilted flash head. The reflected light from the card is softer than direct flash.

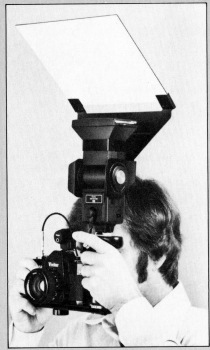

The Vivitar Autothyristor 283 with a white card reflector

Camera bracket You can avoid red reflections in your subjects' eyes with color film if you move the flash unit away from the camera lens axis. Brackets accomplish this and provide a sturdy grip for both camera and flash. A bracket consists of a platform for the camera, a grip, and a mount for the flash. A quick-release bracket lets you easily unsnap the flash so you can hand-hold it at various angles.

Canon makes two powerful handle-mounted flash units, the Speedlite 533G (shown here on the A-1 camera) and the Speedlite 577G. These units use a separate sensor on the camera's hot shoe while the flash attaches to a quick release bracket.

Filters The most common filters for use with flash units are:

• Neutral density for close-up work whenever the lowest power on your flash would be too bright.

• UV eliminates blue cast produced by some flash units with color film.

• Type B for using tungsten-balanced color film with electronic flash.

• Colored filters for special effects.

Attach filters to your flash unit with a clip-on adaptor, if the flash accepts one, or tape a gelatin or acetate filter over the flash light.

Telephoto and wide-angle adaptors A telephoto adaptor extends the operating range of the flash unit for the longer camera-to-subject distances of telephoto photography. A wide-angle adaptor increases the angle of coverage of the flash so that it can be used with wide-angle lenses.

Power sources

Portable flash units are battery operated, sometimes with the option to plug them into an ordinary household outlet. The most popular types of batteries are:

• Alkaline—The initial cost is low but they must be replaced when they run down.

• Nicads—These cost more to begin with but since they are rechargeable, they are cheaper in the long run. You'll need a recharging unit and the batteries must be recharged regularly. Many photographers keep two sets of nicads, one in the flash and one in the recharger.

• High voltage nicads—These are somewhat more expensive than regular nicads but provide the greatest number of flashes without recharging.

The Minolta Auto Electroflash 450 has batteries in the flash handle.

Tips Infrared flash

When photographing with infrared film and electronic flash, cover the lens of your camera with a #25 (red) filter. With this filter in place, you can use the flash normally. However, if you are photographing in low-light situations and you don't want the flash to be obtrusive, you can leave the filter off the lens and cover the flash tube with a #87 gel. The gel allows only infrared light to pass through it so the flash will not be noticed.

If you use infrared film extensively, you may want to consider buying a special infrared flash unit that emits only infrared light.

Lighting

Types of lights

Photofloods are tungsten bulbs that are color balanced to 3200 or 3400 K for use with tungsten film. Brighter than household bulbs (250 to 500 watts), they have a relatively short life (3 to 11 hours). There are three types of photoflood bulbs: a clear bulb is used with a reflector for direct light; a bulb with a reflective coating on the front bounces light back into the reflector and results in a softer, slightly diffused light; a reflector flood has a reflective coating painted on the back of the bulb so it can be used without a reflector.

Quartz lights are small bulbs that are quite powerful (600 to 1000 watts). They cost more than photofloods and have a much longer life (75 to 500 hours). The color temperature, which is balanced for tungsten film, remains constant through the life of the bulb, instead of getting progressively more reddish as is the case with photofloods. Reflectors for quartz lights are small and easy to pack and carry.

Light control devices

Barn doors are lightweight black panels that mount on the rim of the reflector and fold in front of the bulb. By changing their position you can control the amount of light reaching the subject and you can keep light from shining into the camera lens. Some barn door assemblies also include a filter holder.

Broncolor Hazylight barn doors

A snoot is a cone used in front of the reflector to narrow the beam of light. With a snoot, it is possible to light only a specific part of a photograph and leave the surrounding area dark.

A diffuser in front of the light softens the light and makes shadows much less distinct. Diffusers are made of heat-resistant translucent plastic and they may snap onto the reflector or fit into a filter holder.

Spot lights produce a narrow beam of light suitable for highlighting specific areas or for back-lighting. A focusing mechanism in the spot-light housing controls the width of the beam for concentrated or diffuse light.

Tents provide diffuse light for photographing shiny objects such as jewelry and silverware without reflections from your camera and lighting equipment. A tent made of translucent plastic with a hole for your camera can provide even lighting using two or three floodlights. (See p. 144.)

Reflectors are useful for fine tuning a lighting scheme. The light is pointed at the reflector which then reflects it back at the subject. Umbrella reflectors can be set up with the main lights to create indirect or bounce lighting, and flat reflectors can be placed as needed around the subject to reflect more light into dark areas of the picture. Walls, ceilings, white cards, and metallic surfaces are all possible reflectors. Reflectors designed specifically for photography offer the advantages of highly reflective surfaces, exact color control, collapsibility, and light weight. Some common reflectors are:

- Silver—For maximum reflection

- Soft white—For bounce light and softer shadows

- Metallized blue—To balance a tungsten light source for daylight film

- Gold—For warm skin tones or late afternoon effect

- Black—To minimize reflected light

▶
This Smith-Victor reflector, designed for a photoflood bulb, has a swivel base, a mounting stud for attachment to a light stand, a vented housing so that the outside won't get too hot to handle, and a rim-mounted holder for filters and shading devices. The different sizes and shapes of reflectors determine the concentration and coverage of the light beam. Reflectors that are similar but smaller are available for quartz lights.

Light stands

It is easier to place and adjust lights if you have a couple of light stands. The basic models, with three folding legs and a telescoping center section, are adequate for most lighting needs. They come in several sizes with a maximum height of 4 to 8 ft. Many stands are painted black to reduce reflections. For a portable setup look for aluminum stands that are sturdy, lightweight, and easy to fold and carry. Steel stands are preferable for studio work because they are heavier and tougher.

Some helpful accessories for light stands include a *cross-arm* used to mount two lights on the same stand and a *combination light and umbrella mount* that holds both an umbrella reflector and a light or flash unit. Special clamps with a light mounting stud enable you to make use of pipes, rails, or furniture as additional supports for your lights.

Larson Reflecta-Stand

Carrying and supporting your camera

✓ Tripod buyer's guide

Size and weight Tripod size ranges from very small, for tabletop use, to over-size (8 ft. or taller when fully extended) for shooting from a high angle. Most tripods are 3 to 5 ft. high and have tele-scoping legs that enable you to change the height.

Kind of feet Metal spikes give the tripod a good grip in grass or soil, but rub-ber-tipped feet are better on carpet or smooth surfaces. Many tripods have rub-ber feet that retract to expose metal spikes.

Quick-release connector When your camera is attached to a tripod, you can remove it quickly for an impulsive shot if your tripod has a quick-release connector. The connector is attached to the camera with a conventional tripod screw. It quickly snaps into or out of the head of the tripod.

Head movement The tripod head holds the camera in place and adjusts camera angle and direction. With a *ball-and-socket joint*, the camera is free to move in

any direction. This makes it easy to place the camera at the exact angle you want, but slight adjustments in camera place-ment may be difficult. *Pan-and-tilt heads* are heavier and more expensive than ball-and-socket joints, but they give you more precise control over camera movement. Most of these heads will pan (turn left or right) in a full circle, and tilt (forward or back) until the camera is pointing up or down. Some heads have a third control for cross-tilt which turns the camera for vertical pictures.

Column movement Some tripods have a center column which raises or lowers the tripod head. A manually operated col-umn is held in place with a friction clamp, and it's possible for the column to slip or turn when you adjust it. A geared col-umn, operated with a crank, is better for precise adjustments in camera height. Some center columns may be reversed to hold the camera close to the ground. Some have a second camera mount at the bottom of the column.

Bogen Super Clamp 3025

Tripods

A sturdy camera support is helpful in many situations: long exposures, low-light photography, studio work, self por-traits, remote-control photography, or for supporting a camera with a long lens or other heavy attachments.

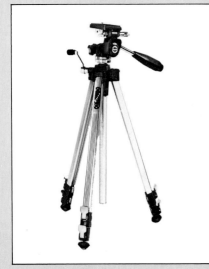

Stitz model 3 UE tripod

Clamps

Sometimes it is more convenient to clamp your camera onto a railing, a door, or a piece of furniture than to set up a tripod. Various types of clamps are made for this purpose. Most have a ball-and-socket head, but some have pan-and-tilt heads that allow movement in three directions. Some also have auxil-iary feet so they can double as small tabletop tripods.

Unipods

A unipod is a one-legged camera sup-port with telescoping sections to vary the height and either a ball-and-socket head or a two-way tilt head. Some have three short feet at the bottom and can stand alone. Others without feet just steady the camera for you. Unipods are not as sturdy or as versatile as tripods, but they are very lightweight, easy to carry, and they provide a steadier sup-port than hand-holding the camera does.

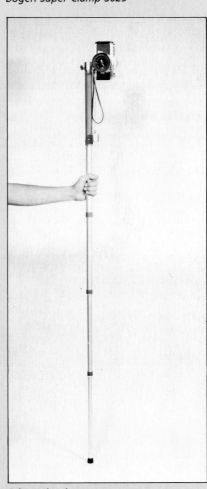

Stitz unipod

Carrying and supporting your camera *continued*

Straps

The neckstrap that comes with your camera is quite adequate for ordinary photographic situations. But for extended use, for hiking, bicycling, or other activities with a camera you may want a more comfortable or more versatile strap.

Wide *neckstraps* support the weight of the camera more comfortably than thin ones. Most are adjustable in length. Be sure the clips lock securely so that the camera can't work loose.

A *chest strap* holds the camera securely against your chest to prevent it from bouncing when you hike or climb. It also takes some of the strain off your neck. The straps are either elastic or have a quick release so you can easily lift the camera into position for shooting.

Chest strap by Necksaver

Cases

Your camera, lenses, and accessories are delicate instruments that should be protected from bumps and dust. In addition to a comfortable neckstrap you will need carrying and protective gear for storing and transporting your equipment.

Individual camera case An individual case for a camera and attached lens is ideal for storage and travel, and provides extra protection when your camera is in a suitcase or gadget bag. With a two-piece eveready case, you can drop down the front of the case instead of removing it entirely when taking pictures.

Outfit case A hard metal outfit case is ideal for storing or shipping camera equipment; each item in the outfit is stored in its own cushioned compartment. Although cumbersome to carry, this is the strongest and safest case available.

Gadget bag Made of flexible material such as leather or canvas, a gadget bag is considerably lighter and easier to carry than an outfit case but offers less protection.

Special-purpose bag Special-purpose camera bags are designed for specific activities such as hiking (backpack design), boating (waterproof and floatable), or biking (strapped to the bike frame). Consult your dealer for available models.

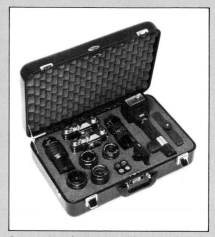

System Case by Zero-Halliburton Div. of Berkey Marketing Corp.

Copy stands

A copy stand provides exact camera alignment and even lighting for photographing books, artwork, documents, or other flat subjects at a close range. It consists of a baseboard, a center column with a movable camera mount, and lights on either side.

The baseboard is usually hardwood and may have a grid or other markings to help center the subject. If the baseboard is metal, magnetic strips may be used to hold the subject in place. The column supports the camera at heights up to about 3 ft. from the baseboard. Movement of the camera mount should be smooth and easy to control.

Lights may come with the copy stand or may be purchased separately in sets of two or four. They are mounted on the center column or attached to the baseboard. Incandescent fixtures may be used with black-and-white film or tungsten-balanced color film (use photofloods for accurate color rendition). Special fluorescent fixtures that emit light the same color as daylight are available for use with daylight-balanced color film.

Another type of copy stand consists of four adjustable legs and a platform with a hole in the center for mounting the camera lens. The item to be copied is placed on the floor or table beneath the stand. Lighting is separate. This type of stand folds into a small lightweight package.

Nikon Repro Copy Outfit

Bulk film loaders

Several popular films are available in 100 ft. rolls and a few specialty films are *only* available in bulk. With a bulk film loader and reusable film cassettes, you can save money on film by buying in bulk and loading the film into cassettes yourself. Put the film into the loader in total darkness; loading the individual cassettes can be done in daylight. The disadvantage is that it is possible to scratch or accidentally expose the film while you are handling it. Most models have an automatic frame counter and footage indicator. Without these features, you have to count the number of turns when you crank the film into the cassette.

Watson Daylight Film Loader

Film shield bags

X-ray machines at airports can fog your film. This is not likely to happen on just one pass through the machine, but if film is subjected to X-ray several times or if the machine is not correctly adjusted, it is more likely to happen. You can request that your camera bag be inspected by hand each time you go to the airport, or you can put your film in a shielded container and forget about it. The film shield bag contains layers of lead foil which block X-rays.

Filters

Numerous filters are available for use with color and black-and-white film, and these are described on pp. 120–123. When you've decided which filters you want, you will be faced with two more decisions: whether to buy glass or gelatin filters and whether to buy screw-in filters or a filter holder.

Gelatin squares cost much less than glass filters, but they damage easily and require a filter holder. Gelatin filters are usually the choice of professional photographers who use a lot of different fil-ters, while the tougher glass filters are favored by photographers who need only a few.

Screw-in filters are convenient as long as all of your lenses have the same size filter mount. Even if your lenses are different sizes, you can buy all your filters to fit the largest lens and use step down rings to attach them to the smaller lenses. (Don't attach a small filter to a larger lens—it will cause vignetting.) However, if you have several different size lenses and you use a lot of different filters, you will probably find that it is more convenient and less costly to use a filter holder and unmounted filters. A filter holder can be attached to lenses of different diameters with adaptor rings. Holders are designed for either the thin gelatin squares, or the heavier glass or plastic filters.

Vignetters change the shape of the image on the film from the standard rectangle to oval, diamond, heart-shaped, keyhole-shaped, or any number of other unusual shapes. The vignetter itself is a mask with a cutout in the center that determines the shape of the image. It is attached to the front of the lens like a regular filter.

Storage

Slides, prints, and negatives all need to be protected from dust, scratches, fingerprints, and moisture. If you want to preserve them for decades rather than just a few years, they must also be stored in archival quality materials. Numerous storage systems are available, and many of them include labels or indexing sheets to aid your organization.

For casual viewing, prints can be effectively displayed in traditional photo albums with plastic covered pages. Some have pockets of different sizes for standard size prints. Others may have a light adhesive on the backing sheet that keeps the print from slipping.

For long-term storage and occasional display of prints, look for an attractive archival storage box. These are available in several standard sizes for mounted or unmounted prints. Protect individual prints by placing archival quality interleaving tissue between them or by putting them in acid-free envelopes. Portfolio cases are available for more frequent display and transport of prints.

Slides may be stored in boxes, slide trays, or plastic sheets. There should be some room for air to circulate around the transparencies, since excess moisture can damage them—don't pack them to-gether too tightly or put them under other heavy items. Metal or wooden storage boxes are good for filing and carrying large numbers of slides. Most of them are compartmented and have an index sheet in the lid.

Projector trays are very convenient for storing groups of transparencies that you show in the same order every time. Depending on the type of projector you use, this system may be quite bulky for storing large numbers of slides.

Plastic sheets with pockets for 20 slides can be stored in three-ring binders or in files. They're easy to organize and label and you only have to hold them up to a light to see what's there. Large versions of this system consist of sheets that hold 100 or more slides and hang on metal racks.

Negatives are usually stored in special negative filing boxes or drawers or in clear plastic sheets. Within the boxes, negatives can be stored in envelopes with contact sheets on the outside for quick identification. Clear plastic sheets for negative storage fit in three-ring binders. The advantage to this system is that you can see and even make contact prints of the negatives without removing them from the sheets. Clear plastic sleeves called negative preservers come in long rolls, and can be cut to any length.

Kenco metal slide file holds 300 transparencies and has a numbered index in the lid.

Miscellaneous accessories *continued*

Cleaning negatives

Dust is such a persistent darkroom problem that many products are made solely to cope with it. We list three of the most popular ones:

Compressed air comes in an aerosol can and blows the dust off the film. Be sure to hold the can upright when you use it. The "air" is actually liquid freon that converts to gas when you spray it, but it can leave liquid droplets if the can is held at too much of an angle. *Film cleaner* is a liquid cleaning solution applied cotton wool or with a clean cloth. It removes dirt and fingerprints. An *antistatic brush* can be used to brush the dust off. Polonium in the brush ionizes the air to prevent static electricity buildup that would attract dust back to the negative.

Exposure meters

Like the meter in your camera, a handheld meter measures the brightness of light, and calculates f-stop/shutter speed combinations that will give proper exposure for the film speed you dial in. However a hand-held meter is easier to use in some situations, such as taking close-up readings from a specific part of a scene or from a gray card. Some hand-held meters can also perform special functions that are beyond the scope of a built-in camera meter, for example, measuring light from a flash or measuring the color temperature of a light source.

Hand-held meters are designed to measure either incident or reflected light, and many have an adjustment so that they can measure both. Reflected light meters measure the light reflected from the subject. Take the reading from camera position or walk up to the subject to take a reading from part of the scene. Incident meters measure the amount of light falling on the subject. Take the reading with the meter pointing toward the camera and with the same light falling on the metering cell as falls on the subject.

Spot meters are used for critical measurement of very small areas. Sight through the viewing window in the meter to find the area you want to get a reading from.

Flash meters give incident or reflected light readings of flash or continuously burning light sources. They are used to calculate precise exposures with flash.

Color meters provide precise measurement of the color temperature of a light source. Used primarily by professional photographers, this meter helps determine which filters to use for exact color rendition.

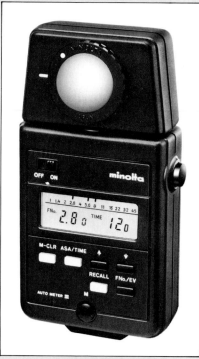

Minolta Auto Meter III

Changing bag

If your darkroom isn't dark enough to handle film, or if you frequently need a darkroom on location, a changing bag might come in handy. It's a zippered lightproof bag within a bag and it has sleeves so that you can insert your hands to work with light-sensitive materials. Use it to load film onto developing reels, to load your camera with infrared film (which can only be handled in complete darkness), or to perform other tasks that would otherwise require a darkroom. Changing bags come in different sizes: the smaller sizes let you work with a 35mm camera or its film; larger sizes are big enough to handle large sheets of view camera film.

Background paper

Seamless background paper provides a solid-color nonreflective backdrop for products, fashion, close-ups, and other types of studio photography. It comes in long rolls 4 ft. wide or wider and in a variety of colors including white, black, and several shades of gray.

Portable background support systems consist of two upright poles (either free-standing or spring-loaded to run from floor to ceiling) and one or more cross bars to hold the background paper. The vertical poles may double as lighting supports.

Freestanding background paper support by Welt Safelock Inc.

Burke and James changing bag

Slide mounts

You can mount transparencies yourself or have them mounted in cardboard, plastic, or glass mounts. Cardboard mounts that seal with heat or pressure are the least expensive. Heat-sealed cardboard mounts require an iron or heated mounting machine. Pressure-sensitive mounts are handy for on-the-spot mounting or remounting without special apparatus. Cardboard mounts hold the transparency tightly around the edges and may cause it to "pop" out of focus when projector heat makes the film expand.

Plastic mounts allow the transparency to expand without popping. They come in a few styles: a one-piece mount with a slot for slipping the transparency into place, a two-piece pressure-sealed mount, or a snap-together mount.

Glass mounts protect the transparency from dirt and scratches by sealing it between two thin pieces of glass. They are recommended for valuable slides and those that are handled frequently, but they should be packed carefully for shipping because they can break in the mail. A slightly distracting pattern called Newton rings may appear when these slides are projected.

Mounting machines

Slide mounting can be done without a mounting machine, but it's quicker and easier to mount large numbers of slides if you have one. The simplest hand-operated mounting machines are for pressure-mounting. Optional features include a heating element for heat-sensitive mounts and a chute that stacks slides in order as they are mounted. You can also buy a separate film cutter—with some models you can tack the transparency in place so it won't slip during the mounting process.

Seary manual slide mounter M-5

Magnifiers

It's difficult to evaluate a 35mm transparency or contact print without the help of a magnifier. The most popular magnifier for looking at transparencies is a loupe, which has a single lens and a clear plastic base. Loupes are designed for looking at back-lit images, such as slides, but with good light they can be used for checking contact sheets as well. A better tool for evaluating contact sheets is a somewhat larger magnifier with a built-in, battery-operated light.

Magnifiers vary from 2X to 10X or higher magnification. Some of the high-powered ones don't show the whole area of the slide and these are suited for evaluating sharpness and detail.

Hand and table viewers

A slide viewer provides greater magnification than a loupe and has a built-in light behind the transparency. Small hand-held viewers can only be used by one person at a time. Larger desk models may be viewed by two or more people simultaneously. Small pocket viewers are easy to carry, but not as easy to use as the larger models. Most slide viewers are illuminated by tungsten bulbs which give off a rather yellowish light and so don't show colors in the slide entirely accurately.

Slide duplicators

Slide duplicators are most often used to make copies from transparencies; to add textures, titles, other images, or special effects to slides; or to copy a slide onto negative film for printing.

A slide duplicator has two parts: a back-lit support for the slide to be copied and a column that holds the camera directly over the slide.

Some units have tungsten lights that are balanced for use with tungsten film. Others have electronic flash illumination for use with daylight film, and a few have both.

Some units have dial-in dichroic color correction filters for altering the color balance in the slide you are copying.

A less expensive piece of equipment that is also used for slide copying is a slide copying adaptor which is used in conjunction with a bellows unit. Illumination is not contained in this unit.

Before you buy a duplicator, check to be sure that it is compatible with the types of lens, bellows, or extender tubes that you have.

Pentax macro stand and lighting table

Light tables and sorters

A light table has an evenly lit back-lit surface for viewing and sorting transparencies. Special fluorescent tubes provide light the same color as natural daylight for accurate color rendition. Light tables vary in size from compact portable light boxes to medium-sized table-top models to large free-standing tables. The most comfortable tables to use for long periods of time are the ones that tilt like a drafting table or the ones that have a slanted vertical section with ridges for holding slides.

A slide sorter is smaller, lighter, and less expensive than a light table. The slanted viewing surface is made of thin molded plastic with ridges to hold the slides and the light source is a tungsten bulb which gives somewhat yellowish illumination. Most slide sorters are collapsible for storage.

Rogersol light table and stand

159

Transparencies *continued*

Projectors

The most popular types of projectors hold slides in rotary trays, straight trays, or cubes.

Rotary trays for carousel projectors are popular because they hold more slides than the other kinds (80 or more slides per tray), and can be used for longer uninterrupted shows. They also have a retaining ring to keep slides from spilling. The main disadvantage is that round trays are bulky for storing slides, and it takes a somewhat longer time to load and unload them. An accessory stack loader allows you to preview a stack of slides without loading them into a tray.

Rectangular (or straight) trays are less bulky to store than rotary trays, but they hold fewer slides. Some projectors will take rectangular or rotary trays; an efficient solution since you can load shorter shows in rectangular trays and longer shows in rotary ones.

Cubes are by far the most compact of the three methods in terms of storage. The slides are placed in a plastic box which is loaded open side down in the projector. The cube also protects the slides from dust. A special feature of cube projectors is a small viewer in the top of the projector which lets you preview each slide before it is projected.

Welt Safelock projector screen

✓ Projector buyer's guide

The projector-to-screen distance and the type of projection screen both have a major effect on the appearance of the projected image. For this reason, it's important to simulate as closely as possible the distance and screen surface you expect to use when you try out a projector, and then check these features:

Lens focal length A 90mm lens is standard on most projectors. A shorter lens will project a larger image and a longer lens will give you a smaller image (if projector-to-screen distance stays the same). A zoom lens is helpful if you expect to use the projector in different situations where projector-to-screen distance might vary.

Brightness of image Both the lens speed and the strength of the projector lamp affect image brightness. Most projectors have an f/2.8 or f/3.5 lens for use with a 300 or 500 watt lamp. Some projectors have a hi-low switch for different intensities.

Color rendition All colors should be bright and true. There should be no color cast.

Quietness Noise level is especially important when there is a sound track or commentary with the slides. Listen for the cooling fan and the slide change mechanism.

Evenness of illumination The corners of the projected image should not appear to be darker than the center.

Focus Three types of focus control are: *manual*, where you adjust the lens yourself; *remote*, where the focusing buttons are on the remote-control unit; or *automatic*, where you focus the first slide manually and the auto-focus mechanism adjusts the focus for each following slide.

Cooling If the cooling system is efficient your slide will be less likely to heat up and "pop" out of focus after a few seconds in the projector.

Reverse button Gives you the option to back up and show the previous slide again.

Timer operated change This optional feature changes the slide automatically at the time interval you select, such as 5 seconds or 15 seconds.

Editing Some projectors pass each slide over a small viewer so you can check it before it goes on the screen. Another editing option is a small built-in screen which allows you to preview an entire show at the projector.

Dark slide shutter An opaque slide automatically pops into place whenever there is no slide in the projector. This means that whenever a slide gets hung up or when you want an interval without a slide, the screen will remain dark.

Built-in reading light A small light on the side of the projector illuminates your notes or script.

Input for tape synch or auto-timer An important feature if you expect to use this projector for audio-visual presentations. Be sure the projector is compatible with the audio equipment you plan to use.

Projection screen

A collapsible screen with a tripod base is portable and can double as a studio backdrop or lighting reflector. A wall- or ceiling-mounted screen is more convenient if you always show your slides in the same place. Less expensive models operate on a spring roller (similar to a window shade). Electrically operated models cost more.

The type of surface on the projection screen will determine how bright the image will appear and how wide the viewing angle will be. A screen with a narrow viewing angle should be viewed from directly in front of the screen—if you move very far off-center the image will appear to be much less bright. A screen with a wide viewing angle will appear bright from the sides of the room and the center.

Matte white screens are preferable for large audiences since they have a wide viewing angle. They are not as bright as other types of screens.

Glass beaded screens have a coating of tiny glass beads which reflect a brighter picture than a matte screen. However, the viewing angle is narrower.

Silver lenticular screens produce the brightest picture, but the viewing angle is narrow. Highlights may look metallic.

Mounting

Many photographers mount their prints to a backing to keep them flat for viewing. This is a simple and attractive way to display a print or to prepare it for matting and framing. However, you may not want to permanently mount a valuable print or one that needs to be preserved for many years because chemicals and impurities in the mounting adhesives can damage the prints with time. See next page if you want to mount a print to archival standards.

Dry mounting uses heat and pressure and a special dry mount tissue to bond the print to the backing. You need a dry mount press at least as large as the backing and a tacking iron to tack the print to the backing so it won't slip out of position in the press. The mounting process is quick and clean; the press may also be used to flatten paper prints.

Technal dry mount press

Cold mounting is a simpler process using a double-sided adhesive to hold the print to the backing. The only equipment needed is a roller to apply pressure to the mounted print. Cold-mount products differ from one manufacturer to another. They usually consist of adhesive on both sides of a paper or mylar core, or adhesive with no core at all. Some products are acid-free (which is best for preserving your print). Some are repositionable which means that you can adjust the placement of the print before applying pressure to make the bond permanent.

Spray adhesives are quick and easy to use, but they are not as strong or permanent as other mounting processes. Some are repositionable, and all will form a tighter bond if you apply pressure to the mounted print with a roller.

Mats and backings

A mat gives a photograph a professional looking finish and it provides a raised border that helps protect the print. In a frame, the mat also keeps the glass from touching the print so that any moisture that condenses on the glass will not damage the print.

Regular matboard, made of wood pulp, is acidic (see Archival Tips, p. 161) unless it has been treated to make it chemically inert. Ragboard, which is made of cloth fiber, is acid-free. Four-ply board is normally used for mats, and thinner two-ply ragboard makes a good protective backing for the print.

In a frame, a stiff backing is also necessary. Corrugated cardboard is very acidic and will age prints quickly. Fomecor, about as bulky as corrugated cardboard, has acid-free paper on the surface and is a preferable backing material.

Mat cutters

There are a variety of mat-cutting tools ranging from simple inexpensive cutters that require some dexterity, to elaborate and fairly costly machines that are precise and easy to use. For making straight cuts in matboard or backing, most photographers use a simple mat knife and a heavy metal straight-edge with a no-slip rubber backing. An alternative that might be quicker is a guillotine-type paper cutter that's designed to cut matboard, too.

The bevelled cut around the mat opening is more difficult. The simplest tool for this job is a hand cutter designed to be used with a straight-edge, such as a heavy metal ruler. One step up the complexity scale is a mat cutter that includes both a hand cutter and a straight-edge measuring system. This makes quick work of laying out the mat opening. The ultimate tool is a professional mat cutter with a built-in measuring system, a straight-edge hinged to a solid base, and a cutter that runs on a track attached to the straight-edge.

Dexter mat cutter

Alto EZ mat cutter

Keeton Kutter

Tips Archival framing

Acid-free materials Wood and wood pulp products contain acid and if they are left in contact with a photo over a long period of time, acid fumes will begin to age the photograph by yellowing it and making it brittle. To avoid this, use only acid-free matboard and backing material when framing your best photographs, and be sure any adhesives you use are acid-free as well.

Adhesives The adhesive you use to attach prints to mats or backings should be acid-free and it should be easy to remove from the print. Very few adhesives meet these criteria. A standard product for framing is linen tape, an acid-free bookbinders' tape with water-soluble adhesive. It is available from suppliers of archival framing materials.

The preferred way to mount a valuable print is to use photo corners. The print can be removed and replaced easily and no adhesive touches it. Look for acid-free corners made of paper or mylar. If the corners don't have adhesive on them, tape them to the backing with linen tape.

Protection from the elements The glass or Plexiglas in a frame protects the print from dust, scratches, moisture, and air pollutants that might hasten deterioration. Seal the back of the frame with paper or tape to keep insects out, too.

Fading is hastened by ultraviolet rays, which are plentiful in direct sunlight and in the light from some fluorescent fixtures. Avoid hanging your photographs in direct sunlight and when they are not on display, store them in a dark place. For very valuable pieces, you can use a special Plexiglas that filters ultraviolet rays. There are also ultraviolet filters for fluorescent lights.

Attaching a print to a mount with hinges

A folded hinge is hidden when print is in place.

A folded hinge can be reinforced by a piece of tape.

A pendant hinge is hidden if an overmat is used.

Overmatting a print

Measure the image area of the print. Here: 7 × 9 in. Add the desired margin around the print. Here: 2 in. on each side. Add the margins to the print size:

$$2 + 7 + 2 = 11$$
$$2 + 9 + 2 = 13$$

Cut two boards 11 × 13 in., one for the backing mount, one for the overmat. Use a sharp mat knife braced against a metal straight-edge like a heavy metal T-square or ruler.

Mark the back of one board with the image area of the print, allowing for the margins. Cut along the lines using the mat knife or a mat cutter (see p. 161).

Position the print on the backing mount underneath the overmat. Attach the print to the backing mount with tape or photo corners (see Archival Tips). The frame will hold the overmat in place over the print and mount.

Frames

The type of frame that's best for your photographs depends on several factors: whether you want to be able to change the photograph frequently, how you want the framed piece to look, and how much time and money you want to invest in framing.

Picture cubes, desk top frames, and plastic box frames are all designed so that you can open them and change the picture easily. They are made for standard size prints and some of them will take matted prints.

Clip frames give you the protection of glass, mat, and backing with an unframed look. There are several different styles of plastic, metal, or wire clips, all similar in design; the clips hold backing and glass together in several places and a wire or string behind the picture holds the clips in place. Some clip frames are designed for small pictures only, others can be used for large pieces. They are easy to assemble at home and since they are adjustable, they can be reused on different size pictures.

Metal frames are also easy to put together yourself—the only tool required is a screwdriver. They look contemporary and they come in several styles and colors. Pre-cut lengths are sold, two to a package with instructions and assembly hardware—two packages make a complete frame. Only a few styles and colors are available in kit form—for a wider selection, go to a store that carries the full line and have them cut to order.

Wood frames come in an enormous variety of styles and finishes. They are usually more expensive than other types of frames and they take longer to assemble. Wood framing options include buying pre-assembled frames (be sure to get good quality frames with tightly joined corners), having the entire frame cut and assembled for you, having the materials cut so you can assemble them yourself, or cutting and assembling the entire frame yourself.

Dax plastic box frame

Eubank clip frame

Nielsen metal frame

Suppliers

General suppliers of archival-quality materials and supplies.

Light Impressions Corp.
P.O. Box 3012
Rochester, NY 14614

Talas
Division of Technical Library Service
130 Fifth Ave.
New York, NY 10011

Processing and printing services

Labs

Many photographers depend on processing labs to do some or all of their processing and printing.

Amateur-market labs deal mainly with snapshot developing and printing. They do much of their work by machine and they offer a limited range of services, which usually includes duplicates, enlargements, and photo greeting cards. When you take your film to a local store for processing, it is usually sent to one of these labs. Prices are generally low, but quality varies.

Custom or professional labs deal primarily with professional and serious amateur photographers, often by mail. They use machines for some of the work, but they offer many services such as cropping, color correction, and retouching that can be done only by people. Although the quality varies as widely as with amateur labs, many more of these labs do excellent work.

Manufacturers' labs—for example, those run by Kodak—usually have more consistent quality and somewhat higher prices than do amateur-market labs. The range of services is smaller than in a professional lab.

Using trial and error to find a lab that meets your needs is a waste of time and money. Ask other local photographers, especially professionals, what labs they use and write directly to that lab for a complete list of their services and prices.

The services offered vary from lab to lab, but if you look around you can find all of the following services:

Processing

Developing the film either normally or with push processing which allows you to use the film at a higher-than-normal film speed rating. Slides will usually be returned to you in mounts ready for viewing, but you can request them unmounted.

Starting point	Possibilities	
Undeveloped film: black-and-white or color	Processing, standard	Normal processing resulting in slides or negatives.
	Processing, push	Increases film ASA for shooting in low light; data packed with film will indicate if feasible.

Printing

Labs will make enlarged prints from black-and-white or color negatives or from color slides. They may offer different types and qualities of prints that differ in cost. Cropping and color correction are usually included in the cost of the print.

Starting point	Possibilities	
Negatives: black-and-white or color	Machine prints	Generally the least expensive print. Made by a machine that automatically evaluates for density and color balance. Only limited cropping and color balance controls are possible.
Negatives: black-and-white or color	Custom prints	Made by a human operator. Allows for use of custom services such as dodging, burning in, cropping, masking, etc.
Negatives: color	Dye transfer prints	The most expensive color print process. Requires the use of three color-separated negatives to make the final print.
Negatives: color or Slides: color	Black-and-white prints	Black-and-white prints may be made from color negatives or slides but quality may not be as good as a print made from a black-and-white negative.
Slides: color	Prints	The print is made directly from the slide (without using a negative).
Slides: black-and-white or color	Internegatives	The slide is enlarged onto negative film and the resulting negative is then used to make an enlarged print. Contrast can be controlled better than with a print made directly from a slide.
Slides: black-and-white or color	Enlarged transparencies	Also called display transparencies. The slide is enlarged onto transparency film, 4 × 5 or larger. The resulting image is lit from behind for viewing. Enlarged transparencies are often displayed in light-box frames.
Slides: black-and-white or color	Duplicates	Cropping, plus some density and color balance correction, can be done in the duplicate.

Proofing

Contact sheets are prints that are the same size as the negatives. An entire roll of film may be contacted on one 8 × 10 inch sheet of paper. Enlarged proofs are also available. Proofs are used to evaluate the pictures so that you can determine which ones to enlarge and what corrections to make in the final prints.

Starting point	Possibilities	
Negatives: black-and-white or color	Contact proofs	"Gang printed," i.e., usually with the negatives from one roll of film on one piece of paper; all images the same size as the negative. Individual frames are not individually exposed or color corrected.
Negatives: black-and-white or color	Enlarged proofs	All images enlarged but printed on the same sheet of paper. Individual frames are not individually exposed or color corrected.
Negatives: black-and-white or color	Custom proofs, previews	Each image is machine enlarged and printed on a separate piece of paper. Allows individual exposure and color correction of frames on the roll.

Printing control

When you order prints from negatives or slides, you can request any of the printing adjustments listed here. Some of these "post-shooting" controls add to the cost of the print (the first four listed here usually do not), but they can help to achieve the effect you want in the final print.

Dodging	Lightening areas of the print that are too dark.
Burning in	Darkening areas of the print that are too light.
Cropping	Printing only part of the image area, usually to eliminate unnecessary elements at the edges.
Color correction	You can request that specific changes be made in the color balance of the print, or if you are uncertain, ask that the printer use his or her own judgment. Some labs will make a test strip to show you what's possible.
Masking	Used to control and reduce contrast. It is especially useful for maintaining highlight and shadow detail when the original negative or slide is contrasty.
Perspective correction	When you tilt the camera to photograph a building, the perspective becomes distorted and the verticals appear to merge toward the top of the picture. Some of this distortion can be corrected by tilting the easel in the opposite direction when printing.
Superimposition	Printing two images on the same sheet of paper. Often used in wedding photography (the bride and the groom superimposed on an image of the wedding, for example).
Negative retouching	Usually possible only with 2¼ × 2¼" or larger negatives. Normally used for removing blemishes from portraits.
Opaquing	Used to eliminate distracting backgrounds and other large areas from the negative.
Embossed texture	The print surface is actually embossed with a texture such as pebble, silk, or linen.
Cutout	A cutout is used to block light from the edges of the print so the image takes the shape of a heart, oval, circle, etc.
Vignetting	A cutout is held in an out-of-focus position during printing so the image blends into the white paper instead of having a clearly delineated edge.
Texture screens	Placed over the paper at the time the print is made, these screens add a textured pattern to the image. Canvas, linen, and mezzotint are some of the possibilities.

Special services

Since photographs are frequently used for interior decorating, cards, calendars, and gifts, many labs offer oversized prints and other special printing services. Some also offer mounting and framing services.

Murals	Many labs will make murals from slides or negatives in color or black-and-white. Price is usually based on the number of square feet.
Cards and calendars	Labs often have stock greetings, invitations, or a calendar which they will print alongside your photograph.
Copy prints	If the original negative has been lost or destroyed, a negative can be made by photographing an existing print. This new negative is then used to make copy prints. Slides can also be made by photographing prints.

Index